# Showbiz Photographer

*Ken Ross*

Published by Clink Street Publishing 2020

Copyright © 2020

First edition.

This book is a work of non-fiction based on the experiences and recollections of the author Kenneth Ross. In some very limited cases names of people and sequences may have been altered (solely) to protect the privacy of others.

ISBNs:
978-1-913340-74-2 paperback
978-1-913340-75-9 ebook

"You should write a book." How many times have we all heard this? Although in my case it was usually echoed in my direction from numerous somewhat bemused and enthralled fellow dinner guests who have quietly sat and listened to my stories about the boy from the 'back streets' of Middlesbrough and his escapades around the planet whilst carrying nothing more than a camera.

Stories of my career, witnessing the opulence, the power and the unbelievable world of the truly rich, the mind-boggling world of rock stars. Tales of photographing beautiful models for the *Sun* newspaper's legendary Page 3, then covering the next story where I am being chased and hounded by rioters baying for my blood – all this a guaranteed silence catcher.

Also working with the most gorgeous of the 'Bond Girls' or terrified as I lay on my stomach 200 feet below ground in a crumbling flooding coalmine. Flying around the world to photograph some of the world's most glamorous women or spending the day in some secret location covering a new television series photographing the screens newest rising stars! All an enthralling interlude to quench the taste buds of the most demanding of hosts, my anecdotes satisfactorily accompanying any after dinner soiree.

At the heart of these tales, the fascinating cast of characters – rock stars and their agents, Hollywood royalty, rioters, police, the elite, the rich and the ultra-powerful (and don't mention the 'M' word), all with copious lashings of treachery, backstabbing and deceit from those you should depend upon – here lies the troubled journey and ambition of the struggling showbusiness photographer, Ken Ross, in his quest to make the big time!

# Contents

# Introduction
## A BOX BROWNIE, SCHOOL AND MY FAMILY

To take your photograph you had to hold the 'box camera' tight into your chest and stare downwards into the small square prism at the top which reflected the image to the front of you. Satisfied and everything ready, you put a little more pressure onto your thumb to push downwards the crude trigger mechanism which protruded from the side of the box – click – photo taken.

To ready your camera for the next photograph you had to go through the complex and careful procedure of physically winding the roll of film forward. To line this up you had a very small round clear red plastic window on the back of the camera in which you could see the number of the photo you had just taken, you would now slowly wind the big round knob on the other side of the camera, whilst watching the plastic window so as to see the number slowly disappearing and the next subsequent number starting to come into vision. Carefully you wound the film, to centre the number of your next photograph in the round window – you were now ready to take your photograph

And these are my first recollections of photography, treasuring my old battered hand-me-down Kodak 'Box Brownie' camera. A square seven-inch black box with a short leather strap handle attached to the top, which enabled me to nonchalantly swing it with pride as I walked through the streets and alleyways of Middlesbrough. Laughable by today's standards, yet at the time this camera was a somewhat formidable piece of kit – not many kids my age could swagger around carrying a camera.

These were the days of my first obsession into photography, which from then never left me. Considering my parents were hard-working people who fought all their lives to ensure there was enough food on the table, my allowed hobby (unrealised by myself at the young age of fourteen) was somewhat of an extravagance. My father, a former war time decorated Naval Frogman (Fredrick William Ross, DSM) had spent several years after the war continuing his career as a deep-sea diver. This initially enabling our family to

have a very brief taste of living in colonial luxury with a chauffeur and servants as we enjoyed life in Ghana, Africa. This unfortunately was short lived, age eventually forcing my father out of the water and back home into the Middlesbrough steel works. My mother (Joan Ross), a true northern professional mum, always managed to juggle a constant stream of jobs, all adding to the family coffers, working in the local fish and chip shop, the local corner shop and later in the Co-operative store in the town centre.

So, the monetary indulgence of my hobby, a constant stream of 'rolls of film' to be purchased and then developed, I only realised many, many years later, must have been a financial burden she shielded from me.

At fourteen I joined in the family spirit and had several weekend jobs, my favourite was working for the local corner shop, my company mode of transport being the shops huge heavy old-fashioned bicycle with the giant metal framed basket on the front (think television series *Open All Hours* or the Hovis bread advertisement). The financial side of these jobs enabling me to pursue my hobby further, this enabling me to purchase a (second-hand) modern plastic moulded shape, Brownie camera – totally hi-tech back in those days. From then on, most of my weekend job earnings and pocket money went into my hobby, I became the family photographer. I photographed my friends, girlfriends (called sweethearts in those days) and family, in fact anyone I could arrange to stay motionless long enough to rewind the camera and aim at.

In the meantime, I achieved moderate standards at school, I was in what was then termed as 'B' Class, (A, B & C) and most years I was top in the annual exams. Unfortunately, no matter what grades I achieved, I was never promoted into the 'A' class, this the normal school procedure for the pupil with the top results (think football leagues). For some reason, I was never a favourite of the headmaster, this never more than evident when nearing the leaving age of fifteen when I put in a formal request to stay on at the school for another year, hopefully to gain newly introduced further educational qualifications. Unfortunately proving further our ever-failing relationship he advised me that he didn't think it to be worthwhile. All a much-remembered brief meeting in his office in which he seemed to give the opinion that he felt it was a total waste of his time that I should even consider requesting such a thing!

On my last day at school I was even singled out by him in his goodbye speech to us 'leavers', the whole school contingent standing to attention for

assembly. He stated how he had been a little disappointed generally in all our efforts for the year and said how (looking down from his podium directly at me), he felt only a very few from his own 'A' Class leaving this year had deserved any rewards in the way of a decent career! This was rather shocking as I had in fact worked hard and had been successful in receiving offers of employment from several of the schools own specially sponsored corporate interviews.

Also, on my own initiative, over the previous months, copying from a library book on 'How to apply for a job', I had approached nearly every electrical contractor in Middlesbrough, requesting an interview. Finally, by my own efforts, I was granted several appointments and subsequently offered an apprenticeship, of which I advised the school. Everyone knew of this, I was the only pupil leaving that term with such a prestigious apprenticeship, so the headmaster's comments directed towards myself were met by gasps from the rest of my fellow pupils, the faces of every young fifteen-year-old leaver turning in my direction with shock, a few smirks, but mostly sympathy!

Goodbye school I thought – and later walked out, trying to look macho and hide the tsunami of tears about to come forth.

All through my life I had a very close and loving relationship with my mother and father, both being hugely supportive on anything I did – I knew my father was at first disappointed at me turning down my first offer of an apprenticeship from the giant ICI Company, which had been offered to me after one of the school sponsored interviews. Although shortly afterwards he was very much relieved later when I told him of my better offer. You must remember that these were the days when a job, especially an apprenticeship, was considered for life. It was something you were groomed into by the system and even by your family, that's how we had all grown up. I just felt there had to be an alternative to setting off to work every day in the very early dark mornings (as my father did) with a tin lunchbox (sandwich lunch box) under his arm, wearing overalls and a flat cap.

Unfortunately, I never settled in my earlier career, I had started my apprenticeship and no matter how I tried, no matter how much I put into it, it just wasn't me. I was looking for more than just working every day in a factory or giant works complex until the day I died. During the next few years I chopped and changed and was successful in several trainee manager retail situations (at seventeen years old I bought my parents their first ever washing machine, later a fridge), and I was the first in my family to own a car.

*So, how from my first pictures with a Box Brownie, did I become a showbusiness photographer flying first class around the world taking photographs of some of the greatest ever film and pop icons?*

*Firstly, ambition, secondly, sticking to a very committed and hardworking schedule. Although, we should never forget 'luck'! Regardless of people denying such, this, and being at the right place at the time, are the totally necessary ingredients to any success story.*

*But before more on my life and career, before my climb to covering some of the world's top stories and me detailing some of the most amazing photographic assignments. Yes, before all this, I have chosen (out of sequence) one special chapter as my opening gambit, my first flurry into keeping your attention and to keep you enthralled in what was to be a rollercoaster of a journey into a world that is usually hidden. Although even here there are parts I am still unable to put into print, with facts and events that legally cannot be reported upon!*

*In this first chapter, I highlight how your photographic dream assignment can all go so terribly wrong. I crossed the Atlantic to Hollywood and then on to Paris to photograph not only a true world class mega superstar, but someone I had worked with several times previously, had a great relationship with and even dared consider as a friend!*

*I returned with – no friends, no photographs and possibly no career!*

THE SO FAR UNPRINTED TRUE STORY OF HOW A
YOUNG GIRL GIVEN OUT FOR ADOPTION AT BIRTH
FINALLY FOUND HER FAMOUS ROCK STAR FATHER IN
HOLLYWOOD AND HER BIRTH MOTHER IN PARIS. THE
TRUE STORY THAT HAS BEEN UNTOLD FOR MANY
YEARS – A STORY OF TERRIBLE DISAPOINTMENT.

A KALEIDOSCOPIC TALE OF A TEN-DAY TRIP THAT
TAKES YOU FROM THE PRIVILEGED LIFESTYLE IN
THE WEALTHY ENGLISH SUSSEX GREEN BELT, TO
THE HOMES OF THE HOLLYWOOD GREATS, TO LOS
ANGELES, SANTA MONICA AND ON TO PARIS.

# 1

## HOPE, LIES AND HUMAN BETRAYAL

It took a few seconds to realise the noise waking me from a deep sleep was the telephone ringing. With the dawn breaking and the early sunlight already creeping through the curtains I was able to see by my watch that it was six o'clock in the morning. Trying to sound alert and coherent as I struggled to grasp the telephone, and putting on my best English accent, expecting it to be one of the American hotel reception staff, I made a very wide-awake attempt at answering – "Good morning."

"Ken!" asked the enquiring and strained English voice at the other end. "Yes," I spluttered.

"O.K., then, listen up, get yourself awake, pack and be ready to book out of the hotel within the hour, you have to go into hiding with Sarah! Ring me back when you're up and ready to move, it's all happening fast here in London."

At that the telephone went dead – and so was about to start the biggest tabloid exposé of the year, a story that was to monopolise the worlds newspaper and television headlines for weeks to come.

As if straight from the pages of the latest Jeffrey Archer novel, this is an amazing and unbelievable story of one of the world's most famous rock stars and his new-born child who he had put out for adoption eighteen years earlier, a child who had finally found out the truth and had come to find her father.

It is also a story of betrayal and greed, of myths and lies. Here, with facts hidden for over thirty years, this is the final ending to the yet unprinted truth about the meeting of world superstar, Rod Stewart, and his secret daughter, Sarah.

## Two weeks earlier in London, October 1982

It was a brief message, I was invited for a coffee at the office of Riva Records on the Kings Road, the invitation from one of the international management team who I didn't know that well but explained how he helped handle the affairs of rock star Rod Stewart. This was nothing particularly surprising, I had previously worked with Rod in both Europe and throughout America and the relationship with the company and Rod himself was ongoing. So I was happy to receive the call, although I did have a few niggling concerns as I had heard just the week earlier that Rod had fallen out with his personal manager and co-director of Riva Records, Billy Gaff, and that it had been a particularly hostile break-up. All this it seems led to Rod losing his shares in the record company, a huge financial fallout for even the richest of rock stars. Nevertheless, whilst I was now unsure of the internal politics, I ventured forth.

The coffee meeting was subsequently held, which after less than an hour saw me leaving in a state of total shock. As a freelance, I had been offered the prospect of a story, which I had quickly decided in my mind to channel the first exposure through to the editor of one of the country's biggest Sunday newspapers; this I felt was the best choice as it then would be with an editor I had worked with for many years. He was one of Fleet Street's professionals and we had a joint history of trust, he recently moving from the *Sun* newspaper to become the editor of *The Sunday People*.

The facts and story that I was about to present to him were mind blowing, a disclosure that could shake the foundations of the world of superstar Rod Stewart – facts which at this stage I was still unable to assess exactly just how much Rod himself was endorsing or not.

Because of my trusted association with Rod Stewart's team, I had been offered this story, but obviously I needed to prearrange a financial deal for the first exclusive with a major newspaper, this for my own funding plus a further financial understanding for the daughter and Rod's team.

Rumours of this story had been swirling around Fleet Street for many years, but nothing was ever proven. Now, on behalf of two of Rods own people, one of his management team (an executive of Riva Records who I had now just met in London for coffee), plus seemingly a female member of Rod's very close and personal team who was working with him in America, I was able to present the truth on this legendary tale.

There had always been gossip and scant stories of Rod Stewart's earlier

years as a young eighteen-year-old struggling musician and his involvement with a girl, an art student named Susannah Boffey. This was rumoured to have resulted in the subsequent birth of a baby girl who was put up for immediate adoption. The whereabouts and identity of the child were thought to be long gone and lost in the archives of history. But now, as I sat in front of the editor of the *Sunday People*, I was presenting not only proof of this girl's existence, but also her own letter that she had written to Rod Stewart and her location.

In the world of tabloids, things happen quickly. Within seconds of me finishing the presentation of the facts, the editor picked up the telephone, asking one of his reporters, Allen Brown, to come to his office. Allen was a hardened Fleet Street senior investigative reporter with a strong reputation within his field. He was nearly twenty years older than me, about four inches shorter with greying hair. We had never previously met, our paths had never crossed due to our different work style and ethics.

So, on this, our first meeting, it was one of those uncomfortable moments where you could feel there was no particular respect for each other's professional track record. His work was purely hard investigative journalism, whereas my world was more about working alongside and cooperating with celebrities. At this stage the passing over of the telephone numbers and contacts was all that was required of me.

The editor of course was as amiable as ever, thanking me for offering him the story and promising me total involvement if the paper takes up the offer. Obviously he wanted formal acknowledgement from me that they get the first expose, adding that it was now for the newspaper to discuss this further and confirm details with Rod's London executive who had given me the information.

## Mirror, mirror on the wall

As I said earlier, things happen quickly, and within three days I was accompanying Allen, being driven to East Sussex, to the home of Rod's secret daughter, 18-year-old Sarah Elizabeth Thubron.

Research would show how Rod and his former lover, Susannah Boffey had placed their child for immediate adoption, the child then first spent her earlier years moving between foster care and children's homes, until eventually

at the age of five, being adopted by Brigadier Gerald Thubron and his wife Evelyn, the couple able to provide a permanent and secure home. Certainly, to most it would seem Sarah had at last been smiled upon, the home we arrived at to meet Sarah for this first time was by many people's standards entering the realms of modest luxury. A detached period house set slightly back from the road in its own small grounds – even having a peacock wandering around the garden.

On our arrival we were met by Evelyn and Gerald Thubron. It was easy to see the care and love that must have been given to Sarah by the Thubrons, they were the perfect devoted couple. He a retired brigadier and Evelyn straight from the pages of *Country Life*-style magazine, a typical older style Little England upper class country couple.

Obviously, several telephone calls had been made earlier to the family by Rod's executive or the newspaper, subsequently our visit had been agreed upon and our arrival expected, although once there, I felt there was still an uneasy atmosphere.

After the initial introductions we sat with Gerald and Evelyn in the lounge, Allen passed over papers which were no doubt written agreements and contracts, all agreed earlier on the telephone between themselves and the newspaper, none of which I had seen or had any knowledge of their contents. All this later followed by a few minutes of small talk before Sarah was finally called into the room.

On Sarah's entrance, if ever there was doubt of her identity, it was settled instantly by her absolute and total physical likeness of her famous father. Had she been a boy, the similarity would have been considered more clone-like than just a likeness.

Years later in Rods own autobiography (*Rod, The Autobiography* published 2012); he wrote of his first meeting with Sarah, "A girl so clearly mine that it was like looking in a mirror."

The talks between Allen and the Thubrons continued for over an hour, obviously talks of the financial agreement being settled, all this to guarantee first exclusivity for the newspaper (which I had also agreed with them). This was all done privately, the whispering in corners was enough evidence for me that I was not considered to be any part of Allen's negotiations, consequently by choice I kept well away.

I always had the feeling that the Thubrons were vulnerable, they were much older than I had expected and Sarah to say the least was a young girl

with her own mind. Knowing the relevant details of the adoption made it easier to understand how Sarah stood out alone from her adopted parents. To me Sarah projected a slightly troubled exterior, whereas the Thubrons had this natural cultured calmness and quietness about them.

Between the conversations with the Thubrons and Allen, their only query was why Rods own people were not here to talk to Sarah, especially as the newspaper was in possession of, and referring to, Sarah's letter. This being one of several which they said Sarah had sent to Rod's American office. Allen assured everyone that all this would happen in America, this meeting was simply to tie any loose ends and arrange to get Sarah to Los Angeles.

At the house I took some photographs of Sarah, followed with more of her with Gerald and Evelyn in house and the garden. I assumed then I would probably be back another day for a more relaxed photoshoot and that this may be the limit of my involvement, but again, the speed of the whole affair shocked even me.

## Four to Los Angeles

Several days later I was advised that Evelyn would accompany Sarah to Los Angeles, along with the *Sunday People*'s reporter Allen Brown and myself. My presence being part of the group was no doubt under the instructions from editor. I had the distinct feeling that I was not the choice of their chief investigative reporter who would have no doubt preferred a staff news photographer who would then work directly under him, rather than our more side-by-side relationship

Because of the age differences, I was far closer to Sarah, consequently we bonded more, becoming friendlier as time went by. During the flight we talked more and obviously Sarah was looking to trust someone in a time that was no doubt a very difficult experience for her. Although not privy to the full details of the arrangements, I had been asked to 'keep a friendly eye' on Sarah. She was after all at that moment the hottest media property in the world, and the newspaper was no doubt paying out a fortune in fees and expenses to Rod's team and to Sarah for the 'exclusive' and obviously wanted their money's worth.

Allen advised me telephone calls from the newspaper had been made to Rod Stewarts American company concerning Sarah.

Again, an entry in Rod's own autobiography, where he admits "there had

been a couple of calls from the British press which had made it clear someone was following up leads around the story of my adopted child."

It seems whilst the *Sunday People* had pursued its requests for a meeting, saying we were on our way, no acknowledgement or reply was ever received, total silence from across the Atlantic.

As soon as we arrived at our Sunset Boulevard hotel in L.A., Allen immediately contacted London asking for any news from Rod Stewart's people. Unfortunately, there still had been no further communication, and this became a problem, one that had not been foreseen by the newspaper at the start of our journey.

Obviously, the newspaper had imagined without doubt that Rod would acknowledge and arrange a hasty meeting with his daughter, especially as she was now in L.A. and no further than a mile away from his home. My own misty vision of Rod Stewart running forward, arms outstretched to wrap them around his long-lost daughter were quickly fading. The photographic opportunities were disappearing fast. Surely, we all thought, regardless of the newspaper's attempts at contacting him, he must have read her letters. Sarah had given him all the proof he would have ever needed, dates and names.

The next day or two in the hotel we played a waiting game, hoping by the hour for a message from Rod, all hoping for the fateful meeting. It was a surreal situation, here we were embedded on the Sunset Strip of L.A. in one of its top hotels with everything being paid for by the newspaper, living the life of luxury but at the same time unable to leave in case something suddenly happened with Rod Stewart. At one stage it was obvious Sarah was becoming particularly bored and restless, so in an attempt to stop the situation getting worse I grabbed her hand and we sneaked out of the hotel and jumped in the car and for several hours and we just cruised around L.A. Sarah talked to me more and more of her earlier life and of finding how Rod Stewart was her father. She told me of how there had always been the odd hint earlier in her life, family briefly mentioning she had a famous father, but this would always be followed by silence, and people giving each other wild stares and nods, as if a secret was about to be revealed but never was.

She explained it was her late grandmother (by her adoption) who had finally first broke the truth to her, a fact the grandmother felt Sarah had the right to know, that her father was in fact the man Sarah even had a poster of in her bedroom, rock star Rod Stewart.

From there, over the following months Sarah had found the address of

Rod's management in America and started sending letters, not asking for anything material, only that one day could they meet?

"I suppose," added Sarah, "that it was just a reply I wanted, something from my father, even a hastily written note, just something saying, hello."

It became my job to join Sarah and Evelyn, Allen spending a few minutes with Sarah or Evelyn when he wanted to top up his story line, then I assumed he spent most of his time on the telephone to London. Certainly, there was no natural camaraderie between Allen and myself, he played everything close to his chest with little being said of the current situation or how we should plan to handle the next few days. This was not so surprising at first, I had worked with his editor for years and we had developed a mutual trust, working on many overseas showbusiness assignments. Whereas Allen and I had entirely different approaches to journalism, Allen had a reputation as a serious investigative journalist, but this wasn't a field I particularly enjoyed. They are a different style of person, not necessarily worse, not necessarily wrong, just different

## The visit

On our third morning Allen telephoned my room, the newspaper had still received no acknowledgement from their approaches to Rod's company, so it had seemingly been agreed with London that we simply drive to Rod's home with Sarah and Evelyn.

I was never sure what Sarah and Evelyn had been told, but an hour later we were all in the car and on our way to Rod Stewart's Hollywood house on Carolwood Drive.

Here again in Rod's own autobiography he refers to this event, Chapter 14 begins with him explaining he was not at home on the day of our arrival, but apparently his wife Alana was.

Alana immediately telephoned Rod to tell him she had answered the intercom (which like all Hollywood mansion had intercoms with video cameras) and told him "there is a man outside with a camera around his neck, a middle-aged woman and a girl." With Alana adding how she felt the scene looked uncomfortably like an ambush.

Now firstly I should explain that Rod's house has a huge driveway with giant gates and over eight feet high surrounding walls, so this approach,

pressing the outside intercom was made by Allen who I could hear simply asking if Rod Stewart was at home. Eventually a female voice did answer, to which Allen introduced himself and explained he was hoping to speak to Rod. Evelyn, Sarah and I were stood further away, next to the car, waiting for a sign from Allen to come forward if the approach had been successful.

The female voice on the intercom explained Rod was not at home but working at the recording studios, Allen thanked her and gestured to us to all get back in the car – the first approach had been simple, polite, but fruitless.

Reluctantly we returned to the hotel and carried on with the waiting game, the following day Rod's lawyer contacted the newspaper in London. A meeting between Rod and Sarah had at last been agreed by Rod's lawyer, it was scheduled for the next day and the paper had reluctantly agreed the lawyers demands that the meeting had to be in private, with a promise of no interference and with no reporter being present.

Obviously, the thought that Rod was not keen to meet his daughter had never been under consideration, it had obviously been assumed by us all that once Sarah was there, Rod would meet her with open arms. All this to be an amazing heart-warming story for the newspaper, but the factual side was becoming increasingly evident – had we all made a most terrible mistake?

My head was spinning, this reaction from Rod was strange, not what I expected. Although we had not met for some time, our relationship had always been very good and yet it seemed that Rod still felt this was some form of cheap seedy press ambush. Something was seriously wrong! Rod surely knew Sarah was coming. the newspaper had Sarah's letter which had been originally been sent to him.

In my mind I now started questioning how much Rod really knew of Sarah and her visit, had Rod ever received this letter from Sarah? Was there more to this, I knew at least one of the letters from Sarah to Rod had been presented as proof of Sarah's existence to myself and the newspaper by people in his own team. The newspaper had always assumed it been offered with his management's knowledge, somehow with Rod, if not fully involved at least having given a nod of approval. But what if he had not! What if Rod didn't know anything at all about Sarah trying to contact him, this could explain his rejection of Sarah's approach. Rod thinking it was she who had approached the press first, that she had never tried to contact him privately. From this point of view Rod's reaction would have made sense – Sarah and the press setting up Rod's 'imaginary ambush'.

As we all waited for notification of the location of the meeting, Sarah and

I cheerfully toyed with the probability of her having lunch with Rod at the Beverly Hills Hotel, or even meeting her long lost family in his luxurious house, Sarah even joking of Rod whisking her away for the day in a private jet. This was all a huge emotional rollercoaster for Sarah, I now felt genuinely sorry for her, the trauma was starting to be too much for the eighteen-year-old. Thank God she would meet her dad the next day and be welcomed into the family – something she had waited all her life for.

## Sarah's hour – finally

An hour later the call came through from Rod's lawyers, the meeting would be at the recording studios (Record Plant Studios) the following afternoon.

This was to be the very first time Rod was ever to come face to face with his daughter.

No Beverley Hills restaurant, no family home that Sarah and I had both wistfully imagined, just the austereness of a workplace, in fact even worse, a room at the studio had been designated by Rod for this all-important meeting.

At the allotted time Allen and I drove a very excited Sarah and a rather pensive Evelyn to Rod's recording studio, Allen assuring Evelyn that there would be no interference but requesting that during the meeting would she please make a point of asking Rod for the opportunity for Allen to have a chance for a quick interview with him, this at least justifying the whole trip.

Watching as Sarah and Evelyn walked over to the studio entrance, Allen and I sat in the car, me settling down expecting a long wait. But after only seconds of Sarah and Evelyn disappearing into the studio entrance there was disappointing comments from Allen, that we should be out there checking the studio, that I should be trying to sneak a photograph through one of the windows.

Throughout my career I have never played the paparazzi game, so I certainly didn't think this was the time to start now. Plus, I explained that recording studios are notorious for 'not' having windows (and except the one at the reception and two small ones high at the front on the first floor, there were no other windows in sight. As neither of us knew even what room, ground, basement or first floor they were meeting in, it all seemed very absurd at this stage to risk everything by being caught in some fumbling pantomime style attempt of taking a photograph through non-existing windows.

The meeting between Rod and Sarah, Rod's lawyer, Evelyn and an extra surprise guest (who wasn't mentioned as being present in Rod's own autobiography) Alana. The results of the meeting varied from whom you listened to, there had definitely been further heartbreak, with nothing other than that very first connection having been achieved.

Rod in his autobiography on meeting Sarah wrote their meeting 'seemed contrived and strange, and that the room was so crowded, adding that, it should have been a warm, private reunion and it ended up cold and somehow public,' but this was Rod's choice! At this stage we have to consider the facts, Rod is extremely wealthy and could have held this private meeting absolutely anywhere, he could have whisked her off in a limousine to a fashionable restaurant or even taken her back to his home to meet the family in absolute total privacy – so why didn't this happen?

After just over an hour Sarah and Evelyn walked back out from the studio. Allen and I had waited for them in the car, this not only to take them back to the hotel but also in case there had been a change of heart and Rod had come out with Sarah, Allen still hoping for his big exclusive interview with Rod.

Unfortunately, this was not going to happen. Their first meeting had obviously not gone well. I looked at Sarah's face, the expected exuberance and excitement was not there, neither was the look of relief after eighteen years of waiting. It was still the face I had seen when I first met her, still troubled, still showing no signs of being at peace – had all this been for absolutely nothing? Her face was one of grief, grief for something that had been alive in her heart for so long but today had seemingly died.

Sarah, Evelyn, Allen and I drove slowly back to the hotel. Of course, naturally Allen was eager to know all the facts, questioning Sarah and Evelyn non-stop. But actually, very little was said by Sarah and Evelyn, both seemingly reflecting on their meeting with Rod, both full of an overwhelming feeling of disappointment, Sarah had met Rod but the daughter and father connection she had so wanted was not to happen this quickly, it was to take a little longer.

It was hours later over dinner back at the hotel that the four of us finally started talking, Sarah and Evelyn now giving their account of the meeting. Even Allen, eager for every word for his story, stopped writing notes for a while as we looked upon Sarah's face, her pure disappointment and anguish was impossible to ignore. Of course, we all talked of a next meeting, of a more relaxed atmosphere and how at least she had made the connection with her father and that there would no doubt be many future possibilities.

Allen got part of his story, although not present at the meeting he had the facts from both Sarah and Evelyn and consequently, probably spent the whole night re-writing and padding out his somewhat brief exposé many times over before sending it to London.

In Rod's autobiography Rod says of the story, "The Sunday People may have been excluded from the meeting, but it still had its field day, publishing a spread full of bullshit."

## Hide Sarah

Next morning it took a few seconds to realise the noise waking me from my sleep was the telephone ringing. I was able to see by my watch that it was only six o'clock. Trying to sound alert and coherent as I struggled to grasp the telephone, and putting on my best English accent, I made a very wide-awake attempt at answering, "Good morning."

"Ken!" asked the enquiring and strained English voice at the other end. "Yes," I spluttered.

"O.K., then, listen up, get yourself awake, pack and be ready to book out of the hotel within the hour, you have to go into hiding with Sarah! Ring me back when you're up and ready to move, it's all happening fast here in London."

Putting the phone down, it immediately rang again. "Are you up?" enquired Allen.

Back in London, with the time difference it meant it was already two o'clock Saturday afternoon and the story was about to hit the streets the following morning, Sunday.

The *Sunday People* was worried, with the story already being laid-in and print-presses scheduled to start printing in a few hours, inevitably the news of their exclusive was already being whispered around Fleet Street. With any newspaper, once the story leaves the editor's office, it is more or less in the public domain, discretion and loyalty doesn't necessarily come into this from all the newspaper workers. Consequently, and I had seen this many times, the newspaper had to ensure its story was being protected, especially as this particularly very hot story was to run for at least two weekends, hopefully three, so securing their exclusive was paramount.

Quickly showering and getting myself packed I rang London back. Allen

they advised me, was to stay at the hotel to liaison with Rod Stewart's people in case they could negotiate an interview with him. In the meanwhile, Sarah was the priority, by now the *Sunday People* realised the word was out about her existence. So, it was obvious that not only the rest of the English and most of the European press, plus also the American press itself (us being in their midst) would want a piece of Sarah. For us, being in a Sunset Boulevard hotel, in Los Angeles, was about as obvious as it gets for the press, and it wouldn't take a lot of door-stepping for another newspaper to quickly find our hideaway. Therefore, my instructions were simple, hire another car, get Sarah and Evelyn packed and get them away, hide them anywhere, as long as it's out of Los Angeles. The instructions were with an urgency, just get moving and ring only the editor's office in London with the location of where I finally located. 'Don't ring Allen at the L.A. hotel,' this was nothing to do with trust, it was purely the fact that hotel telephones have ears and with the outlay of many tens of thousands of pounds involved in this story, the *Sunday People* didn't want an opposition newspaper getting a tip-off from some hotel worker or quick cheap photograph of Sarah and using it as a spoiler. This especially as the syndication rights if sold back to America and Europe could more than cover the *Sunday People*'s outlay, and still leave them smiling with the year's top exclusive.

I walked over the road to the car-hire opposite the hotel and arranged a car, being English they always assume you want a compact, but the little bit of theatre I had left in me, wanting desperately to disguise and soften our dash out of L.A. to hide Sarah. I felt I had to dress it up, to make it look more like an extra mini fun vacation. A 'big American' car was my request, amusingly met by the smiling faces of the staff. And just as dramatic as the launching of the USS *Enterprise* in 'Star Trek', out came a huge light blue Chevrolet, it seemed the length of the street itself with a giant set of head-lights, white leather interior and huge long fins, yes this was America after all – and nobody, but nobody, would drive this unless they really were on vacation.

During a quick breakfast with Sarah and Evelyn I explained the problem, although both seemed unhappy to leave Rod's city. I quickly negotiated an awkward compromise – how about a few days in Santa Monica I whispered. Think of it was a couple of days away from all this turmoil and negotiations, and the three of us enjoy a few days extra vacation at the expense of the news-paper. Whilst I realised this was never going to be easy, I looked at Sarah

and Evelyn's face and I could see they had inevitably accepted for now it was the end anyway. They themselves seemed to have the feeling that with Rod Stewart it was all over, nothing else would happen for the moment and they may as well accept that fact – and in the meanwhile go along for the ride.

Bags in the car, without checking-out of the hotel (our names still on the hotel register would be a 'red-herring' for any enquiring press) we quietly set of for Santa Monica. It took us about an hour and a half cruising there and looking around for a small quiet hotel. I found a white wooden fronted hotel, not a brand name or in a chain, independently owned, on the beachfront facing the ocean – ideal I thought, perfect. Within half an hour we were all settled in and I made the proverbial telephone call to London, advising the editors secretary of our location. She would in turn ring Allen, who would then telephone them back from a payphone to get our location and number – I was not to ring the L.A. hotel and he would contact me from a payphone.

The day went along uneventfully, nothing especially happening and the three of us just doing the tourist thing, with me continually looking over my shoulder, ready for anyone following us with a camera.

## Come to Paris – said the spider to the fly

After two days Allen popped down to Santa Monica to meet us for lunch. Whilst there had been no more contact with Rod, Allen did have a surprise none of us could have ever expected. Whether it was after seeing the first week's *Sunday People*'s exposé on Sarah or through the papers own contacts I never got to know, but the paper had spoken to Sarah's birth mother Susannah Boffey (now Susannah Hourde) in Paris and arranged for Sarah to meet her. This was a total shock, something no one had originally conceived or thought possible. Suddenly Sarah was alive again, the paper had added not just a touch of pixie-dust, but a whole shed load of it, Sarah was ecstatic, for the first time she was smiling.

The next day we were back at Los Angeles Airport, boarding a flight to Paris. Other than discussing the basics of the first part of the story, which had come out a few days earlier in the *Sunday People*, very little was said between Allen and myself. All three of us were advised by him that we would be staying in Paris for two nights, where it had been arranged for Sarah and Evelyn to meet Sarah's long-lost mother, Susannah. Their initial first

emotional meeting was going to be just them together, but with the following day scheduled for us to accompany the pair around Paris for loving mother and daughter photographs – the whole procedure all assured and agreed with the paper and Susannah.

Things were now going well, there was a lighter mood coming from Sarah, even Evelyn's worries and slightly suspicious attitude seemed to have disappeared. I was particularly happy, at least the paper had come through genuinely for Sarah. Rod's disappointment was now overshadowed by the feeling of elation of the pending meeting. Thinking everyone at the paper must be happy at this conclusion, I genuinely felt I must have got it wrong about Allen and that he had pulled everything out of the fire in the end. So, the long flight and the taxi drive to our Paris hotel was relaxed and enjoyable – so why did I still have this niggling doubt, what possibly could go wrong now?

I had been working in fleet Street for over ten years, so I knew the usual working procedures, I had been on showbusiness assignments photographing celebrities and models all over the world, so I had come up against every scenario that could be thrown at a photographer, at least that's what I thought?

A few hours after we had checked into the Paris hotel I walked into the bar where we were to meet Sarah and Evelyn before they set off for their evening rendezvous with Susannah. There I found Allen standing talking to someone I had never seen before, but obviously by his bags and equipment around his shoulder, definitely a photographer! Allen made a quick introduction, which I must admit to not really listening to, my head spinning with so many questions and thoughts.

Allen simply told me our new companion was a *Sunday People* staff news-photographer who had flew over from London 'just in case we wanted an extra pair of hands.' Immediately alarm bells were ringing very loud in my head, why an extra pair of hands now, why at this stage?

Everything had been prearranged, there was nothing to do until the next day, when after their meeting tonight, Sarah and Susannah would pose happily for me at the Eiffel Tower, the Louvre, even a walk around Montmartre, everything had been discussed and agreed upon. Allen started hesitantly to explain how Sarah and Evelyn's first meeting with Susannah had been agreed to be without the presence of the press, a moment that was to be private and no doubt emotional. This I had of course heard earlier when he was assuring Evelyn and Sarah about the meeting on the flight from L.A., so there seemed no necessity for me to be told again. His expression and tone told me

something extra was about to be added, but before anything else could be said he broke off mid-sentence when a very excited Sarah and Evelyn joined us. Their taxi was here, their meeting being in a restaurant on the corner of Champs-*Élysées*, a five-minute drive from our hotel. So other than expressing our happiness for Sarah, with Allen adding how we would be probably all still up when they returned, we all hugged, kissed cheeks, and wished them well. With Sarah and Evelyn comfortably in the taxi, they disappeared into the night.

Within seconds, "Ready" shouted Allen, "let's go!" He and the staff photographer moving towards another awaiting taxi outside the hotel. "Go where?" like an idiot I spluttered.

"To follow them" was the short sharp reply. I looked at Allen, questioning what the hell was he talking about. Allen it seems, true to being an investigative reporter, was not going to let this opportunity go. The idea, regardless that it could obviously ruin my agreed photoshoot the following day, was to follow and doorstep them in the restaurant.

This going against all the promises and agreements he had given them! I couldn't believe we were to just jump in front of them. It was envisaged by the time we arrived they would have gone through the introductions, sat down in the restaurant and no doubt relaxing in each other's company. Followed quickly by ourselves, walking towards them through the restaurant, with cameras flashing, taking as many photographs of the no doubt very surprised mother and daughter as we could.

Still unable to comprehend what an earth was going on and why, I asked if London had agreed this. What about all the arrangements for tomorrow and all the promises? We had just given Sarah and Evelyn a cuddle, kissed their cheeks, gave them our blessing and all talked of tomorrow's photoshoot. But as far as Allen was concerned there was to be no further discussion, I was told to get in the taxi.

No! And that small word at that precise time is one I will never forget saying. I explained I just couldn't believe what was happening, after days of giving promises and assurances, we were going to just burst in on Sarah, Evelyn and her newfound mother Susannah. Regardless of the situation of what was happening, to just go in upsetting everyone, snapping away with our cameras. Surely this wasn't the story of reconciliation we wanted, this would be no more than hard investigative reporting and photography of people distressed, trying to shield themselves from photographers. I thought

this was supposed to be an emotional story of a young girl finding her family, her famous father, and now her long lost birthmother. We had been with Sarah and Evelyn for over a week, we had our breakfasts together, lunches, dinners and never once did either Sarah or Evelyn ever betray our trust or disappoint us.

I have always understood aggressive and investigative journalism, there are times when you encounter wrongdoings, people who put others at risk, embezzlers and corruption, where this style of journalism is necessary, and I admire the journalists who do this. But this was not the case here. This was a simple matter of an emotional meeting between people who trusted us, who the newspaper had agreed to photograph the following day, an emotional scenario, beautiful caring photographs of them walking around Paris together.

Obviously, I now realised why the other photographer was here, Allen knowing that I would never agree with his aggressive paparazzi plan it needed a back-up, a photographer who was totally under his instructions and would follow his every word. I never found out if this was sanctioned by London or whether it was Allen's decision, either way it was out of my hands and any decision I made was entirely on my own behalf, and I would no doubt suffer the consequences. In the end this was the paper's story, if push comes to shove, here Allen was in charge and made the ultimate final decisions, all I could do was decide if I wanted to be part of this, I decided not to be!

Leaving me standing in the hotel doorway, Allen and his photographer rushed into the taxi, Allen staring at me vindictively as the taxi drove away. I now realised that Alan must have decided upon this action some time ago, I consider myself intelligent and a worldly person, but now felt foolish and utterly betrayed.

My head was in a total spin, my stomach churning, I felt physically sick. What had I just done, was my decision to hasty, should I have gone? Was it a time I should have forgotten my principles, surely now my career was finished? I walked backwards and forwards in the hotel reception area and outside for nearly an hour, my heart beating louder than ever before, my blood pressure feeling at boiling point – the whole scenario was utterly devastating.

It was about then a taxi screeched to a stop outside the hotel, two women rushed out in a huddle, clutching at each other, both crying hysterically. It was a few seconds before I even realised it was Sarah and Evelyn. They didn't look at me, they just pushed by, both looked in shock, both in tears.

I stood there for another ten or twenty minutes, now I was in shock, what had happened, what had sent these two women back in such a state after such a short time from such an emotional meeting? I thought of going to their room, but the visible state of them rushing by in such distress made me err on the side of caution.

Before I could make any decisions, another taxi arrived, from this appeared Allen and the staff photographer, a quick glance from Allen said it all. He brushed past me with his photographer, both into the hotel and upstairs to their rooms.

Minutes later the photographer came back down, joining me outside. "Allen's gone to bed," he mumbled, followed by, "You were right."

I was at bursting point, asking what the hell had happened?

The photographer explained, he and Allen had followed Sarah and Evelyn's taxi which stopped outside the restaurant, there they waited a few minutes before following into the restaurant, the photographer could see Sarah and Evelyn seated with a small group of people, so with Allen at his side he walked towards them taking photographs.

For the meeting with Sarah and Evelyn, Susannah had reserved a private table in the far corner of her local restaurant with her French husband and a few of her close friends. It seems as Allen and the photographer entered with the camera flashing, the friends of Susannah quickly stood up to object to the invasion of their privacy. Consequently (the photographer still explaining), there had been a bit of pushing with her friends shielding Sarah and Susannah, with at least one chair being knocked over. Susannah and Sarah had also stood up objecting and other restaurant guests were now joining in, turning it into total disruption. During this time the local police, whether simply passing or had been called by the restaurant, quickly became involved. Whilst the policeman talked to Allen and the photographer, Evelyn and Sarah had become even more upset. With Susannah quickly arranging for them to meet the next day, they all left. The whole group disbanded, leaving Allen and the photographer with the policeman who was advising them these were private premises and asking for the film from the photographer's camera before they left.

Outside our hotel the photographer and I talked for nearly an hour, the photographer expressing his regret of the whole situation, but adding that he, unlike myself, didn't have a choice.

So there were no photographs! But could there ever have been? I never

understood how photographs of the group in possible distress, holding their hands in the air to shield themselves was ever going to be a great emotional story of a daughter meeting her long lost mother – especially as it was all arranged and agreed with the paper that I was to get beautifully posed photographs of mother and daughter walking around Paris the following day.

I never saw Sarah and Evelyn ever again, next morning they were not there for breakfast, I was advised by the reception staff they had booked out of the hotel. Obviously, all very disappointing on a personal note, despite my good relationship with them and although I had fought in their corner every step of the way, I suppose they just looked with disgust at the whole event and assumed I had been part of all this.

Allen and the photographer were having breakfast, poignantly at a table just for two, and as for me, a quiet breakfast on my own. The staff photographer's loyalty had obviously returned to his paymaster, his only quick passing comment to me was "for the sake of my job would you forget that I had spoken to you during the early morning hours outside the hotel."

I made my own way to the airport, happy to be finally going home from what I had first envisaged as an amazing opportunity to cover another top world exclusive story, to what had become a week of pure hell.

## Did the truth ever come out?

I did see Allen once more, when visiting the editor in his office a week later. As I walked through the *Sunday People* newsroom one of his associates who was sat next to Allen, a columnist at the paper, murmured "There goes a photographer who won't door-step and take the pictures he is told to" – all I could do was turn and say, "That's not a photographer you are talking about, what you need to hire is a cheap lying paparazzi snapper!" But I never forget, there always must be a scapegoat, for Allen, at least amongst his colleagues, I was it!

The editor of course was as amiable as ever, I was thanked, paid in full, although amazingly he never once asked me what had happened on the Paris trip, or where the photographs were. Unfortunately, the day I popped in to see him he was obviously busy, phones ringing constantly, other people queuing to get into his office, so there was no opportunity for me to sit down and talk it through. Probably any reasoning wasn't wanted anyway, I had worked

for him all over the world for several years and never had or made any problems – so he probably guessed and filed it all away as something now 'water under the bridge', and as they say, something that was now 'tomorrow's fish and chip paper'.

I had to put my hope in another expression 'the truth always comes out'. Surely someone at some time had to account for the fact that there was no interview or photographs of Sarah and Susannah's meeting in Paris, but of course the absent freelance is always the easiest target. I will never know what excuses were made, what story was told – and possibly, just possibly, the truth did not come out!

The newspaper the following weekend published a pathetically small one paragraph account of Susannah and Sarah's emotional midnight meeting:

'Rod Stewart's love child Sarah Thubron wept tears of joy last night as she met her long-lost mother. It was all so different from Sarah's tension packed first meeting with Rod Stewart a week earlier. Susannah's eyes glistening with tears as she invited Sarah to make a new life with her in Paris.'

Obviously, there was no actual interview with Sarah and her mother, there were no photographs from Paris, the paper reusing my earlier photographs of Sarah taken in her home in Essex!

Years later Rod and Sarah did meet again, their relationship blossoming. She was never intergraded entirely into his family, but she had the acceptance, love and acknowledgement from Rod – and that's all that Sarah ever wanted.

For my part, I can only hope Rod eventually discussed all this with Sarah, at least enough to discover the truth of the whole sad affair?

***Still to come:*** *I have my first big break, news pictures published in London. I am both welcomed and rejected within an hour by the Sun Newspaper.*

# 2

## BUT FIRST – ALONG COMES ANGELA

It would be hugely unfair to go any further in my memoirs without first introducing one of the most important people in my life, a young beautiful teenager I met near Manchester.

I was now twenty-three (my professional photographic ambitions having temporarily been put on hold, conceding that it was impossible for me to become a photographer in Middlesbrough). Nevertheless, I was single, driving a red sports car, was relatively happy with life – and then something happened. I had become the rising star in a huge entertainment organisation, subsequently enjoying an absolutely fantastic man-about-town lifestyle. Then I met someone – she had just celebrated her nineteenth birthday and she was called Angela.

Comparatively younger than me in those days that for several years when people asked how we first met, I would joke that I used to hang around waiting for her outside her school! In reality we first met when, with another fifteen-company staff, we were all booked in the same hotel on a training programme which I was conducting.

I noticed her straight away, long blonde hair, wearing a short grey coat which just covered a barely visible mini dress (very trendy in the late seventies), all projecting what I would describe as a leggy blonde who instantly blew my mind away.

The following evening, I made a point of finding her, she was comfortably ensconced within a group of her colleagues on the terrace of the hotel bar, which I quickly eased myself amongst and managed eventually to extract her from. We seemed to hit it off straight away, taking advantage of the warm summer evening, we walked out along the country lane, continuing our conversation for over an hour.

From that night we started what I would call an old-fashioned courtship. For me, I knew from that very night I had found my special person (although Angela to this day still refuses to believe me, insisting I was enjoying my

single, well-paid, glamorous sportscar lifestyle far too much). But I had really fallen head over heels for her, she was stunning with such a big heart. Dressing formally for a night out, she could enter any room and bring it to a dead stop and yet at the same time, without any makeup she could look absolutely fabulous, sexy and so naturally gorgeous with her hair tied back and wearing just jeans and a T-shirt.

Much later, after several months of holding hands and doorstep kisses goodnight (and meeting her mum), I won her over and we finally moved in together.

Within the coming year, at a speed that still stuns me, encouraged by her friends, family, and even some of my own work colleagues, Angela entered and won some of the country's major televised beauty competitions. Riding on the success of the competitions she attracted not only the attention of the local Manchester newspaper but also Granada Television, all this encouraging her to dip her toes into the world of modelling. Resigning from the company we were both working for, Angela soon became everyone's favourite girl, quickly becoming one of Manchester's (and later London's) most successful photographic models.

# 3

## SAINT-TROPEZ AND THE RING OF TEARS

Still based in Manchester Angela and I had now been together several years and for summer our favourite holiday was to the drive to the glamour and splendour of the French Riviera.

This season, having my newly acquired gleaming white Triumph TR6 serviced and made ready a few days earlier, it was a case of Saint-Tropez here we come! A quick early morning buzz down to Dover to catch the ferry! All this to make sure we had the early crossing to Calais, ensuring we were south of Paris by early evening. One luxury we would always try to give ourselves was stopping for a nice evening stay at one of the local country hotels, this rather than the plastic motorway café stopovers.

This obviously meant a diversion off the motorway, but the relaxation and change of scenery was worth the extra hour in travel time.

Then it would be a relatively early evening, ensuring we were off early next morning to arrive in Saint-Tropez with still hours of daylight before us.

And that's how we would spend many happy summers, fitting our favourite holiday between our hectic work schedules. However, on this occasion this trip was to have an additional purpose, hopefully making it an even more memorable trip. I had extra luggage – nothing big, in fact on the small side, but very valuable and an item Angela could definitely not know about.

## Several months earlier – shopping in Manchester

Angela and I were very close and enjoying life together so I must admit I couldn't find any reason to think this would not last forever. Forget that she was now becoming a very popular and successful Manchester model and a frequent face on Granada Television – she was more than just my lover, she was my best friend and my soulmate, even my own mother and father loved her – so the obvious progression of our relationship was due to move up a notch.

Having a day out in the city centre, we had been walking up towards St Anne's Square, generally looking in shop windows, a sort of nothing to do window-shopping day. One of the shops was a rather upmarket jewellery store and as we casually looked at the selection of men's watches, to the side there was an especially beautiful selection of diamond rings, one which caught Angela's eye. Just a quick comment from Angela on how it sparkles under the spotlight, with the conversation then moving back to the selection of watches. End of discussion, moments later we moved on to other shop windows, finally finishing at our favourite wine bar for lunch.

Now here, I must admit, money was not an easy subject for me and at that stage, I had to be careful financially. Therefore, my next day's discreet and secret return to the previously mentioned jewellery store was an expedition to find the price of the ring which Angela had commented upon, this to say the least was a little scary.

"Bloody hell" I bellowed as loud as I could as the salesman brought the ring from the window and read the price from the tiny sticker underneath.

Well no! Obviously, I didn't scream bloody hell! I wanted too, but as we all know, 'one' must act the part in a 'posh shop' – so whilst the scream inside my head was certainly loud, in reality, I uttered no more than a respectful and muted "Ummmn"!

Not only did I not have the money to purchase the ring, there wasn't any chance of me saving up and buying it for several months.

"A cluster of eight beautiful diamonds on white gold, each diamond mounted on its individual rising stem with a slightly larger stone raised as the centre piece, each held within its own claw. Something I can advise you sir is totally unique, normally one diamonds would be set in a flat heavy base surrounded by lesser more inferior smaller stones," were the words from the now superior and smug sounding salesman.

"Yes, it is perfect," was about all I could splutter or afford to at that moment. In this jewellery shop even splutters I assumed were expensive.

"Can I leave a deposit on the ring; I am going abroad for three or four weeks so I will pay and collect it when I am back?"

Deal done, handing over my pocket full of folded and embarrassingly crumpled ten-pound notes, receipt in hand, I left the shop.

And so, started probably one of the longest jewellery purchases this shop would ever experience, certainly something the *Guinness Book of Records* would have been interested in!

Of course, I was not going away, the truth is I didn't have the money and wanted time to procure such.

Consequently, every Sunday (knowing the shop would be closed), without Angela's knowledge, I would quietly walk by my jewellery shop. I say 'my' jewellery shop, this because due to the price of the ring, I therefore felt I had actually purchased at least half of the premises.

On each occasion, on arrival outside the shop, ensuring I wasn't being watched, I stealthily looked around then bent down pushing my envelope (addressed to the manager) through the shop's letterbox – this by way of being yet another payment from myself towards the cost of the ring. In the envelope another forty or fifty pounds with a note, usually saying, as if being delivered by a friend, that I was still away and this was another interim payment, securing the purchase of the ring. Basically, the Sunday envelope deliveries went on for over two months before I had paid enough, enabling me to now go and pay the final amount, at last to retrieve my purchase of the ring.

By then, on entering the shop, seemingly I had become a legend amongst the staff. Each being called out to the counter as if to be personally introduced and to greet me. I of course made my excuses, travelling abroad, having a friend who owed me money to deliver the weekly envelopes in my absence – all very excitingly and amusingly received by the now group of six attentive smiling staff.

But full praise to the shop (and its ever-smiling staff who seemed to find each of my words hilarious), they had catalogued my payments, receipt after receipt stapled to the original. Subsequently they presented the ring, cradled in a beautiful crafted leather box.

Thanking everyone and thinking I had retained some dignity by stressing I had been abroad working and my friend had delivered the envelopes – I was waved goodbye from each and every member of the staff. With the manager casually mentioning as I was closing the shop door that it wouldn't be the same on Monday coffee mornings for the them anymore, when all the staff would gather around the CCTV Camera screen watching the regular Sunday recording of the weekly ritual of 'me' hesitantly looking around outside the jewellery shop before venturing forward and slipping the constant stream of envelopes in their letter box!

Oh! The total embarrassment and pain as I walked away, still not to worry! I had my ring and as I turned the corner, the shop now having disappeared, I realised another exciting chapter of my life was about to begin.

## Back to the trip

So, throughout the drive to Saint-Tropez I had to keep switching the hiding place of my secret article inside the cockpit of the TR6, under the seat, in the glove compartment, amongst my camera equipment, all this making sure Angela didn't come across it by accident.

Arriving in Saint-Tropez, settled and relaxed, I booked a table in our favourite trendy quayside front restaurant. Booking secured (last table I was assured), ring now hidden under my jacket. We set off to our rather full restaurant. Of course, when you are about to 'pop the question', it is then you must decide exactly at what precise part of the evening do you approach the subject. Before the starter course, during the main course or afterwards, with the strawberry's and champagne? Do you do this during the small talk, the humorous and joking moments, or try to bring the conversation to a more romantic subject but without giving the lead away to early?

I decided to wait until ordering the strawbs and champers – then stretching my hand across the table to place it on Angela's and at the same time bringing the conversation into a more romantic flair.

My actual words were not important (also because I cannot remember exactly what I did say) but sliding the still boxed ring (lid open) across the table I asked Angela to marry me!

Now here are several reactions to be anticipated! Obviously, a smiling yes, an excited appreciation, even just a wow! Or of course the unthinkable, but sometimes the dreaded, no!

Neither of these was forthcoming – Angela looked straight at me, no doubt recognising the ring, she stood up and immediately burst into tears, a tsunami, a virtual monsoon of crying tears. From her now standing position, she then rushed away from the table to the lady's washroom!

Now I have to say this wasn't done in a subtle manner, her quick movement to stand, chair scraping back along the wooden flooring, the image of Angela crying and the rushing out to the washroom made every head in the restaurant turn towards our table. So, there I was, sat alone, getting terrible looks of disapproval from what was now looking like hostile diners. All who obviously misinterpreted Angela's actions, assuming no doubt she had been upset by some terrible actions or words forwarded towards her from the man (me) sitting opposite her. Dark looks were being projected at me across the restaurant like missiles, tut-tuts could be easily be heard. Even the waiters

were giving me the thumbs-down look. Yet in comparison, there was I, looking like televisions soppy Mr Bean, smiling with a huge stupid grin, turning my head side to side, holding the boxed ring up in the air and pointing to it, then putting my hands together as if in prayer, miming how I had asked her to marry me – puzzlement and sideways nodding heads abounded.

Of course, ten minutes later (a long ten minutes), Angela returned with a huge smile on her face, other diners now realising the outcome, I now getting one or two nods of approval, even a respectful round of applause from the minutes earlier disapproving guests.

Angela said "Yes" and in the end, that is all that mattered, I was to be with the woman I so wanted for the rest of my life.

Although still living in Manchester, I was travelling around the country as a high-flying company executive, whilst Angela was successfully pursuing her modelling career. She was outgrowing Manchester fast and had now even been chosen by the world's most famous footballer, George Best, to be the face of his fashion empire, attracting huge national publicity. All this at the same time adding a new somewhat high-profile drinking 'football buddy' to our already hectic social lifestyle, George becoming a somewhat formidable drinker to keep up with!

Angela was now starting to work more and more in London, her agency there, Top Models Agency, constantly barraging her with requests to relocate to the capital. They insisted that she could not carry on commuting so much without it being detrimental to both her health and her career.

With Angela's life now being more and more in front of the camera and mine now seemingly being further away from the camera, it was time for important decisions, we relocated to London.

Taking a deep breath (very deep), I gave up my job, secured several excellent offers of employment in London, eventually choosing the more surprising of them all – not being tempted by the initial financial rewards but one that still pulled at my heart – working at the biggest commercial fashion photographic studio in North London. I was to be the studios client liaison executive, obviously not being an actual photographer, but about as near as I could get – and I realised working with photographers would at least expand my knowledge and opportunities. After all, photography is a state of mind and working amongst cameras and models all day I hoped would reignite the photographer's dream still inside of me – and it did! I watched and observed, using every opportunity to be there on the shoot. I would engage with each

photographer on the client's requirements and watch for their reaction and how they would alter and light the set accordingly. Fashion, room-sets and food photography, in this seemingly endless world of photography I had complete freedom to move around and watch everything, the learning curve was endless.

# 4

## LONDON AND MY FIRST
## PUBLISHED PHOTOGRAPH

It has to be an instinct, something inside your brain that clicks a switch and you automatically go into 'photo mode' – you have to look physically in front of and then beyond the actual image you want to capture. Double checking foreground and way into the background. You must sense the very second you press the shutter that you are capturing the very heart of what you see, although more importantly, showing the full story! Instinctively you must be both creative and visionary, and yet you must also have the ambitions of a dedicated businessperson – a sort of 'The Wolf of Fleet Street' approach.

Why all these things? Of course, the obvious question is why isn't just taking nice photographs enough? So, let me briefly explain (and as this is certainly not a teach yourself photographic 'How to' book), so I will be very brief. The only way I can ever answer the age-old question of what makes a professional photographer is – a creative eye, a visionary instinct that way-out performs all your other senses, plus a very firm business head.

I was once asked to put that into simple words, to demonstrate the theory – so here is my answer. As I press the shutter on my camera, I must be aware if it tells the story, and just as important, where I will place the photograph. Basically, who will buy it? Is this a money-making photograph? It is many, many years since I have taken a pretty photograph for simple pleasure, probably the curse and downside of being a professional!

### The floating Mini and the flooded roads

Arriving in London I had swapped my rather cheap Russian copy of a Nikon for the actual real thing. Yes, it was second hand, but it was the legendary 35mm F2 Nikon with the Photomic-head (totally pro' and a very serious piece of kit).

I already knew that taking just a pretty photograph into even the most

minor local newspaper was never going to be a career-changing event. Certainly, it seemed as if there would never be the opportunity to join the professional ranks. Least of all for a lad from Middlesbrough, who although for three years had worked his way through evening classes at both art and business college, had never read a book or attended any classes on the subject of photography!

But this is where the earlier mentioned 'instinct' comes in, were the switch in your brain clicks into 'photo-mode'. A time you have been waiting for – because this is the big test – plus I have always said that in any profession you always need luck – the clever part being that you are able to recognise any luck offered and use the opportunity?

*Years later when being followed and filmed constantly by a BBC video crew I learnt from them one hugely important comment – 'If it's not on film, it didn't happen.'*

Nothing is more relevant and nothing more true, the number of times I have sat and listened to photographers (like fishermen) talking of the one that got away – the fantastic situation that was happening in front of their very eyes, the one that would have been the perfect photograph – except they didn't take the picture! No camera ready, not quick enough or simply they themselves were not in the photo- mode – all excuses. If you're going to be professional – then that's what you must be, professional and always be ready!

And so, back to my own experiences and how it all really started…

I was driving home from the commercial photographic studio where I was now working, travelling out of London towards Brent Cross, just coming up to the North Circular and Golders Green major junction. It had been a particularly wet day with the heavy storm rain continually battering the capital. Suddenly I found all the local traffic had come to a halt, nothing was moving at all. Instinctively I pulled over, parked and walked further on towards the junction, there to find the whole road system completely flooded, the major junction looking more like a huge lake. The water level was already halfway up the traffic light poles and one car, a Mini, which seemingly had attempted to drive through the flood was now actually floating in the water.

## 'Photo-mode'

Whilst the crowds viewed this as entertainment, I realised it as a photographic opportunity and rushed back to my car and grabbed my camera from the boot. In the couple of minutes this took, the Mini, now half-submerged but still floating had been abandoned by its driver. Bobbing up and down alone in the water like the *Mary Celeste*. The Mini was now being pushed around by the waves caused by the huge lorries and trucks still pushing their way through the flood, it now smashing into what were once the curb-side pedestrian footpath barriers.

Click and click again, I snapped away at the continuing chaos – another photographic moment was about to present itself. A Rolls Royce driver, thinking his superior car was totally above all this mediocre floodwater commotion, drove straight ahead into the flood waters – and yes – it stalled! Almost immediately a group of local teenagers waded in to talk to the driver, obviously to negotiate a fee to help push the Rolls Royce out. Instantly a deal was done, the lads at the back pushing, helping the huge car slowly back out off the water!

Of course, the now swelling crowd of watchers gave out an enormous cry of laughter, and yes! Click and click again.

I didn't stay, I didn't join in the now almost carnival atmosphere that was happening all around this temporary new ocean of submerged cars – deciding to leave my car where parked I quickly walked to the nearby tube station and in minutes was on my way back into London, to Fleet Street.

An hour later, I stood removing the roll of film from the camera at the reception desk of the *Sun* newspaper. Explaining what I had, or hoped I had? Remembering these was the days of 'rolls of film' and there was no checking the back of the camera screen to confirm what you actually captured. The receptionist put the phone down and told me to go up the two flights of stairs where someone would meet me. There I was met by one of the picture desk assistants who simply told me to have a seat in the lobby while they develop the film to see what I had.

Twenty minutes of nervousness and tummy churning anxiety followed – but then another face suddenly appeared beckoning me to follow him to the picture desk. This was a huge open office floor which was obviously combined with all the news desks, each of the dozens of people busy running backwards and forwards, carrying photographs or papers in their hands. The

atmosphere was electric, it was getting near to setting up the papers page's, so time was obviously of the essence. I had an amazing feeling of anxiety, worry and yet a feeling, even if only momentarily, of being a part of it all – from that very moment I knew I was forever truly hooked! I was a photographer and I was at the *Sun* and people were looking at my photographs.

A seat was pulled out for me and I found myself sat next to the man who I was later to get to know as Tom Petrie, the assistant picture editor (a man who would later be hugely instrumental and influenced me in my photographic career). "Looks fun," he said, looking at me whilst holding the metre-long thin contact strip on which I could see the images I had taken earlier. "Yes, we can use one or two of these, sit yourself over there at one of the typewriters and give me fifty words to go with the pictures, the Rolls Royce one and the pic of the Mini floating in the water!"

That was to be my baptism into Fleet Street.

Luckily, I had used a typewriter (this before everyone had computers), but sitting there amongst all this bustle, energy and excitement of this engine room of one of the biggest newspapers in the world, I just sat motionless and stared at the typewriter.

"Papers in the tray next to you" Tom shouted! I have forever remembered that moment, rather than him making some derisive or mocking comment, I always felt it was more a helpful dig in the ribs to bring me back to my senses, Tom probably guessing this was my first time and of my utter and total bewilderment.

The next day I opened the *Sun* to see my published photographs, under them my typed caption plus the by-line; Pictures by Ken Ross – this was the start a journey which would be the most momentous 'rollercoaster' ride that would continue for the rest of my life.

# 5

## EIGHT BUSES, POLICE
## AND MY BIG CHANCE

Still feeling happy about my first 'car flood' photographs published in the *Sun*, this particular day was to be a simple day out in London. Angela's brother Tom and his wife Jackie had come to visit with us for a few days in our new London home, so it was a case of doing the tourist thing, and on a nice sunny Sunday, where better than Hyde Park which we would often frequent for Sunday lunch. As we passed Speakers' Corner we would always look to see if anything was happening.

This was in the age of political demonstrations, when every political group or individual who felt they had something to say would eventually congregate at the north end of the park at Speakers' Corner. Consequently, as we often passed Marble Arch, as a struggling and still very much a would-be press photographer waiting for his first 'big' break, I would always look over to the park to see if anything was happening. The easiest gauge of that (Angela and I joked of it as our 'radar') was to see how many of the old green 'police buses' were parked on the Marble Arch end of Bayswater Road. We had a simple system, one or two buses meant absolutely nothing was happening, four buses meant possibly worth pulling over and having a look, whereas six buses was definitely a 'find a place to park and go there with your camera'. So, on this day, whilst all four of us were enjoying a relaxed drive and look-ing forward to a refreshing drink at the Serpentine bar, suddenly our radar brought in the number of police buses to eight. This was major alert time, the bells were definitely ringing, this was an unprecedented police attendance, what was happening to need such a police presence?

Finding a quick spot to park the car on Park Lane (still possible in those days) I grabbed my camera from the boot of the car and ran over to where I could see a huge crowd.

Leaving Angela, Tom and Jackie following, I arrived at the scene when the police had obviously just started to try and break up what I quickly realised was a massive political demonstration.

Usually these affairs started with a succession of speeches and patriotic songs by the organisers, the event at the early stage no doubt initially spreading a carnival atmosphere for the intended audience. This until a wrong word is said or a small incident ignites a surge of violence that suddenly sours the whole mood. This is when all the bottled-up energy, and for a minority the whole purpose of the meeting, boils over with violence. Battle lines had no doubt been drawn up earlier by the ever-watchful police, and a decision had been made at some stage that the line had now been crossed. By today's standards this was probably very tame, this the era when the 'bobby' (even on riot duty) wore nothing more for protection than his traditional policeman's helmet, and between them and the demonstrators it was simply a case of pushing and shoving, with a few old-fashioned fist fights thrown in.

The fight was on, obviously the police trying to get to the organisers and make a few arrests, the crowd of accompanying demonstrators not happy about the intrusion – and so the game begins.

There was already about ten press photographers present, circling around the mass of demonstrators and police, trying to get amongst them to take their pictures. To me it was obvious, they had far better equipment, each also having several cameras, and they had been here earlier, so no doubt had surveyed the better positions and angles from where to get the best pictures. Therefore, my job (and instinct) was finding an edge that they had not considered, a vantage point, something or somewhere they had overlooked. Looking quickly around, I could see one opportunity that amazingly was not being covered by any of the press.

For no matter who fought who, I surmised there was one point where the struggling arrested demonstrators would all be taken to the police custody van. Spotting its location, I slowly made my way around the surging and fighting masses, eventually to come to the side of the police van. Here as I expected, the police were trying to bring the arrested demonstrators to the van, the demonstrators struggling for their freedom, the police, joined by their commanding officers were all in the death-throws of capturing and arresting what they no doubt felt were the leaders of the demonstration.

I was instantly held back at arm's length by one of the senior police commanders. *Daily Mirror* I hesitantly (and shamelessly lying) shouted, holding up my camera and a very dubious press pass which I had purchased from a picture agency that had advertised in one of the many amateur photography magazines. In the scurry and mayhem that was happening all around us, I

think it was just a case of it being far simpler for the Commander to ignore me and say OK, than have one of his men move me away. And there I was, leaning on the side of the police van, the only photographer present, with the struggling arrested demonstrators being forcibly dragged towards the van – and directly towards my camera. This was (as I will no doubt mention many times to come) the days of when cameras held only a thirty-six-shot roll of film in them, no limitless hundreds of digital images available for you to take and review as there is now. So, prudence and making sure you only take the shots that will work was very much the order of the day. Unlike the press photographers still involved in the centre of the mayhem of struggling bodies, no doubt photographing all arms and legs and back of heads. I was able to wait for the right moment, focus and frame the photograph, ensuring I not only had a picture, but one that told a story – and that is how I launched (and continued) my career. Not just a photograph, but also one that shouted out its reason and existence for being taken.

Realising I had the photographs I wanted (and yes, admittedly with the camera also telling me I had used the last frame of the one roll of film I had!) I moved away to re-join Angela.

There was adrenalin running wild amongst us all by now, Angela having watched me closely and knowing of the opportunities I probably had for a decent picture. Tom and Jackie excited for simply being part of something they had never experienced other than watching it on television. We all got back to the car and then it was decided unanimously by our excited group that we drive straight to Fleet Street. Two weeks earlier I had sold my photographs of 'cars stuck in the flash flood' to the newspaper, but this was something completely different, this was now the serious world of Fleet Street journalism.

It took ten minutes to drive to the *Sun*, quickly parking in Bouverie Street, and asking reception for the Picture Desk. I ran upstairs and was met by one of the news desk staff where, out of breath or through excitement, I breathlessly explained about the pictures I had on film. "Have a seat, let's see what you really have got here" was his less than enthusiastic reply. Obviously, this from someone who had heard it all before, simply to find that what was of boasted of was never there at all.

And so, there I stood, watching him walk away with my single roll of film. In those days there was no back of camera screen to flick through all your pictures, so this (and for many years to come) was where the worry really

begins. Left alone, the excitement all gone, the adrenalin having drained, this is when you suddenly question yourself, and your own insecurities flood in. Did I really get the picture, did I turn the lens fast enough to focus it sharp, is the manual exposure correct, did I miss the exact moment I wanted as I pressed my finger on the button?

It was about twenty minutes before someone came back to me, another strange face, gesturing me to follow him. We walked through the huge crowded editorial office of the paper, eventually coming to the picture desk.

"Yes, some good ones here, we will probably use these two," said Assistant picture editor Tom, who remembered me from earlier with my 'car flood pictures'. He held up the metre-long two-inch wide roll of contact sheet that had been made from my film. The pictures chosen by Tom had been marked by simple tear marks at the side of each selected picture, signifying to the darkroom which to print up.

It was explained the actual film was now being brought for me from the darkroom as they had already printed off their chosen prints. "Well done," another acclaim! "We had our own staff guy there and he hasn't anything as good, so well done," and with that, a pat on the back as he passed me his private telephone number. Telling me when I had other pictures to telephone him immediately and he would have a messenger collect the film, this was to be my 'in' to Fleet Street. With that, another handshake and the added advice that I should now take my roll of film, with the contact sheet which Tom had let me keep, to other newspapers and try and sell some more.

I raced downstairs to the car, everyone waiting to hear what had happened. The buzz between us was now electrifying, we set off, another newspaper, another sale of a picture, and yet another newspaper and the same reaction, another 'yes'. By now we were all on such a high that when one of the newspapers had mentioned selling the last rights to the television, News at Ten, it was an unbelievable challenge.

An hour later we were rushing home to switch the television on, it was getting late and News at Ten would be on soon and this we didn't want to miss, especially as they asked to keep two of my black and white prints to show the News at Ten editor.

The only stop on the way back to Hampstead was to an off-licence. Here Angela ran in, grabbing a bottle of champagne and a few bottles of wine. We never did get to enjoy the proposed drink on the Serpentine, the whole afternoon and evening being taken up with the demonstration and our visits

to the newspapers and the television offices, so this particular drink was well overdue.

Finally, back home, we rushed in and switched the television on as we fumbled for wine glasses. The television coming to life synchronised exactly with the loud popping of the opening of our champagne bottle. As the champagne poured, we watched the screen, Reports of a 'Riot in Hyde Park' were the headlines, with my two black and white photographs of the demonstrators and police filling the television screen – job done – now I really was on my way!

# 6

## REJECTED BY THE SUN – BUT A
## WRONG TURN BRINGS SUCCESS!

I was still working as the Client Executive at the Studios in North London, but with the free time I had, I was pursuing my own photographic career – firmly entrenched as working for the press. I had been successful in achieving several more news stories, even a big front-page scoop covering the troubles at the Notting Hill Festival – although this particular photograph had caused me great concern. I had become in serious trouble during a mini-riot and was being chased by a yelling mob after they noticed me photographing their antics, drugs and illegal drink sales. The financial reward for the photograph was nowhere near enough for the risks, the baying mob, hellbent on getting me and my camera, together with the lack of any help or response by the police, (who held there line leaving it up to me to be able to get to them for safety), all taught me a very big lesson as a freelance – I would have been totally on my own if it had gone wrong!

That day I decided the dangers as a freelance in news situations was scary and financially even more precarious! A frontpage scoop, but financially not much more than I had received for more mundane photographs.

Every day I would look through the newspapers, the fashion, the celebrities and the glamour, all obviously being the elite section, this by what was considered as the top photographers. This I decided was my goal, my field of photography – I would challenge the top drawer of London's celebrity photographers – and I had a plan!

"I often talk of luck, but there is also a time in your life when your future and destiny can change direction, this can be by some amazing feat of strength, a given opportunity, by some amazing business acumen – or even by the simple decision of one day choosing to turn 'left or right'."

Walking through the huge editorial department of a newspaper was by now not such a daunting task, so it wasn't as if I was phased out by the busy work load atmosphere, it's just that you always feel there is an undercurrent, an aura of apprehension, of competition and tension. The apprehension never more so

than as a visiting freelance photographer, who is probably not the most loved persona by the surrounding rank and file newspaper staff photographers.

This never more evident than when you are there to ply your trade, the staffers assuming you are there to take something away from them, or about to be given an assignment that should have been theirs – facts that are in essence very true – hence the long-term distain between the two sides. All editorial newspaper offices are by their very virtue staffed by the ambitious (or more commonly by the would-be ambitious but not necessarily good) journalists and photographers.

On this occasion my visit here was something even more special to me, the completion of months of planning, research, massive investment and hard work. Certainly, a one-off, something I considered as the future path of my career, so I must admit on this occasion the nervousness was seriously taking hold.

## Two weeks earlier in the South of France

Angela and I had driven from the London, down through France on holiday to the trendy and very glamorous resort of Saint-Tropez. This over recent years having become somewhat of an annual recreational event for us, although on this occasion this expedition had become somewhat more of a work project, a business venture, I was to try and fulfil my Fleet Street ambitions.

A month earlier I had upgraded my cameras, admittedly pushing my financial limit through the roof, going from the then simple 35mm Nikon to the top professionals 'two and a quarter inch frame' Hasselblad camera, to which I added the makers famous 150mm lens, the true Rolls Royce of cameras (and probably just as expensive).

Over the previous weeks I had spent hours becoming familiar with the equipment, this to ready myself' for the trip, to try and break into the very sacred and professional photographer's elite world (as it was then) of the *Sun*'s Page 3. Remembering in the early 80s Page 3 had serious status with only top professional models being used by the *Sun*. This had tremendous prestige and those that held this status of having their photographs in the *Sun* were amongst the serious names of London fashion and glamour photographers.

Therefore, a successful conclusion of our trip would be for Angela and me to have hired one or two models in Sant Tropez, and for me to come back

with my first Page 3 portfolio, the object being to present and sell my pictures to the *Sun*.

## Back in London

So here I was, after our trip to the South of France, standing in the 'hallowed halls' of the *Sun*, stood clutching my black leather portfolio of topless Page 3 style photographs of our models in St Tropez, at the picture desk, nervously waiting to talk to the Assistant picture editor, Tom Petrie.

Tom was busy on the telephone, the conversation between himself and his caller on the other end of the line was not sounding as if it was going too well, some discord and a few frustrating grunts from Tom. It was one of those occasions when you realise you have got the timing all wrong, not a good moment to follow on from.

By the tone of Tom's agitated and continuous call, this just did not sound the right time at all for me to make my first (and most presumptuous) photographic presentation. Especially this being one of glamour pictures (and Tom knowing me only as a recently inducted general news photographer). It was one of those times you wish the floor would open and swallow you up, a time when you just realised you shouldn't be there, and just as I was actively contemplating how to escape, to make a somewhat urgent and discreet exit!

"OK", Tom said, as he banged down the handset of the telephone, "What can I do for you Ken?"

Whatever was said next I have totally forgotten, but obviously involved me laying down the huge black folders containing my photographs on Tom's desk. I remember a few 'mms' and a few 'tuts', this followed by Tom gathering up the prints and folders and walking towards one of the empty glass partitioned side offices, beckoning me to follow. The office was clearly signed 'picture editor' and once inside Tom laid the large 20" x 16" black and white bromide prints out, side by side, three sets of five photographs each of two French models. Taking his time to study them individually, a smile eventually appeared on Tom's face, he looked up and told me how refreshing it was to see something new, a different style and approach. Tom explained, his boss, the picture editor (responsible for Page 3) was at lunch but would be back within the hour. Closing the folder and leaving it on the desk, Tom told me to come back in an hour and a half.

"I really like them, and I want the boss to see them." At that Tom shook

my hand and I remember him patting me on the shoulder as we left the office, me walking (on cloud nine) out through the editorial department towards the stairs and to Angela waiting for me downstairs in the car.

I suppose the big smile on my face telegraphed everything well ahead, Angela and I left the car parked where it was and walked up into Fleet Street, to one of the bars where I told her of the events and the pending meeting with the Picture Editor and Tom.

The hour and a half passed quickly, and I was soon back at the *Sun*. As I walked towards Tom, he gestured for me to go to the Picture Editor's office, the Picture Editor now obviously back from lunch and visible through the glass partition. Tom followed, quickly putting his head through the doorway and announcing me, simply saying, "This is Ken" and then going back to his desk.

A quick handshake, but no smiles from the editor was about as clear as it could be, none of Tom's enthusiasm, just a quick flicking motion through my photographs was about all I was to get. "No," was the first word, the rest going to some hazy oblivion, for several minutes. I listened to him explain why he didn't like them. If the old cliché, 'don't give up your day job' ever had a place in my life, it was right now. The euphoria I had felt over the past hour or so was now in tatters, the hopes, the dreams I had so stupidly harboured since my earlier meeting with Tom were now lying dormant at my feet, I was a reject, I had failed, a loser, a no-hoper!

Walking past Tom, clutching my rejected portfolio, with me obviously still visually in shock, he stood from his chair and apologised, saying he had genuinely liked them and he had wanted to put them before the *Sun's* editor Larry Lamb, but unfortunately he wasn't the boss and it wasn't his final decision.

The next telegraphed expression I no doubt sent to Angela was something totally different from the earlier one, enough for her to simply ask what had gone wrong. "Don't give up my day job" was all I could answer as I put my portfolio in the boot of the car. We sat there motionless for a while as I explained what had happened, both of us in shock, both no doubt feeling overwhelmingly demoralised.

## Turn left or right – and suddenly your life changes

And this is where fate takes a hand, where life can change by something so insignificant, so trivial as a simple change in your route home.

With our morale totally destroyed, Angela and I set for home, driving down Bouverie Street, but instead of going along to New Bridge Street and up towards Farringdon. I did a quick left turn on the next street, coming back onto Fleet Street, and because of the heavy traffic, for some reason I turned up into Shoe Lane, finishing behind a line of cars queuing at the traffic lights near the Mirror Groups building. With so much traffic building up I had come to a stop some hundred yards before the building, suddenly I turned the car in towards the kerb and parked.

"What the hell," I said.

Although I had not considered a presentation to the *Daily Mirror*, I realised at the same time I had absolutely nothing to lose. I grabbed my portfolio and walked into the *Mirror* building reception, asking for the picture desk. Directed to the lift, I was told someone from the picture desk would meet me on the fourth-floor reception area.

Exiting the lift, I waited a while and was eventually met by one of the picture desk staff. After looking through my portfolio, he asked me to wait as he walked off towards the editorial offices with my photographs. It seemed hours but was probably only ten minutes when he came back and asked me to come with him, the picture editor wanted to meet me. There was a smile, a firm and welcoming handshake followed by a conversation with the picture editor of how it was nice for him to find someone new, and yes, he would certainly use two of the three sets I was presenting. Not only that, but he wanted me to ring him early the following week to arrange to meet again to discuss some fashion picture ideas. I expanded the conversation as much and for as long as I could, pushing myself and with brazen pretentiousness, talked myself up to being new to London, but that I was one of Manchester's top photographers. We shook hands again, me trying to look cool but probably not being able to hide my excitement and I walked out of his office in total bewilderment. How can two opposites happen in such a short space of time, how can I get such rejection, and then overwhelming acceptance, all within minutes?

Of course, I was on a total high, a rollercoaster of emotion. Nothing could touch me now, as I entered the lift, I was about to press the ground floor button but in front of me was a sign with flashing neon lights, two, three feet high, with arrows pointing all around it. Well not really! But in my new state of mind, looking at the button that was simply marked *Sunday Mirror* held no anxieties for me now. Without even thinking

further I pressed the button and travelled the two floors higher. Here I had no introduction, I had no one to meet me or no idea where to go – so with all this testosterone rushing though my body, and my veins pumping blood at a hundred miles an hour, I simply walked into the huge editorial office and asked for the picture desk. At the desk I confidently asked for the picture editor, a pointing finger gesturing further along the desk. With a portfolio of only one set of photographs left this obviously wasn't going to be the biggest presentation probably ever made to a picture editor, but luckily this hadn't even entered my mind. Smiles, handshakes and another 'yes' and the agreed sale of my single last portfolio of the model in Saint-Tropez.

I was literally in heaven. All this late acceptance had surpassed anything I had ever anticipated. OK, the picture editor at the *Sun* had rejected my photographs (or, as I now reflected, more importantly, was it me, the lad from Middlesbrough he had rejected?), but within minutes two equally giant newspapers had not only accepted and purchased my total portfolio, but I had achieved an ongoing relationship with them both.

The lift going back down to the reception was the slowest, yet fastest trip I had ever experienced. I walked on air through the reception and towards the car. As I got closer, watching Angela, I could see her expression of anxiety, she no doubt deciding whether she had to put on a smile and once again comfort my failure. I tried to stretch the seconds out by looking cool and nonchalant, but half way towards the car I waved my empty portfolio case in the air and my smile must have said it all – my project had worked, I was now one of the select few Fleet Street 'press glamour and fashion photographers'.

Looking back all these years later, I can now clearly see what was part of my original problem. I was a square peg in a (London) round hole. Whilst most 'would-be' photographers were local, having trained and worked their way up through an established list of photographers and as such being recommended and passed-on though the Fleet Street system. I unfortunately was raw, unknown, untrained and certainly from a much more obstreperous school of the North East. So to stand inside the hallowed halls of a major newspaper in front of a 'God-like picture editor' could no doubt be considered somewhat audacious and imprudent! Luckily, and I many times mention the necessity of such, I had at least met Tom Petrie, a hardworking Fleet Street man who didn't take himself so serious or God-like, a man whose later advice and direction helped changed my career!

# 7

## MICHAEL CAINE'S RESTAURANT, £100 AND SNOW WHITE

These were hectic days and we were all enjoying a time when Fleet Street was awash with seemingly unlimited funds – budgets were high as each publication fought off their opposition to be top in the circulation war.

At the same time London was also seemingly full of stars and celebrities – and to pander after their every need, prestigious clubs and restaurants abounded.

One such Mayfair restaurant, certainly to be considered as one of the top elitist eateries of its day, was (and still is) Langan's. This in Mayfair, a haunt of the rich and decadent movie stars, ensuring a permanent camp of the paparazzi outside every evening. The eatery, under the simple title of 'brasserie' – was in fact one of the most swanky and upmarket restaurants in London. Opened in 1976 in partnership with the somewhat outrageous Irish restaurateur Peter Langan, 'Michelin Star' Chef Richard Shepherd CBE and one of the Britain's most popular film stars, Michael Caine.

Obviously humongously expensive, unless celebrating a rather nice spectacular agreed fee for a story or photograph, it was far too expensive for Angela and I to contemplate any regular visit. Nevertheless, on one occasion, after I had worked for two days on a fashion assignment, Angela and I booked a table and took the commissioning Sunday newspaper feature editor with us as our special guest. The evening was a total success, the splendour, service and surroundings, totally mesmerising, certainly another whole new world opened for us. With no one knowing we were 'press' we also realised we were sat amongst all this elitism and thespian luvvies and were just sitting watching who was with who and listening to all the juicy gossip

All this wasn't wasted on our feature's editor, who two days later called me into his office, asking what the evening had cost. It had been just under *£100* for the three of us (remember this was in the late seventies and back home in the North East this was around the average weekly wage). The reaction was a smile, followed by the comment 'that we should do this regularly on a Friday

evening' (this when he stayed overnight in London to get the paper ready for the Saturday evening print run).

This set my mind racing, could I ever afford this as a regular event, every Friday, impossible! I was about to voice this, when Robert, sitting at his desk suddenly started writing an expense sheet out.

"This is an expense sheet you can cash downstairs immediately, it's for *£100* and we will do this regularly." Although taking a camera was obviously out of the question, the snippets of racy gossip and tales of who was there with who had been enough for Robert to realise financially our little soirée to the restaurant was financially worth every penny to the newspaper!

And so, started many months of total joy, Friday evenings became our special nights when we wined and dined amongst the very rich, the famous and the top of London's society. Our first visit had been innocent enough, but after that it was like a secret undercover assignment, enjoying ourselves outrageously, but at the same time getting all the gossip we could from the hottest restaurant of the day.

As we became established as regulars our status (and table) became somewhat elevated, from downstairs we were suddenly positioned upstairs to find ourselves amongst the more exclusive and recognisable clientele. And because of the privacy and exclusivity of this floor, diners were at ease and the atmosphere was light-hearted, the wine flowed and so did the jokes amongst tables, politicians leaning over to talk to stars of the silver-screen on nearby tables. Backslapping, whispers and raucous laughter, this was where the elite could drop their formal facade and wallow in mirth and foolishness.

For some reason on one occasion Angela (with the wine flowing) somehow jokingly had set fire to a hat we had fashioned out of a serviette and had placed on our Robert's head. Noting this, a passing waiter, without an air of disrespect or concern, nonchalantly decanted a small amount of water from a glass he was carrying, instantly quenching the flames.

The ambience of the restaurant never failed to amaze us, Angela and I would arrive purposely early, to enjoy relaxed pre-dinner drinks (they made a superb Rye & Dry Old Fashioned) in the lounge area where we could people-watch, as faces you knew from the silver screen would sit next to you.

As an example of the humour and the many comical incidents, one occasion we witnessed from our new upper roomed table was when a group of very smartly dressed businessmen (wearing ties and expensive suits) had all gone to the loo as a group. Minutes later a young glamorous twenty-something

girl from the men's table came over, stood outside the men's loo doorway and looked around hesitantly. This actually did attract some interest from nearby tables, followed by every one's total attention when she then (cupping her hands around her mouth) shouted "Hi-Ho! – Hi-Ho!" Instantly the whole floor of the restaurant came to a stop and turned to look. Hi-Ho! She loudly repeated again, this just as the door of the loo swung open and coming out, 'walking on their knees', came her 'seven' businessmen, all singing "Hi-Ho, Hi-ho – it's off to work we go." The group led by the glamorous 'skipping' girl as she led the men all around the restaurant between the tables (the men still walking along on their knees) singing the entire words of Snow White's 'It's off to work we go'. A fabulously funny evening, the stunt attracting a huge standing ovation of applause, laughter and cheers from every guest, including many recognisable faces. This setting the scene for a totally joke filled and relaxed evening creating many other interactive jokes amongst the tables on what could have normally been a somewhat staid evening with everyone keeping to themselves. No camera but the stories and events did of course (through Robert) still make the Sunday papers 'Gossip Column', no one ever knowing who the spy was. All which allowed even more funding for our secret Friday evening soirées.

Hi-Ho, Hi-Ho, it's off to Langan's on Friday nights we go!

# 8

## THE WORLD OF FASHION & PAGE THREE

After the successful presentation of the Saint-Tropez Page 3 photographs, I was now regularly working with the picture editor of the *Daily Mirror*, and *Sunday Mirror*, with several assignments quickly following I was also becoming involved in fashion shoots – my first assignment for the *Sunday Mirror* being a jungle print swimsuit fashion article. This was obviously an important first trial, and as not having my own studio and not having hired any studio enough to be relaxed and confident in, I choose to shoot on location, Kew Gardens! The people at Kew were happy to oblige and because of all the publicity they would receive, I was granted the freedom to choose where and when. I had already selected the models, two 'Page 3' favourites Monica and Carole.

On the day of the shoot I made sure I was there several hours prior to the models, the fashion editor and her team. This allowing me time to check the location, set up my lights (two powerful mains flash heads with brollies), and complete any tests. All this allowing me to look calm and cool as they arrived, on my part therefore everything set to go. Fashion editors although for ever being a problem themselves on time keeping are notorious for throwing tantrums when there are any delays by others, especially by the photographer – so my first rule, always be early, look totally in charge and be the calm, cool professional.

The giant palm leaves and general flora in the tropical greenhouse at Kew was perfect, the models merging amongst the foliage, giving the animal print fashions the perfect authentic jungle setting.

Job done, the next day my delivered prints were gleefully accepted, becoming a centre two-page fashion spread with a front-page lead. What more can you ask for your first entry into the world of fashion, the centre spread in one of the most read Sunday newspapers – 'Photographs by Ken Ross' emblazed across the centre pages!

Although rushing around the world being chosen for some of the top

and most amazing model assignments herself, Angela was becoming more and more interested in photography, so we decided to take the chance and open our own office and studio in Creed Lane, next to St Pauls Cathedral, a one-minute walk from Fleet Street. Taking a huge chance, I reluctantly quit my job in the North London studio, my own newspaper photographic career was taking off, so it was unfair to try to juggle both.

With our new studio up and running and nothing else to take up my time, I was now focused one hundred percent on my chosen career (and the obvious task of earning money). I soon got in the daily habit of looking through every showbusiness paper or magazine, a new movie being released or someone in London on a promotional tour was my main target. It only took one or two approaches to the public relations agents and movie distribution companies to get one of the lesser known small-part actresses booked into our studio for a press photograph. All this so when they saw the published photograph in the newspapers, this would eventually open the doors to the more serious names. One of my first approaches was when a movie called *Rollerball* (starring James Caan) was about to be released, a film based on an ultraviolent world dominating sport of the future. What attracted me most was the hardware – the costumes. This involved heavy sci-fi war-like spiked crash-helmets with visors and metal framed gloves, armoured bodice and leggings, plus of course the rollerblades, all looking very dark and very dramatic. As it became obvious that I could not get any of the actual stars from the movie, I took another angle. What if I took the very masculine outfit, and put it on a beautiful woman? I collected the heavy boxed costume (plus most of the other glamorous futuristic fashions) from an apologetic press agent, excuses abounding for not being able to get me one of the main actors, but I simply gave him a smile and walked away with my prize.

Angela posed for me in the costume, helmet, gloves, body armour and the roller-blades, she looked amazing, the photograph worked – and that's exactly what the *Daily Mirror* editor must have felt – filling half of their front-page, top to bottom, of the prime Saturday issue with my picture- 'photograph by Ken Ross' blazed underneath this page one picture!

Job done, movie companies' doors now opening – I now had a steady stream of beautiful actresses coming to our studio! One of these, I was being requested as a special favour by the press agent to please photograph a young unknown Australian actress who had just arrived here, a very attractive blonde called Pamela Stephenson. My photograph of her appearing in the

*Sunday Mirror* the following week ensured this opened one very big door, Pinewood Studios – another great source of contacts and non-stop actresses.

It was only a month or so later before I received a phone call from Tom Petrie at the *Sun*. The picture editor, who I had first been so ceremonially rejected by, had suddenly retired – and a new picture editor had taken his place. Consequently, I was asked to come to the *Sun* for a meeting with Tom and the new guy.

The new picture editor was remarkable, Arthur Steel. He had worked his way up from amongst the ranks, having been a photographer with the *Sun* for many years and had several royal photographic scoops under his belt.

Tom had told him about my earlier approach and rejection, with Tom once again endorsing me one hundred percent. Arthur immediately took me under his wing, giving me an immediate assignment of working on the following week's 'Page 3' pictures. He also took the unusual action of not only sponsoring me but pushing me for membership into the National Union of Journalists. At that time, it was a somewhat formidable and difficult (but necessary) union to join, this he explained would stop any 'snipping' by staff photographers looking for a reason to make my life a little more difficult.

Arthur was great to work for, but unfortunately, he didn't last long as picture editor, nothing to do with his ability. Arthur had proven he was a good editor; he certainly got the best out of his team. It's just his heart wasn't in to being the 'boss', his love was the camera and although nearing retirement age himself, he decided to do his final time back on the streets with his camera – the loss of a good editor, but the gain of an amazing news photographer.

Tom now took over as the picture desks editor and I was now being commissioned regularly to take Page 3 photographs for the Sun. I worked in conjunction with the *Sun*'s legendary staff glamour photographer, Beverly Goodway. I would receive a phone call from Tom simply saying the Sun were doing a 'cricket' theme (as an example) the following week and I was commissioned to do three of the weeks six Page 3 pictures, and that I was to liaise with Beverly on which models he was using, so as not to duplicate them.

## 'For your eyes only' – but I needed a gun

Another day, another Page 3 assignment. For this session I had booked a young blonde model, Kim Mills. I had used her several times, she was

likeable, young and had her own elfish look. For this session there was no particular theme, so when she arrived we sat going through ideas for a photograph when Kim very casually and innocently mentioned that she had just returned from Corfu where she had been an extra on the set of the latest James Bond movie, *For Your Eyes Only*, working with Roger Moore.

Of course, forever on the lookout for a scoop, this was a definite eureka moment! Admittedly Kim was only one of six extras in a swimming pool shoot, but regardless of that she was in a Bond movie – thus – a Bond Girl! She was featured amongst the glamorous group of six bikini girls, Kim adding how she had also been used in a sexy studio publicity bikini photograph along with the other girls, all gathered adoringly around Roger – a very typical James Bond stereotype photograph in its era.

This instantly took what was about to be a normal Page 3 photo into a different league, my mind was whirling, I could trounce the moviemaker's own publicity shots with my own, mine being a topless Page 3 photograph of Kim, this being published to coincide with the movies publicity release, a 007 exclusive!

Of course, no Bond girl was complete without the all-important Bond prop, a gun. Remembering this was a Page 3 photo and the model would be wearing very little else, so in fact there was no other way to encapsulate the Bond theme, other than Kim posing holding a gun.

Here I must admit I at first had no concerns about acquiring the prop. I told Kim to relax and I would pop out and buy a toy gun from a local shop, not realising that there were no shops around Fleet Street and the ones near my studio, next to St Pauls Cathedral, were strictly tourist shops – no guns!

Half an hour later I arrived in Regents street, outside Hamleys famous toyshop. Unfortunately, this was one of those periods when toy guns for children were being frowned upon, so at first, I was told they had none, but after a few desperate minutes waiting, the shop assistant arrived back from the storeroom with the choice of – one! Eagerly paying, I grabbed the (very expensive) boxed toy gun and jumped back into the waiting taxi.

On the way back to the studio I did start to worry that Kim may have rung her agent about the photograph we were about to do and in case of problems with the moviemakers, she may have been advised to refuse to do the Bond style photo. No such problems, although she had been getting concerned that I had been away nearly an hour, she had spent the time getting ready and we instantly worked on the photograph.

Two hours later, at the *Sun*, I quickly explained to the picture editor the story behind the photo, he immediately went up to the editor's office where the already selected next day's Page 3 was scrapped and the whole of the Page 3 was cleared for the exclusive Bond Girl story; 'Page 3 Bond Girl – For Your Eyes Only'. The picture was an amazing hit and this publicity certainly did Kim no harm, my idea being copied with Kim featuring the following month on glamour magazine covers and inside features, even in *Playboy*, all copying my theme – 'For Your Eyes Only'.

## I wish they could all be Californian Girls – or Lord Litchfield's

There were several other similar occasions where a normal Page 3 session turned into a major story. Another instance was when I was looking for a new face, someone different, consequently I took a chance and booked a model I hadn't previously worked with or even met. The week earlier her agency had sent me photo-cards of their new models and a girl called Claire Waugh looked the most interesting.

On her arrival Claire turned out to be more stunning than her agencies pictures, a 26-year-old shorthaired blonde who had an amazing smile. Whilst we talked generally and were getting ready for our session, she spoke of how she had recently attracted the attention of Caledonian Airlines, who after a massive campaign to find a new face, had chosen Claire to head their worldwide poster and television promotion. In the television and press advertising theme they were using the Beach Boys hit song; 'I wish they could all be Californian Girls' (slightly changing the words to – 'Caledonian' Girls).

What was soon to prove a hugely popular and successful campaign was to be launched this very week. In the television commercials and billboard advertisements, dressed in the airlines tartan airhostess uniform, Claire's look was to be demure, sweet and even shy at all the attention she was receiving, surrounded by male passengers singing the song.

Obviously for me this was yet another opportunity to turn a normal Page 3 photo-session into something much bigger – another eureka moment, another top exclusive.

Claire oozed confidence, had an amazing camera presence and like many top professional models, absolutely came alive in front of the camera. Whilst

it can be said it's important that 'the camera loves you' – in her case, Claire also loved the camera!

So, to coincide with the Caledonian Airlines huge television commercial and poster campaign, the *Sun* now had the exclusive pictures of the airlines top featured model – without her uniform. Another big exclusive set of photographs that were used many times over the coming months.

There was also a double whammy with my photographs of Claire, she had also earlier been photographed for Lord Lichfield's then famous calendar, so now more glamour photographs from my session with Claire were again being shown in the *Sun* to purposely coincide with the big calendar launch. My full-page pictures of Claire certainly took the thunder out of Unipart's presentation, especially as my photographs of Claire were considered to have bettered his calendar shots!

This pre-empting him again with me featuring Lord Lichfield's exclusive models just before his calendar launch a year later after a trip to Ibiza, with the result of me being barred by him personally from all his press launch receptions. I had been holidaying in Mallorca with Angela when the *Sun* feature's editor contacted us, they wanted a fashion shoot done over in Ibiza and asked would Angela and I fly straight over that day, meet the fashion people and complete the shoot. Flights had been booked already and we were to collect our tickets at the airport, we had been booked in a hotel which we had stayed at previously, The Royal Plaza Hotel, in the centre of the old town. On arrival we left our overnight bags in the room and went to the roof top bar and pool area to relax. Here we were in for several surprises, firstly we met one of London's top art directors whom Angela knew and had worked with a month or two earlier in Israel.

So, it was drinks, introductions and talk of the hectic schedule he was now on working here with Lord Litchfield on one of his famous calendars. Litchfield at this particular moment we were told was on the other side of the island being taken to selected locations which his assistants (each an established photographer in their own right) had found, completed tests at and wanted him to see them.

And this is where fate takes a hand and smiles upon you! The art director had just left us to go back to his room to go through his layouts, this being immediately followed by the arrival at the pool of a group of chattering gorgeous bikini girls – in fact not just girls, they were six of the beautiful Lichfield models – who we both worked with previously!

More chatting, more laughs, drinks, talk of previous assignments and of course never forgetting to not take your camera with you – I started snapping away, with everyone joining in the fun and posing.

Back in London, besides the fashion spread we had done, the cherry-on-the-cake was surely the photographs of the Lichfield models. So much status was put on his calendars in those days, that my pre-empting centre spread photographs of his calendar models in the *Sun* (obviously we said, complementing his calendar) was not something he found amusing!

## 'Page 3' in space

Another model I used for the *Sun* was Sian Adey-Jones, who strangely I had first met and photographed as a guest on the night of Peter Stringfellow's opening of The Hippodrome in Leicester Square. It was just one of the many pictures I took of people on the night and I thought nothing more about it until a month later when Sian had been sent to our studio by her agent, a sort of go out and meet the photographer's expedition.

Sian was not as obviously beautiful as most models, her accomplishment was more an overall appearance, she exuded a sort of sexual confidence and this came through in the photographs.

Later I was to use her on a particularly lengthy Page 3 project, which I had been specially commissioned to work on. It was to be a running series of pictures and I would certainly need someone who basically would work with me on what could be a difficult and possibly an uncomfortable session.

A week earlier on the news NASA (USA) had announced that its next launching (of the now defunct) Space Shuttle, would include one of the team being female.

The idea tossed around by the editor was to produce a light-hearted (and sexy) tongue-in-cheek Page 3 style scenario, the *Sun*'s fun version of 'women in space'. This to be all very glamorous, in photographic terms following the story line of the opening scenes of the sci-fi cult movie *Barbarella* (starring Jane Fonda), but ours to be in black and white stills – a daunting prospect to follow on from the amazing footage of the movie!

An authentic spacesuit was hired from a specialist movie props supplier, this being delivered to my studio in a huge six-foot crate. Sian was booked for two hours with a possible over-run period of one hour.

The suit and accessories were heavy and when laid out, piece by piece, stretched some fifteen feet along one side of the studio.

The idea, following the Jane Fonda's *Barbarella* movie, was to be a girl in the spacesuit – or in essence – coming out of it (all very Page 3).

This probably far easier for the *Barbarella* movie makers with their twenty technicians, makeup artists and all their assistants, plus their million-pound budget.

For Sian and myself, a somewhat cumbersome, tiresome and slow to learn approach. The first task was to dress Sian in the suit, taking nearly half an hour at which time we quickly realised that she was already dramatically sweating from the heat inside the suit, to such a degree that any makeup or hair preparation was already totally destroyed, this before we could even start the first part of undressing procedure with the removal of the helmet.

We stopped, quickly getting Sian back out of the suit, although even rushing as fast as we could, still took a slow ten minutes.

So, there we were, a beautiful naked Sian, looking as if she had just been dragged out of a swimming pool, plus a very wet spacesuit – both, which needed time to dry out.

Sian retreated in the dressing room to restyle her hair and makeup.

Already an hour had passed and there we were, only about to start again! This time I decided I would reverse the whole procedure of undress, actually starting by taking the final photograph first, of the Sian stripped (except for one or two discreetly held props), then proceeding to go through the sequences in reverse, dressing Sian in the suit and equipment piece by piece as we proceeded on the scripted photographic journey. I had quickly drawn up a rough movie style sequence chart, a frame-by-frame scenario, putting parts of the suit and equipment into groups for Sian to wear as we progressed along with each shot – the final photograph being of Sian totally encased and dressed in the suit!

A total success – as you can see by the finished photographic sequence run.

During the years of working on all these glamorous assignments I was able to book any model I chose, which covered about every top model from any of the London agencies. Some of the models were a delight and became good friends of Angela and I, unfortunately some were prima donnas and a total disaster. Others like the above models were a pleasure to work with, making a photographer's job far easier. Two of my other favourite Page 3 models were Debbie Boyland and Denise Perry. Debbie a beautiful brunette and Denise a

pretty blonde – both had a clean and youthful look and both with no inhabitations if the photo story needed a full side-on or nude look.

A great experience and I was certainly living the life, but I was still pushing more and more towards showbusiness photography – anything to get out of the studio, I was yearning to travel.

I was still working on Page 3 photographs and to an extent enjoying everything, but amazing as this sounds it was becoming repetitive. I went through a stage of boredom and even unrest. Obviously, I was living the dream of every photographer, but I was forever in the studio and whatever your own thoughts are, it is as they say, a little bit like working in a chocolate factory – boredom was setting in.

One day when talking to the picture editor Tom Petrie I mentioned how it would be nice to be involved in bigger features, even to travel a little, to involve myself in showbusiness photography.

Here again, Tom was forever supportive, explaining that his responsibility extended no further than simply supplying a staff photographer to the features department when asked. Due to the general policy, he explained he would have to have a big reason to not use one of his own staff photographers, and if there was ever an opportunity for a freelance it could only be on rare occasions, with good reason, especially for a high-profile show business in-house session.

A few weeks later when I was delivering a set fashion prints, Tom explained he had talked about me to the feature's editor – with an introductory meeting consequently been arranged for the following day.

The feature's department was itself a unique, closeted and independent department, writers only. They were considered by many (and no doubt rightly themselves) the elite of the crop, the chosen ones. So, when photography was involved, this would be simply a case of them booking a staff photographer through the picture desk. Obviously, it had been explained how this could be frustrating for the feature writers who would have had their own vision of the pictures they wanted for their story – but had little control or even connection with the photographers.

Therefore, a never tried before association using their own photographer would be something quite new and untried – the only way of this happening would be the introduction of a freelance photographer that they could build a close and personal connection with, one which was not in any way controlled by the picture desk.

My subsequent meeting started the most amazing and rollercoaster relationship between the feature's department, its editor and myself, one that would take me all around the world many times.

Now working with the feature's department, closely liaising with their writers and their interpretations of how they saw pictures to accompany their story, I was also being given freedom to put forward my own ideas. After only a few months the relationship between myself and the feature writers had bonded, and I became one of the team. Total freedom to come and go to the feature's office, now adding my own ideas on themes and stories in the 'thinktank' meetings to the feature's editor. I was also able to get an instant approval on any ideas I wanted to work on, a celebrity photoshoot or a story line, even building up a library of photographs for the department.

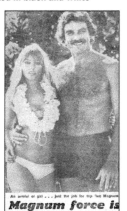

Hawaii - Working with Tom Selleck on the Magnum television series       Angela & with Tom Selleck

*Magnum force is*

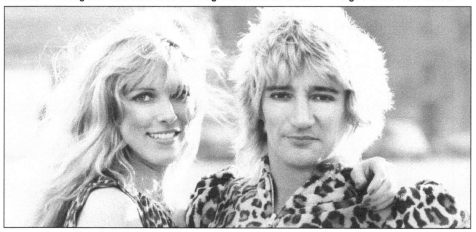

Paris - Rod Stewart arranged for his limo to take us to the Eiffel Tower for photographs

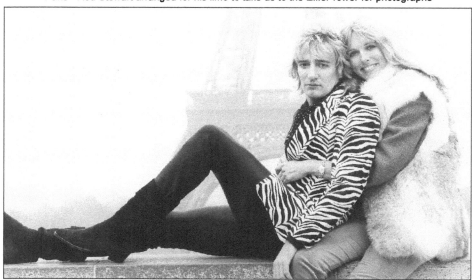

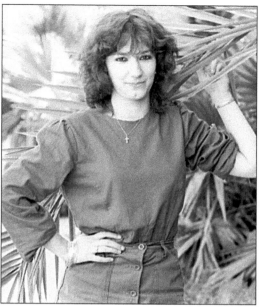

Sarah Thubron - Rod Stewart story.

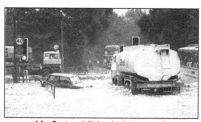

My first published photograph

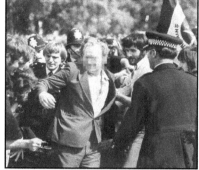

Used by four newspapers & News at Ten

Denise Perry

(*Sun*, page 3)

Debbi Boyland

Caledonian Airways girl - Claire Waugh

007 Bond movie - Kim Mills

# The Glamour Days

Amongst the stars -
two sets of photographs in
which I used a sci-fi theme.

*Opposite page (lower half)*
*Page 3 and my first Fashion Feature*

# playboy

Playboy Party; Kenny Lynch, Ringo Star & Keith Moon

The Playboy Bunnies sing-along

Playboy supremo Victor Lownes

Playmate Marilyn Cole

Angela and Christopher (Superman)

Anthea & Kenny

Marilyn

With all the top stars

The party goes into the Jacuzzi

Angela & Susan Shaw

# Miami

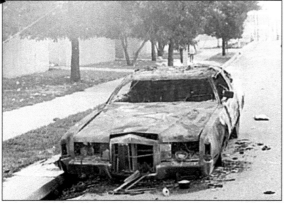

A very brief and hasty trip into war-torn 'down town' Miami City - the next day 2 reporters were killed

Honorary Citizenship for Miami Beach

My favourite photograph - Angela in Miami (an iconic photo that needs no caption)

Cuban child refugee

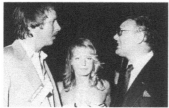

Meeting Sir Freddie Laker       -       and me cruising around the Miami waterways

Key West - across the ocean to freedom - the Cuban refugees crowd on to anything that floats

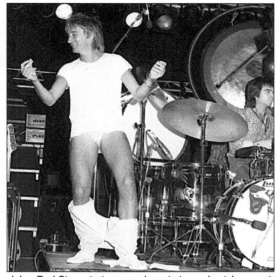

Joker Rod Stewart - trousers down to try and catch me out

Rod, we play football in Beverly Hills

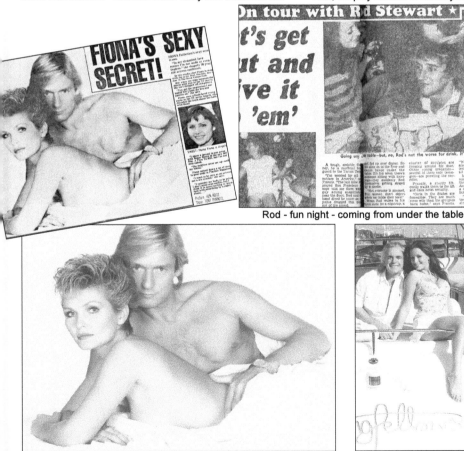

Rod - fun night - coming from under the table

The Beautiful Fiona Fullerton - 'Between the Sheets'

Peter Stringfellow & Bella

Dempsey and Makepeace (Glynis Barber & Michael Brandon) - became televisions biggest hit

Favourite Bond Girl - Caroline Munroe

Secret rendezvous in the sky - a surprise for Angela

Ken & Angela; Our early days     -     and our Rolls Royce life style

Kenny Everetts top television dancers - Hot Gossip     Bond Movie - the Russian submarine

Bride Angela - and with agency bosses and models Vicky Michelle & Spot

Ken and Angela

Angela - our honeymoon - on safari in Kenya

Diving100 ft deep,1 mile off Mombasa beach

Featured on 3 front pages of national Newspapers

We are Sailing; A restful anchorage - three hours later we were in a force seven storm

I was Live Aid photographer - with all the stars - but I didnt see the show

# LIVE AID

David Bowie - one of the many stars

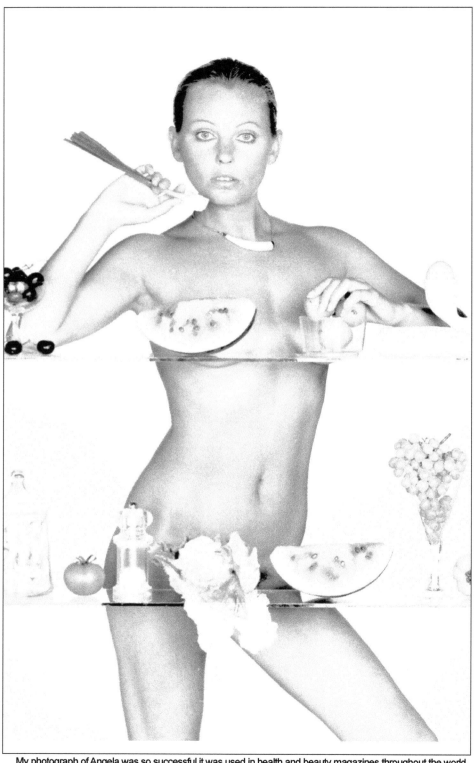

My photograph of Angela was so successful it was used in health and beauty magazines throughout the world

Three weeks working with Richard Branson, hard work but fun!

Marina Sirtis - Star Treck

Another of my favourite photographs - The Twins

# 9

## STAR WARS – IN MY STUDIO

A long, long time ago in a galaxy far, far away (or so it seems now), Angela and I were two of the select people to see the first ever secret-press screening of the first *Star Wars* movie.

I had popped into the feature's office of the *Sun* when one of the writers who was on the telephone held up their arm and shouted out if anyone wanted passes for a new movie being showing tonight at one of the private press preview theatres. This was a sci-fi movie that no one had heard of or knew anything about! No takers it seemed amongst the writers, but for myself it fitted-in well with my evenings schedule. Angela was on a 'shoot' (modelling assignment) and we were to meet later in Wardour Street, just about the time and place where the movie was being shown. So, for me a perfect end to the day, I agreed to go and four hours later Angela and I were comfortably entrenched ready to watch the movie. These press showings are usually held in small private cinemas which have huge comfortable chairs, with the added luxury of a complimentary bar and snacks. Totally relaxed and spoilt with the non-ending drinks and nibbles, we were watching the start of what we didn't realise then but was about to be the biggest movie franchise of the decade, something that would change the whole world of movie making.

Next morning, still stunned by this amazing *Star Wars* movie, you must remember this was before today's movie computerisation and overload of special effects, I was in the feature editor's office vehemently praising the movie as the next big hype in cinematography. The enthusiasm carried my cause and within minutes I had received the OK to contact the filmmakers and go ahead with an idea which Angela and I had compiled overnight. This was to be a fashion feature using the characters and hardware from the movie (and giving the movie its first huge newspaper promotion). The movie distributers were ecstatic and within two days we had the props and characters brought to our studio, we were ready.

We laugh now, but the photo session started with what became a total disaster in both time and energy. One of the props arriving was the now famous (but then unknown) R2-D2. We had been advised there were several full-size models, one in which the actor Kenny Baker would sit inside and steer, plus a couple of plastic dummy models and of course the full electronic model. And yes, you have guessed it, when it can ever go wrong, it does – big time! They sent the full electronic one, which weighed so much it took four of us over an hour to get it up the two flights of stairs to the studio, one step at a time.

Next to arrive was actor Peter Mayhew 'Chewbacca' – he was a natural seven foot two inches tall, a former hospital porter turned actor who had landed the star part playing opposite Harrison Ford in this new movie. Peter was the only star of the movie presently in the UK and had jumped at the idea of joining in on our photographic coverage. It took over an hour for the makeup and costume people to get him into his eight-foot tall Chewbacca suit, he was totally professional and throughout the session kept us all entertained with stories of working on the movie with Harrison Ford and the other stars, a great guy to work with.

The Stormtrooper was easier, the actor arrived, unpacked his suit of white sci-fi armour from a large case and was ready in half an hour.

Angela, working on the production side with me, had selected and booked the models and worked with the *Sun* fashion department who had brought the fashion items. With a packed studio of weird looking aliens, racks of clothes, makeup and hairstylists and models, it probably looked like we ourselves were making a sequel to the movie. Hard work but great fun, it took us the full day to complete the photographic session, but we were all pleased with the results.

The *Star Wars* fashion spread was used a week later over the two centre pages, with a front page lead, plus the lead on their weekly television advertisements – this gave the movie its first and biggest plug – and for Angela and I, a big pat on the back from the movie distributors and of course the *Sun*.

A month later Angela and I were having our first Christmas party to officially launch our new studio, inviting all the Fleet Street newspaper people. With a bit of wangling and arm-twisting we had managed to get hold of a film clip of *Star Wars* (which was still unseen and not out on general release for another week). We screened this on the huge white wall of our studio and all the top newspaper editors of the time were there to watch it – this was our biggest coup d'état ever – we still smile about that one even today.

# 10

## A PRIVATE EYE AND A TRIP TO PARADISE

Reading a snippet about a new crime drama television series being filmed in Hawaii was all the excuse I needed to have a word with the new feature's editor of the *Sun*, Nigel Blundell. The new show was not so much a remake of *Hawaii Five-0*, more a new take on the old theme, but using the same amazing location – a great subject for a glamorous newspaper feature. All this happening in the days when money seemed 'a-plenty' amongst the newspaper industry, plus coincidently, at the same time the tourist boards in America were proving more than generous with complimentary trips to promote their own particular locations.

So, leaving my idea with Nigel, he to approach the tourist board whilst I pursued the American television production company who were still in the middle of filming – the idea was simple. We (Nigel and I) would go to Hawaii and produce a feature promoting the new series, its star being a then unknown American actor called Tom Selleck. Obviously at the same time satisfying their tourist board with our articles, the finished feature obviously pushing the amazingly beautiful location of Hawaii.

As the series was being brokered to the UK television network the production company were more than eager to have us on set, guaranteeing us two days photography with the stars and their team.

Amazingly everything fitted in quickly and within ten days, with eager approval all around, I was on my way to Hawaii. (Oh! and did I mention that I was accompanied by Angela and Nigel and Nigel's wife?) Never one to miss a free junket, Nigel had done an amazing job selling what we could offer. He had waved a magic wand and all we had to do to take our partners along was simply to pay for their (discounted) air tickets. On offer for our group, all hotels (a choice throughout each of the islands), all fully inclusive of meals and drinks, hire cars plus all inter-island flights would be complimentary, provided by the Hawaii Tourist Board.

So, there we were, a day or two to kill before moving onto the set of

*Magnum* – but what an initial first disappointment Hawaii was for us. The hotel we were given was something we joked about being probably from the actual days of the original series of *Hawaii Five-0,* so past its sell-by-date, it was terrible.

Day two, after a few quick comments about our accommodation, everything changed, we were quickly moved to a modern skyscraper style beachfront hotel. Settled in on the twenty-fourth floor, with panoramic balcony views over the beach and sea.

Next day, up and ready for work we drove to the other side of the island and joined the production crew on *Magnum PI.*

I always add how the Americans are the best networkers and public relations people in the world, no exception here. Their PR was totally professional, on our arrival she escorted us to their office where a buffet lunch and refreshments were lavishly laid on. This so we could relax and before meeting the stars of the show, watch one or two episodes of the so far filmed *Magnum PI* series, this so we would understand who and what we were joining.

By the time we walked on to the film set and started shaking hands with the stars of the show, Tom Selleck (Magnum), John Hillerman (Higgins), Roger Mosley (TC) and Larry Manetti (Rick), it was as if we already knew them.

Over the next two days we were given all the time we needed for interviews and photography, Angela even secured a small part for herself in the episode they were filming (including lots of beach photographs on location with Tom Selleck).

We achieved everything we set out to do, a fantastic huge exclusive with amazing pictures of Selleck on the beach with beautiful bikini-clad Hawaiian girls. All this, plus photographs of the entire cast carrying on throughout filming with of course lots of action shots. All great to take back to the *Sun,* especially as it was now announced *Magnum PI* was scheduled to appear on our UK television screens in six weeks' time – perfect!

## Guilty pleasure in paradise

What to do now was our only thought, here we were in Hawaii and we had successfully completed our mission with the *Magnum PI* production company, everyone being extremely happy. It was then that we realised we had an added bonus with the Hawaii Tourist Board who seemingly were in no

rush for us to go home – 'see some of the other islands was the offer'. Flights (island hoppers), hotels (again all fully inclusive, at a luxury level) and hire cars all put at our disposal.

We were recommended to first visit Maui, not knowing of it but having heard amazingly good reports we agreed. This was to be our first stopover but so amazing was this island, the difference between our previous hotel/location and Maui is like comparing a bed and breakfast in Blackpool with the seafront luxury of Barbados – Maui was exactly what your heart believes all Hawaii to be.

We had the one week left and unashamedly we entrenched ourselves there and we never moved. The hotel was a pure luxurious fantasy, an amazing exotic location with full size sixty-foot palm trees inside the reception. Nigel and I were each given a huge two bed roomed sea-view suite, each laden with exotic fruit and wines. Dining in the exclusive water side restaurant meant we were accompanied by black swans effortlessly gliding by.

Obviously, we had to undertake several lunchtime interviews with local dignitaries (top restaurants assured) and to photograph beautiful Hawaiian girls under palm trees – all hard work of course we would laughingly tell ourselves, but the beauty of this island was worth everything.

Evenings in Maui, when we did eventually prise ourselves from the absolute luxury of the hotel, we would visit the old whaling town of Lahaina. Magical back then for its unspoilt wooden built architecture and casual lifestyle, but totally exquisite dining – even today still an amazing draw, but back then a totally unspoilt paradise of character and charm from days long gone.

But of course, amongst all this fun, including unforgettable evening (and probably drunken) rickshaw-chariot racing around Lahaina, work was calling us back, flights booked for home, we were on our way to London.

The *Sun* gave massive exposure for *Magnum PI*, which I had correctly predicted as the next big blockbuster hit on television – and of course the Hawaiian Tourist Board received lots of coverage, especially Maui. The *Sun*, blazing our feature as 'Another Big Exclusive Sun Picture Special' – my pictures being used constantly throughout the run of the televised series.

# 11

## THREATS, THE EIFFEL TOWER
## AND ROD STEWART

Remember what I have repeatedly said earlier about luck and how to use it. This is a prime example of just that!

Berkeley Square, one of the most famous areas of the London, and tucked discreetly in the north-eastern corner of it is Morton's, the most trendy and prestigious private members clubs in Mayfair.

It was to be an evening out and about, Tiffany, Angela's model girlfriend had telephoned earlier to remind us about the 'The Butterfly Ball' which is the most prestigious 'End of Summer Party' in Berkley Square. We had forgotten about it, we had been so busy working that we had ignored the London social scene for a while but we had agreed to go with a group of other model friends and their boyfriends. Tiffany insisted that this was a party not to be missed so we all decided to meet up in Morton's in Berkeley Square which was another of our favourite haunts. We were all very comfortable and relaxed, sat on the high stools at the bar, when our friends who were seated to our left kept discreetly gesturing and making nudging motions towards us with their heads. Smiling back at them enquiringly was about all we could do until we slowly realised they were trying to direct our attention to our right, a sort of panto 'he's behind you' gesture. And then as they say, is when the proverbial penny eventually dropped, they were obviously silently beckoning us to look over to my other side

Now of course, having had a very quick peep over my shoulder, there to my right, sat on the bar stool right next to me was the rock superstar, Rod Stewart. He was sat with a companion who later introduced himself as Bill Stonebridge, the London senior executive of Riva Records (at that time both Rod and his manager Billy Gaff each owning a significant share of the company). For me, working at that time with the *Sun*'s feature's department on a full-time freelance arrangement, I had no hesitation in turning around and introducing myself to Rod and Bill (taking a deep breath and crossing my fingers) as the *Sun*'s features and showbusiness photographer. Thus, ensuring

a lengthy conversation in Morton's with the two of them, (although Bill did step forward taking over, or shielding Rod, as I queried Rod's reason for being in London) – all of which was eventually to lead to my very first big-time showbusiness assignment.

The following day I attended the hastily arranged meeting which Bill and I had agreed upon in Morton's, this to be at their record companies Kings Road offices. The timing and circumstances of our previous night's meeting was extraordinarily lucky, and it was surely by pure chance that all this was one week before the start of Rod Stewart's European Tour, the first event being staged in Paris.

Now ensconced in Stonebridge's office, I was sat looking hugely confident (but inside shaking with nervousness) enjoying a coffee whilst agreeing arrangements to publicise the megastar Rod Stewart's tour. Arranging to meet Rod in Paris where he would give the *Sun* an exclusive photographic feature, all promoting his tour.

All agreed, all formulated and set out, only one problem now – I had to go back to the *Sun* and deliver what as a freelance I had just agreed. The assistant editor, Nick Lloyd, who had absolutely no idea that I had met Rod, so absolutely no idea why I had telephoned ahead asking for an urgent meeting.

Of course, standing outside the Nick's office, waiting for his shout of 'enter' – suddenly it all seemed not so simple. Had I done the right thing? Had I dropped myself in very hot water, contacts and careers are lost on such reasoning?

I had everything set in my mind, how I would carefully deliver the synopsis to Nick, my slow protracted reasoning and how I had come to my decision, yes I would admit without any previous consultation with him, but all for the good of the paper, I had totally committed the *Sun* on his behalf for a fantastic feature!

Ready, passive breathing and keeping myself calm, ready for my slow and formal delivery, I entered Nick's office –

"I have got Rod Stewart!" I excitedly shouted as I opened the door.

All the planning on a smooth delivery, the synopsis and rehearsals of how I would explain how I met Rod and what I had agreed, completely having gone totally from my mind.

"Sounds good, sit down," said Nick, and that's how it went. Of course, the *Sun* was over the moon that I had arranged an exclusive with Rod Stewart, although I will never actually know how much of my involvement was ever

passed up to the actual paper's editor himself. This in itself is the curse for the freelancer, yes, the money but no swift progression up any promotional ladder. Suffice to say Nick was pleased and my personal (freelance) arrangements were followed through by the *Sun* to the letter, nothing being questioned.

It was an early morning flight to Paris, the reporter assigned to work alongside me was a well known female showbusiness writer. Both of us no doubt a little red-eyed at our 4.30 am wake up call, meeting at the airport for 7.30 am.

When in Paris it had been agreed that we immediately join Rod Stewart and his crew at his concert venue, this from where he was to launch his European tour.

Pulling up in our taxi it was not difficult to see where everything was happening, countless giant lorries queuing up to be unloaded, seemingly miles of cable and dozens of giant speakers and electric equipment everywhere. More a military operation than a pop concert I thought, people, trucks, vans and equipment as far as the eye could see.

"Rod around?" I asked.

"Follow the noise," was the joking response of one of the road crew.

There was obviously the proverbial soundcheck and stage construction in progress, and as instructed, we followed the loudest sound. Rod was stood in the middle of a group of twenty of his people, stage crew, assistants and his band all surrounding him.

Cautiously we walked over, a wave and a smile being offered. Rod waved back, beckoning us over. This was a huge venue, a colossal stadium in which over one hundred production staff were scurrying around ensuring this 'Cathedral of Rock' would be ready in two nights for its expected 12,000 inhabitants.

The atmosphere between Rod and ourselves was totally relaxed, no superstar attitude from him at all. It wasn't a case of a lot being said, it was more a case of keep-up and follow-on, as Rod moved from one part of the stadium to another. He seemed as excited as everyone else at what was happening around him. He was happy for me to just snap away with my camera, even bringing his then girlfriend Alana into the shots, putting his arm around her and posing. It was over an hour before Rod said he was leaving, he and Alana going back to their hotel. Certainly, from my point I had achieved a great many more photographs than I expected, remembering the main portrait pics had been arranged for me to do the following morning.

The clock was ticking on this story and the newspaper now wanted us back the following night, with pictures and the story complete to be used the next day to pre-empt the show. For the main photo session, I had already arranged to meet Rod the following morning after breakfast at his hotel, the Hotel George V, probably one of the most famous (and expensive) hotels in the world. Our own newspaper budget did not seem to stretch as far as rooms in the George V, so we stayed at the Lancaster, a smaller, but very pleasant hotel just around the corner.

Being careful to be on time next morning, we were at the Hotel George V and were instantly whisked up to Rod's rather palatial suite by his PR guru, self-appointed bodyguard, Tony. Although I had never met Tony, Bill Stonebridge had hinted of his reputation at keeping everyone except for his own personal contacts away from Rod. We hadn't met at the rehearsal the previous day but it didn't take long for his reputation to show itself. Tony physically grabbing my arm as we walked out of the lift, actually pulling me to a halt, saying how we had to sort something out before we meet Rod? Here I must admit, I had not become hardened to public relations people at that stage in my career and I was momentarily totally intimidated by him.

Tony telling us "You have just a few minutes with Mr Stewart today, so you will take what he offers and you will ask for nothing more, a quick interview and as for pictures, just take them in his suite and say thank you and leave," was the abrupt and harsh instructions from Tony.

It was totally unbelievable, it was if I had been hit on the head with a baseball bat, I was stunned. As we walked along the corridor and into Rod's suite, Tony was literally breathing down my neck. I was quickly trying to get myself together, to regroup and bring reasoning back, reality and awareness were not even with me yet.

The interview and photographs would all happen together, simultaneously. This all arranged by Tony, in his eyes the schedule was set in stone, and there seemed no other way, no way to avoid this rather boring format of me taking photos of Rod on the sofa between chatting to the reporter. If you ever see this style of photographs in any publication, you know the photographers been allocated (and accepted) no time at all, these photographs are a photographer's nightmare!

Rod entered the suites lounge from one of the bedrooms, a quick smile in my direction, obviously a remembrance of yesterday, Rod moved towards me for a handshake. This I noticed back-footed Tony, this he had not expected,

Rod's knowledge and previous meeting with me as the photographer was not to his liking.

"Right" said Rod, "so what are we doing for pictures, what do you want Ken?"

At this precise moment, like some old Peter Sellers comedy movie, Tony had stepped closer to me from behind and gave me a seriously hard dig in my back.

"I don't think Ken wants anything complicated," mouthed Tony quickly, "just a few snaps on the settee possibly."

"Well?" asked Rod, starring straight at me.

Decision time again I thought, what ever happened to photographers just taking photographs they wanted. In an instance I thought what the hell, a shot on the settee isn't going to impress them back in London.

"I'd like, well I was hoping for," I spluttered hesitantly, coming to a stop.

"Yes –" asked Rod, obviously not knowing what was going on between us all and possibly starting to get impatient.

"The Eiffel Tower," I spluttered "This is Paris after all and we should be able to show this in the photograph, to tell a story. If you have the time Rod, a picture of you with the Eiffel Tower in the background."

Now if I say at that precise time that I could hear a small nuclear explosion directly behind me, this would not be an exaggeration. Tony could not contain it, there was no way he was going to have any of this. "We have not got time for this," words from Tony's over red angry face blurted out, he moved forward, physically brushing me to one side.

"No!" came Rod's reply.

As for me, the would-be star-studded showbusiness photographer, time really did stand still.

"No," repeated Rod. At which my heart sank to the depths of the Titanic.

But Rod, finishing his sentence, in an instant followed his 'No' with "It's a good idea. Tony, Ken's right, get the limo at the front in fifteen minutes, I'll also get Alana to come in on the pics, and we will do the Eiffel Tower in the background, the full tourist thing."

Again, it was as if time stood still, as if in one of those special effects in movies were everyone is frozen still. The pause, probably a few seconds seemed to have trapped us in-time for hours, nothing happened, no one moved. The situation being broken only by Rod who assuming there was no problem with all this, thinking how everyone must be happy with his

decision, turned and went back into the bedroom to change. Of course, Tony just stared at me, nothing said at first, the silence being broken by him finally saying, "Go down to reception, I will arrange the limo and we will all meet there in fifteen minutes."

On time, Rod and Alana arrived in reception, Tony meekly following behind. Rod and Tony were not communicating at all, I felt Tony must have said something, trying once more to scuttle the shoot but had probably again been overruled.

Rod and Alana had dressed in similar black outfits, Rod adding a Zebra patterned jacket and a huge fur fabric overcoat. Alana in black with a heavy fur waistcoat style top. Outfits that were absolutely great for photographs of a rock star, everything was going so well.

Even in a world-class hotel such as the George V, Rod Stewart's presence had caused a quite a stir. As our little but exclusive group walked through the reception, guests and staff all momentarily stopped to stare.

Suddenly you are reminded of the fame and status that Rod has, possibly reminding me of who I have got in front of me and who I am photographing.

Outside the uniformed doorman was already holding the limo door open for us, the reception manager beckoning us forward, another of the reception staff standing on the pavement with outstretched arms, keeping our path clear to the limo.

Ten minutes later we were at a huge terraced area, which in the background, in all its splendour, stood the magnificent Eiffel Tower.

"This OK?" asked Rod with a huge smile on his face.

"Fantastic," I smiled back with an equally huge smile, repeating, "fantastic."

In the years to come I would find that if Rod was in the mood, if he was happy with those he was working with, he would do anything for them and especially if it involved photographs.

Rod and Alana moved over to the low terrace wall and started their own poses, both suggesting which side to stand, who would be at the front, with coat or without, but always asking me if they were in the correct position for me to get the Eiffel Tower in the background.

Unfortunately, the weather didn't hold for long, what had been a bright sunny morning suddenly fell into low cloud and covering us all in a light drizzle. Being forever the professionals, Rod and Alana never commented on it and continued, regularly changing their pose, the pair eventually sitting on the wall for the final photographs. Whether they would have carried on

longer was by now irrelevant, the low cloud was getting worse and the Eiffel Tower was slowly disappearing into the grey sky.

"Great," I said, as a way of bringing the shoot to an end. The quick drive back to Rod's hotel was all the time the reporter was given for the interview. I had been given the lion's share of Rod's time, something the reporter was never going to be happy about, and never forgot! Proving once again that too much success for the freelance photographer doesn't always gain him professional respect or friendship.

For me a total triumph, the then pinnacle of my career. Not only had I achieved an amazing photoshoot with a top world star, but also, we had sparked an amazing connection between us – one, which I was soon to find, was to catapult me even more into the international status.

By now my career was going from strength to strength, I had proven I was completely trustworthy on foreign assignments. My by-line on some of the bigger show business newspaper features was sending out a message to all the Fleet Street publications.

The following week, on a rather wet and chilly day whilst delivering some photographs, I was sat chatting to the writers in the features office when my name was called out from the feature editors office. "I have a little job for you Ken", were the words from the editor, "how would you like a few days in Miami."

No need for any thoughts or questions, it was an immediate – yes!

# 12

## MIAMI, AND AN OFFER I COULDN'T REFUSE

An unbelievable opportunity no one would want to miss, an amazing four to five day all expenses paid trip (plus a big fee) to Miami Beach. This to work with their tourist board on a huge budgeted Miami promotion – all assured to be glamour and fun – what could go wrong? Welcome to some of the most life-threatening moments of my career!

Basically, as the feature's editor explained, Miami Beach has seen better days and the State of Florida was endeavouring to smarten up a now degenerating area, to reinvent itself, to bring back the old glamour and style and attract the European tourist market to their shores. Millions of dollars were to be spent on a huge facelift for the once trendy beach city, a location that had previously starred in many top television series and films but has recently fallen out of favour with even its own American holiday makers, who were now all travelling further afield. Add to all this that even the vast majority of their own local community annually head north in the early summer months to escape the blistering Florida heat – all this was effectively leaving Miami Beach very quiet, empty and very, very alone.

So, it was a stroke of genius that someone in the Florida state tourist office had a eureka moment – "The Europeans love sunshine (regardless of the heat), lets entice them here."

And so, the *Sun*, being one of the largest circulation papers in the world was approached and offered the opportunity to send their very finest to Miami to work with their tourist organisation and local government officers. All this to achieve a glamorous summertime feature for the *Sun*, which at the same time would certainly help promote Miami Beach.

Admittedly there was a little luck involved in my participation on the assignment, firstly I was sat outside the feature's editor's office when the offer from Miami was phoned in, secondly I was delivering a set of prints for the next week's two-page feature, which one minute prior to the phone call had gained his enthusiastic and much appreciated approval. Timing is always a

help, no matter how good you are, you also need a little luck, and, on that occasion, I was fortuitous in having both.

And that's how staff reporter Joe Steeples and I found ourselves three days later, on a particularly dull April day at Heathrow, boarding the flight to Miami.

Angela was in Kenya on a modelling assignment and was coincidentally also due back home within four or five days, so I was pleased I would be back about the same time and it would all fit in quite nicely – timing again!

Joe and I checked in to one of south beaches most famous hotels (all booked and provided by the local tourist office), the Hotel Diplomat. Positioned directly on Miami Beach, our huge rooms with gigantic terraces offered amazing beach and sea views galore.

Unfortunately, as we were to quickly find out, whilst Americans are without doubt the best hosts in the world, they don't give you much time to relax. They are highly business-activated networking people and whilst being welcomed to Miami, we were also advised to rest-up and relax 'for an hour' (this after our long trip to their shores) and a car would collect us to take us to a welcoming barbeque.

True to their word, one hour later, the telephone rang in both our rooms to advise Joe and I that the car was waiting for us.

As we were driven along Ocean Drive, we were mesmerised by the amazing art deco buildings, each individual hotel, bar or café highlighted with subtle lighting so as to reveal their unique and magnificent architecture. And as if accessorised by designer fashionistas, each also having its own glamorous clientele posing on the terraces as they sipped exotic cocktails. On the opposite side of the road, straddling the promenade and beach, absolutely gorgeous suntanned sexy bikini girls were rollerblading against the backdrop of the sea and the setting sun – welcome to Miami!

At the barbeque we were met by people we didn't know and had never met before, lots of handshakes and small talk – and lots of drinks thrust into our hands. After an hour I looked over at Joe and thought, 'God he looks tired, about to fall asleep and had probably drank too much already' (the next day Joe mentioned he had looked over at me and thought exactly the same!).

So during this first evening's encounter, when a man, medium height with thinning white hair, wearing an immaculate white suit came over (I remember there were also two other men, one each side of him, in dark suits) introduced himself, explaining if I needed anything at all, absolutely anything, I just had

to ask him. Unfortunately he received very little recognition or thanks from me. Seemingly I smiled all the way through his soliloquy whilst he was telling me how Miami Beach was his' and he could open any doors for me.

Whether the stress of the trip, having no rest, tiredness, even overexcitement and just possibly a few drinks too many, I was obviously starting to feel a little over confident. Consequently, I was very polite but thanked him and I think I verbally patted him on the head, a sort of 'Yes, Yes, of course you can' – then walking away with a huge smile on my face to join another group.

## Don't mention the 'M' word

It was about nine o'clock the next morning when the telephone rang. Still in bed and grappling with the handset and trying to sound coherent, I spluttered the obvious, "Yes, hello."

"Mr Ross," said this sweet American female accent.

"Yes."

"Sir, good morning – there are two police officers at reception for you."

Utter panic, jumping up, ringing Joe's room and getting much the same spluttering, "Yes."

I told him what was happening.

"Christ!" was his comment, followed by, "What the hell did you do last night?"

Joe and I met a few minutes later in the corridor, Joe having come to his senses a little more and made from what was his point, a very prudent comment. Asking me was it 'both' of us the police wanted to see, or was it just Ken Ross?

Giving a killer stare back to him, Joe said no more and followed meekly, we arrived at the reception like two sheep to the slaughter.

Two smiling police officers were waiting, as we walked nearer, we could see through the glass doors of the hotel a police car parked outside.

We were greeted with "Good morning, sir" and an outstretched hand. Hesitantly I shook hands, staring down at my hand as the officer eagerly clasped my hand, wondering if a set of handcuffs were to discreetly follow.

"We are to escort you to the Mayor's office, there is a car waiting for you outside."

The Mayor's office was big, but very American, all very straight up and

down furniture, none of the traditional grandeur that you would expect from a London's Mayoral office.

There next to the desk was what we assumed by his stature and the fact that a group of six other people were all stood to the other side, was the Mayor of Miami Beach, Mayor Meyerson.

"Welcome to Miami Beach," that coupled with a huge smile and another held out hand was all the reassurance we needed, all was well and this an added bonus we didn't expect.

One of the group at the side, their photographer, jumped in front of us and took photographs as we shook hands with the Mayor and City Directors. Then the most amazing thing happened, plaques made of antique parchment with gold ornate seals, headed with our names suddenly appeared, we were being presented with 'Honorary Citizenship of Miami Beach' and with even more welcoming handshakes and more photographs, we were then given the 'Golden Key to the City'. It was like being in another world, here we were in the Mayor's office, and being awarded the ultimate in prestige. I just kept thinking who do they think we are, hopefully not thinking we were the owners of the *Sun* or its editors. This was way above anything we had ever expected, we had only just arrived, and we were being treated like Gods! All we had done so far was get totally trashed the previous evening and stagger around making a huge amount of promises that we probably could never keep. We had told everyone of how we would promote Miami Beach – O! yes, and I think I may have insulted some guy in a white suit?

A few moments later, amongst all the smiles, all the chatter and back-slapping, I looked over towards the far side of this huge room, there sat in the corner was my man from the previous evening, medium height with thinning white hair, wearing an immaculate white suit – and, yes, two men in black suits each side of him! On this occasion it was he who had the huge smile on his face. My guy in the white suit had sat discreetly out of the way whilst all the pomp and ceremony had carried on, but when our eyes locked, he raised his hand and with his fingers making a sort of 'gun' shape gesture, he pointed it at me, as if firing!

And so, started one of the most amazing, unbelievable and at times, scar-iest few weeks of my life.

The man in the white suit I was to find was Mr H.J. Uchitel, a man who in time would prove he really did own (or at least had power over) Miami Beach – and no!, we never did use the 'M—' word.

Mr Uchitel, a quiet and very dignified man drove, or at least was chauffeured in a huge Rolls Royce, and had two male 'assistants' (black suits, sunglasses – yes I know what you're thinking, straight from the movies) constantly with him, be it that they walked at a discreet distance behind him, or in a following car.

From then on I was to meet Mr Uchitel on many, many occasions. His office (a modest name for such a huge complex) was located in a presidential-style building, being the penthouse on one of the small billionaire islands that linked the Miami Beach strip to the mainland Miami.

I suppose you could say he and I formed a friendship, a bonding, at times good humoured, although when he spoke and made suggestions it was always with an assumed authority and more possibly as an instruction, but always friendly and respectful.

I was invited to dinner the following evening to join Mr Uchitel, although when I say invited it was one of those 'offers' you couldn't (or wouldn't) ever feel you could refuse.

A car collected me, and I was taken to a restaurant called Place for Steak. Exteriorly all typically American, a detached building surrounded by its own car park, it offered no special ambience for the passers-by, but inside it was another world. Designed more like a film set, the décor was 'showbiz roaring twenties' with candlelit tables set around a centred circular bar which in turn enveloped a huge grand piano with a most striking female singer dressed in a simple white shift dress, dusky completion, hands behind her back leaning forward singing into an old fashioned microphone on a stand, her amazing voice captivating every guest. Waiters scurried around carrying huge silver trays one handed above their heads. You really expected to see Marlon Brando and Al Pacino sat at one of the corner tables – a total world of what seemed American (underworld) elitism.

If I had been told that the director of the movie *The Godfather* had eaten here the day before filming the famous movie, I would believe it – it was actually like being on the set, sat amongst it all, I was living *The Godfather*. The women were young and beautiful, the men all slightly older with gold bling everywhere. Any younger male guests you assumed were the favoured sons of the elite, or if not, they would be sat on nearby separate tables, keeping a careful and guarded watch over their bosses.

Miami was obviously changing fast, respectability was coming in, a huge clean-up of the Miami Beach area and the city was underway, local police

and the federal government were putting the squeeze on the Cuban American drug lords who had for a time controlled many of the Miami Beach and inner-city clubs.

Miami was to become a tourist safe place (that's what I was there to promote after all). So, the later Al Pacino famous movie *Scarface*, showing the dark image of the 'Tony Montana' character (a Miami drugs baron) was worrying to the bosses of Miami. In the clean-up many of these clubs and hotels featured or even hinted at were soon to have their doors closed forever.

But in the meanwhile, for me everything was going according to plan, evenings I was popping into some of the Miami's most beautiful (and respectable) restaurants, which were recommended (suggested) by Mr Uchitel. At each I was his guest, collected and returned to my hotel, no bill ever presented, just more leaving handshakes from the manager and maître d' and a much sought-after assurance that everything was to my satisfaction.

During the daytime my time taken up with working with the staff from tourist office.

## From Cuba with love?

After about a week, when Joe and I were thinking our time here in Miami was coming to an end, the newspaper rang from London – it seems we were in the middle of one the biggest worldwide breaking news stories which was about to change America forever.

Fidel Castro of Cuba was suddenly rumoured to be allowing a mass exodus of his citizens, who reportedly were to form one of the greatest armadas of modern times and head for their nearest neighbour, America. Their immediate destination, hundred-mile sea voyage to Key West.

The instructions from the *Sun* were simple, Joe and I were to 'drop everything' and get down to Key West and follow the story.

Of course, this was over thirty years ago, the roads and the area infrastructure were more basic, nowhere like what they are today, the now modern set of islands linked by modern bridges that form the popular holiday 'Keys' is an easy drive, not then!

Nevertheless, eventually after driving a hard 150 miles we arrived at Key West, rooms having been booked for us by the newspaper in one of the local basic white painted boarding houses. We first made a quick drive-by 'recce'

of the Key West concrete jetty, which formed the fishing boat harbour. This the southernmost point of the island and the nearest point of America if travelling from Cuba by boat, little was happening, nothing unusual, all was quiet so we left.

We checked into the boarding house, Joe settling into his room after buying all the local newspapers and copying extracts of the story so far, for myself, I was busy checking my cameras. In honesty, this is the part I always hated (or was jealous of) with reporters, they actually don't have to see it all happening or even be there – local newspapers are a great source of information to copy for the nationals, even popping into the local newspaper office and chatting with the local press gives a visiting reporter everything they need to know. Whereas photographers, if you are not on the spot, not at the scene, you have absolutely nothing!

A few hours later, camera bag slung over my shoulder, I wandered back towards the harbour, locals sitting comfortable on their porches nodding at me as I passed by. Back then, this was a small, probably best described as a quaint hillbilly style very laid-back small fishing town, with its amazing character of white boarded houses and narrow tracks and streets (with chickens wandering around freely) which led to the quaint working harbour. But as I arrived on the jetty, only a few hours since Joe and I had driven by, everything had changed, the quiet jetty was now in turmoil. A constant stream of assorted army vehicles was unloading soldiers and their equipment. Two coast guard boats were now docked alongside the pier with people running around everywhere, temporary cordons being quickly put in place.

I had just managed to walk onto the harbour jetty and loose myself amongst all the chaos minutes before more permanent cordons were put in place to seal off the harbour. The soldiers were marines and with me already being positioned amongst them everyone assumed I obviously had all the necessary credentials to be there, plus the English accent was then still rare and popular in that part of America, giving me a sort of novelty value.

And so, with the harbour and jetty now sealed off from the outside world, I just waited, trying to lose myself amongst all the chaos and look as inconspicuous as possible. The general feeling was that at any time now, with favourable weather conditions, the armada would set sail from the Cuban port of Mariel and would eventually appear on our horizon.

Luckily, I had established a good rapport with one of the platoons of the Marines, the English aspect still working in my favour.

Early evening, Joe wondering where I was, had ventured down to the harbour. Too late by then, even with all the press passes in the world no one could gain entry through the now extended six-foot high wire cordon, the jetty having been sealed off seemingly forever. Joe was held back with the other now massing American press corps, all unsuccessfully trying to gain entrance along the jetty. He could see me across the cordon, we discreetly nodded, Joe realising I had somehow gained entry and he not to wave or try to make any obvious communication or acknowledgement as being 'press'.

With night-time approaching my relationship with the Marines was extended, the platoon having now adopted me, it was all very casual, and I was invited to join them at their hastily set-up army canteen. A tin of coke, coffee, hamburgers and chips was on the menu, and considering that I had no supplies of my own, just my camera and four rolls of film, their offerings were gratefully received and absolutely delicious. As it got later everyone started bedding down, army sleeping bag were stacked amongst the dozens of boxes of supplies. I simply wandered over, pulled one of the bags and discreetly bedded down on the floor amongst the multitude of marines, within minutes I fell asleep.

"They're coming!" was the early morning shout that awoke me, everyone rushing to get out of their sleeping bags and move to the end of the jetty – to see what looked like small specks on the horizon, not a dozen but seemingly hundreds.

Boats of every shape and size were heading towards us, boats originating from Cuba, but also boats that had set out from Florida to go to Cuba, many owned by American Cubans having gone to collect family members and friends who were now allowed to leave the communist state. The flotilla varied from small open speedboats to sea-going shrimp fishing vessels, everything was heading our way. The exodus had begun, hours in stifling hot weather and dangerous waters, humanity was on the move, boats massively overcrowded with fleeing Cubans who were all heading to Key West.

Whether shepherded or being monitored by the US Coast Guard, it didn't matter, the refugee armada was grateful of their presence. Some boats had broken down or were too overloaded, with coast guard cutters taking on refugees and towing boats.

As the armada reached Key West the marines were being assigned different areas of the harbour to deal with the docking boats, the embarkation and most importantly to register and control the refugees as they put foot on American soil.

The waiting press outside the jetty were now to be dealt with, the marine's press aids being assigned to groups of about four members of the press who they would then escort and totally supervise. As this was being discussed between the officers all eyes eventually settled on me. The marine commander, Captain Tracy, looked at me and commented that I had been here for the long haul, not just an easy press day-out and that he would personally be my escort, all nodding in agreement. As they disbursed one of the marines said to me, "what are you waiting for, you're on your own, go get the exclusive you guys always want."

At that I followed my adopted group of marines, one of the shrimp boats, named *Peggy Sue* was just docking, totally over laden with people who were hanging on to any available part of the boat that would support them. The marines with loudhailers warning everyone to stay on board for a few minutes, they would then disembark in a controlled and supervised manner. I witnessed the marines taking out their own cigarettes and throwing them over to the refugees on these vastly overcrowded boats. Cases of cold drinks, chocolates and food were being ferried from the marine's canteen and passed over to the occupants of the boats. Old, middle-aged, the young and newly born babies, they were all clinging onto the packed boats which had just brought them to freedom. At the harbour front, at the gates and the wire cordons it was just a chaotic, Cubans living in Florida had all driven here to try and find any relatives and friends that had successfully made the crossing. With over 4000 Cuban refugees having arrived already and now hundreds pushing against the wire fencing outside, the small laid-back world of Key West was totally overrun

Everyone was welcoming the refugees – unfortunately as it was to prove later, a welcome some refugees did not deserve!

In the meanwhile, I was moving around freely, photographing the boats and its exhausted passengers – an amazing experience, amazing times. The marines shouting me to go there or come here, each wanting me to photograph, to witness another case of need or of tragedy. On the lighter side one marine carried a young girl whose parents had given her an American flag to carry – my photograph of Marine Tim Lyman and the six-year-old refugee, Sandra, went all around the world.

To witness one man's humanity to another when some are in need was amazing. The marines were there to help, and that's exactly what they did – an extraordinary group of men who having been trained to be so tough and resilient, were as gentle and as giving as could ever be expected.

But even before the end of this first day things were not as harmonious as they should have been at Key West. Rumours were quickly circulating around the jetty of Fidel Castro having emptied his prisons and mental institutions of over a thousand convicted criminals (thieves, murders and rapists) and had transported them to Cuba's Mariel Harbour to be mixed in with the fleeing Cubans.

Castro's special police forced many of the departing boats to each take on board a number of these special guests. Boat skippers being warned that if they told the American authorities of this on their arrival, they would 'all' be interned as suspects, most people having had their documents taken from them, so no one had proof of who was who in any case.

This was initially suppressed but has been a legacy over the years that America, in one of its greatest hours of making a humanitarian gesture, had to deal with an invasion (armada) of the type they never envisaged in their worst nightmare.

Over a short period, 125,000 Cubans seeking refuge from Fidel Castro's regime, packed into a total of 1700 boats, left Mariel Harbour to make the dangerous sea crossing to Key West. This mass exodus opened a new chapter in America's long immigration history and permanently altered Florida's cultural identity.

Back in London my photographs went viral, the *Sun* covering its front pages and centre spreads with the heading '*Sun* Picture Exclusive'.

For Joe and me, it was the long trek back to our hotel in Miami – but little did we know what was waiting for us there!

## Back to the glamour

Having returned to the civilisation of Miami, we contacted our local tourist board friends and the Mayor's office, to reschedule our last few days here to try and complete the actual reason for our trip, the Miami Beach promotion feature.

The next morning, after a restful sleep we had breakfast, spending an easy day meeting a few officials and tourist board members. Several meetings had been arranged with local businessmen. One of the meetings was with Mike Winters (one of the comedy double act, Mike and Bernie Winters, 1960's popular UK television comedians). Mike had been the straight man of the

duo, good looking and a smooth talker but had fallen out with Bernie and the act had split up two years earlier, with Mike moving to Miami. He had become involved with various business ventures and was also attempting to write thriller novels. We were taken to his house and introduced with some wild theory that we could help his business in some way, but other than actual photographing him and hopefully including him in some side story to the feature there was little we could get involved in. All this is very American, everyone is a brand and product, and products can be bought and promoted.

An early night for us had been decided, but only after a delicious meal at Mr Uchitel's favourite restaurant, the Place for Steak, actually a truly amazing restaurant which had become my favourite – the one restaurant I have to admit I loved going to (of course, as usual, no bill was ever presented).

## Miami on fire

Back at the hotel and just as going into a deep sleep, and yes, the telephone rings. "What are you doing in bed, Miami is on fire, and it's a war zone, get out there and cover it."

Words definitely made to arouse you from your slumber. The London editor's office had rung both our rooms, it was coming across the wire in London from Reuters that Miami was in the middle of the biggest riots for a decade. The City (not Miami Beach) was on fire, the African American community rioting due to a court case where four white police officers that day had been found not guilty of the killing (acquitted of manslaughter and evidence tampering) of a local member of the community. Subsequently, a race riot broke out in the neighbourhoods around Overtown, Brownsville and Liberty City in Miami.

Another quick 'get dressed and be ready' and within minutes Joe and I met at reception. We had telephoned the reception ahead and the valet-parking people had brought our car to the front.

Joe wasn't a confident driver so it was agreed I would drive until we reached the point where I would need to take photographs, we would then swap over, leaving me free with the camera.

We ventured forward, a little nervous to say the least (where was all this glamour we had been promised?), on we drove towards the City of Miami. Here you must remember that Miami Beach is separated from the mainland

City of Miami by a network of bridges, which span between the small islands that populates the thin stretch of sea (gully) that separates these two land-masses. As we approached the bridges we found them to be closed off by police, being quickly advised that the City of Miami Beach authorities had decided to 'lift' the bridges, to seal of Miami Beach from the main land, but if we were quick the southern bridge was still in operation.

Over the southern bridge (heavily guarded) and onto the mainland we went straight to the central police station – now here you cannot confuse an American police station in this area with anything at home or even what you have seen in their own glossy brochures. This was a fortress, an austere building with the ground floor having no windows or doors (other than iron roller-shutters for the vehicles to enter or leave the fortified garages which were housed underneath). We parked at the front, there a huge out-door pedestrian concrete ramp led all the way up to the first floor, the only visible way in or out of the building. This was more like something out of the Egyptian Pharaohs and the Pyramids. We started to walk up the steep ramp, only to see ahead of us two police officers at the top wearing full riot equipment and holding shotguns. Certainly, if you were not there for friendly purposes, you wouldn't go further. Obviously, the idea of the buildings design was derived from previous experiences. One of the police officers later told us they had learnt many lessons from riots and attacks on police stations over previous decades.

Coffee and a quick chat to bring us up to speed on the current situation (again, all very American) and we were invited to go out with their recon-naissance team. Enthusiastically we agreed, safety with the police rather than our own attempt to reconnoitre the local scene was we felt an extremely good idea. But no! None of this was what we expected, I suppose in our mind a police car with two armed officers in the front seats – no! "Don't confuse your local English disturbance with a riot here," smirked one of the officers, "this is serious stuff, as you are about to experience."

Down at ground level inside the huge garage areas we first saw our mode of transport, a fully equipped army style Armoured Carrier. Six heavily armed riot officers (full riot military dress) in before us, followed by Joe and myself (we look so out of place in jeans and T-shirts, it was nearing on the side of being absurd).

We could hear the huge metal doors lifting, and the armoured carrier lurching forward, we were out and on our way to the riot's abyss, the centre

of all that was happening. Through the small thick glass window slits in the side of the carrier we could see flames, houses and shops burning, total Armageddon. Throughout our trip we experienced loud banging on the side of our carrier with flames licking over our small window. Joe and I assumed these were bricks or Molotov cocktails (or worse) being thrown at us. Little chance for us to do anything, no photographs and definitely no stopping and the opening of doors. After an hour the carrier was returning to base, with no doubt everyone inside relieved – certainly for Joe and myself one of the worst drives of our life.

We stayed at the station all night, the police advising us that it wouldn't be safe to travel while still dark, "The rioters will all sleep this off when daylight comes, then get yourselves back to your hotel, besides there is no guarantee that the bridges are down to let you get back to Miami Beach."

Back at the hotel we realised we had very little to use, so reassuring the newspaper we would venture back on our own and this is where the famous saying comes in – Fools rush in where 'angels' (in our case, 'English') fear to tread.

So still with the riots in full swing, the next day after a few hours' sleep Joe and I set off from our hotel, venturing back across the only bridge still passable (all the rest still raised, sealing off Miami Beach).

We arrived on the outskirts of the riot area at one of the roadblocks, with three police cars parked across the road and heavily armed officers on guard. Discussing our situation and quest, we were again warned about the lack of guarantee for our safety. One of the officers basically put the whole situation in a nutshell. He explained (as far as he was concerned), "It was the rioters own area, if they wanted to burn it down then let then go ahead, we (the police) will go in later when everyone there has realised there is nothing else to loot or burn!"

At that, (being somewhat bemused at these strange English guys) they moved one of their police cars to let us pass. We, not really knowing what the hell we were there for, set off. Joe not being so happy about driving so I was at the wheel, but we still had the agreement about swapping over when necessary for photographs.

We weaved through the streets, a surreal scene zigzagging between burnt out cars and burning oil drums, containers and rubbish and the empty packing cases left by the looters (stopping briefly for me jump out to take photographs of smashed shop fronts). The police the previous night had been correct about the rioters sleeping it off during the day, there was very

little sign of life, more like one of those after the apocalypse deserted scenes from a movie.

But within a few minutes people started to appear, it was now turning into one of those zombie films, people appearing and walking slowly towards us. We didn't hang around to summarise if they were the goodies or the baddies, this was real life and neither Joe nor myself felt like being heroes that day. I was back in driving position and I looked at Joe, and at our seats. I suppose wondering if we had time to swap the driving so I could attempt photographs. The noise from the group was getting louder and we could hear things being thrown. Far away at the time, but getting nearer very fast, suddenly something hit the car, nothing was said, Joe looked at me, I pushed the car into drive and swung around, the tyres screeching as if in some police movie car chase, but this was real, we accelerated away.

I raced the car forward, foot full down heading in the rough direction from which we had come from, still weaving between the pieces scattered on the road – after a few minutes, which truly felt like hours, we spotted a police roadblock straight ahead. Flashing the lights, we went straight towards the police cars, two of the cars parting to give us a narrow exit. I screeched to a stop, and all my life I have remembered one of the police officer's words as he came and opened my car door

"Where the fucking hell have you two come from?"

The police officers were dressed in full black riot gear, full armour, helmets and visors, holstered hand guns, a belt of stun grenades and holding automatic shotguns – all staring at two English guys in a dented car that looked as if it had just been in a crash-derby, and both Joe and I were still wearing just T-shirts and shorts!.

"It's hell in there," I spluttered!

No one else spoke. There were a few nodding heads and glances between the officers as we slowly drove away. All the way back to the hotel Joe and I said nothing all. It hadn't been our proudest moment, but in real life it's difficult to be a hero every time. What could we have done to have got more of the story, I had played the brave man once before in my career and other than an injury I had got little for it, in fact that was one of the reasons I had stopped doing hard press news stories, I never felt it was worth the risk or justification!

Here in this location we had no local knowledge, no contacts and were completely blind to the real facts and history of the situation.

Next day on the television it was announced the rioters had dragged two French reporters out of their car and used the car to run over them several times, all this just a few hours after we had been at exactly the same location. In total eighteen people had been killed, over 300 hospitalised and over $100 million worth of damage caused. Over thirty-nine businesses, shops and even factories where the rioters had themselves worked had been burnt to the ground.

We took our rented car back, reminding the rental company we had taken the full insurance, but we were sorry for the mess, mostly superficial we explained. As we walked away the car rental guy shouted us back, "Superficial! Then what's this bloody one-inch round hole, clean through the wing, luckily whatever did this didn't hit a petrol line or someone inside eh!"?

## Mr Uchitel opens doors

We forced a day off, blatantly telling the London office that we needed to crash out and rest.

Next day we attempted to reconnect with our somewhat bemused colleagues from the Miami Tourist Office, they now seemingly getting used to us being there one minute and the next suddenly disappearing for a few days at a time.

It was getting time for Joe and me to return to London, even my Angela who had now been back home for nearly a week was questioning what I was doing all this time.

"I have to get back to London," I mentioned to Hi Uchitel during one of our now regular evening dining sessions together, hoping this would sound a good enough excuse for me to leave Miami, sighting Angela as an excuse for me to return home.

"Has Angela ever been to Miami?" asked Hi.

"No," I answered, thinking he just wanted to make conversation, "she seems to work mainly in the more exotic locations, she has just been working at the famous 'Tree Tops' location in Kenya for the Kenya Tourist Board. It's there or locations like Israel, working for their tourist board, or for Slazenger in Kuala Lumpur or in winter skiing for one company or another in Saint-Moritz and Verbier, but no, never Miami."

"Well let's put that right for a start!" At that Hi' raised his hand and a telephone is brought over to him, I couldn't tell who he was ringing, or hear

the conversation. Nothing further was said about it for over an hour until one of his staff placed a folded piece of paper next to his hand. He unfolded the paper, looked at it for a moment and then passed it to me.

"This is the number of a side door at the south side of the American Embassy in London, your Angela has to go to tomorrow, she will simply have to take her passport, give her name and her visa will be sorted there and then."

Possibly I should explain that at that time American visas were not easy to get and could take weeks to arrange. Even special visas for press were never easy, before my own trip when I applied for my visa, also having access through a specially numbered door, but it still it took me the whole day. So you can guess how worried I was starting to become over the power of Mr Uchitel, after Angela the next day explained that when she had gone for the visa, carefully following the instructions given, she was offered a coffee while they sorted her visa, all within forty minutes.

The flight ticket for Angela would be there for collection at the American Airlines desk at Heathrow I was advised, early flight the day after tomorrow

## The Bonfire of the Vanities

"Don't worry about rushing back to London" he laughed, "Tomorrow a story will break at your London newspapers office and they will ask you to stay and cover it," more laughter.

The next day, exactly as Mr Uchitel predicted, a telephone call from London! Sir Freddy Laker was joining in the big Miami holiday boom and was setting up his massively orchestrated and publicised inaugural flight the following weekend – London to Miami. This was to be the very first of the no-frills low-cost airline services, Freddy Laker was to offer fares less than half the current cost of competitors. His first Atlantic Crossing Jet would land and be received by the Mayor and all the City Officials at a grand tele-vised ceremony at Miami Airport.

"This is big breaking news," said the features editor, "A whole change in the way we look at air-travel," and yes, I was to stay on in Miami to cover the story!

I sounding surprised and yet disappointed at not to returning, said how I understood and would of course stay on! Once again Uchitel had shown his power and complete knowledge of what was happening in his kingdom!

Next day Angela arrived in Miami, I was excited to be seeing her but wondered how she would react to all this high end 'M—' hospitality, which was now beginning to worry me. I was now starting to feel more like being controlled rather than being looked after – my main concern was how could I repay all this hospitality. I had always made it obvious that I was a freelance photographer working 'with' the *Sun* and that I had no more influence than that!

A big hug from Angela at the airport, putting her bags into the car we set of back to the hotel.

Now whether this was due to overexcitement or me just talking too much, but on the way back to the hotel I stupidly took the wrong exit off the express-way flyover bringing us into a part of downtown Miami City I had never seen before, the scene of some of the earlier rioting.

If you have ever seen the film *The Bonfire of the Vanities* where a couple coming back from the airport take a wrong turn and finish-up in the war-zone of the South Bronx, where they were faced with problems from local people which changed their whole lives in a minute – well now you can begin to understand why I was starting to panic.

Not wanting to pass on my growing anxiety to Angela, I simply sum-marised that although I had not taken the turning I wanted, this was in any case quicker. This scenario lasted about one minute before Angela realised, we were not in the glamorous place I had been describing over the past week or so. After driving for a few minutes, I eventually plucked up the courage to stop and ask a group of local guys, which was the road into Miami Beach. The screech of our wheels soon heralded our exit from the situation, it wasn't what the guys said, in fact they said nothing at all. It was the way they looked at each other before lurching quickly towards our car!

I worked on the principle that if you keep driving in a straight line sooner or later you get somewhere, luckily for me that theory eventually worked, and we found the expressway again.

## A scene straight from the movies

The next day I had a meeting arranged with Hi Uchitel, he wanted me to visit his office, what he called his little hiding place. I only had an address and so asked the concierge at the hotel how to get there. Even he was impressed,

it was on one of the most exclusive private islands laying between the beach and the mainland.

Once again, I entered the realms of another world, a small private island set between the mainland and Miami Beach approachable only by small private bridges with security stations on each entrance. Giving my name to the immaculately dressed (and armed) security guard, I was waved across.

Uchitel's office situated on the top floor of a huge glass office block had no name marking in reception, simply an anonymous number.

Leaving the escalator, I faced a huge door, again no nameplate or markings whatsoever. I pressed the bell and the door immediately swung open to reveal an amazing white furnished large reception area with the obligatory beautiful receptionist in attendance.

"Mr Uchitel is expecting you Ken" and with that, a sort of follow me look – which obviously I succumbed to.

Uchitel was sat behind a white shinny desk in a room that seemed to have only one solid external walls, simply plate glass everywhere, giving the most amazing panoramic views of the whole of Miami and its famous beach.

"Something I wanted to show you Ken," were his first words as he stood and headed for one of the doors leading from his office. Firstly, we walked through another lounge area (again all in white), which led us to yet another door. Opening this left me totally bewildered, even in the movie *The Godfather* they would not have dared to try to make this look factual, no one would or could ever believe this.

I was in a room five or six-meters square, again plate glass exterior walls giving the most magnificent views – but this room was furnished with just one single piece of furniture. One chair, placed in the centre, this was one of those barber chairs you only now see in the oldest movies. Obviously completely renovated, all sparkling chrome and white leather, standing on a huge circular chrome pivotal base. It was between something from science fiction and the better days of the glorious past of bootlegging and giant cars with running boards with men hanging from them firing Tommy-guns, all amazingly stunning!

If ever there was a palace, a lair, a thrown room for a King of Miami Beach, then this was it! It was difficult to understand, everywhere I had visited was like a scene from a movie – had these people copied the movies or in fact had the movie producers of *The Godfather* actually copied the world I

103

was now living in? Uchitel slowly walked over to his Throne, settling gently into the chairs embrace, he gestured me towards him.

"When I was young there was one thing I hated more than anything else, and that Ken, was shaving. So now, every morning I come to my office, I sit in my chair, look over my Miami whilst I relax, and my barber shaves me."

Of all the things which Hi Uchitel has done over the past weeks to impress me, this alone stands out, something totally unique, something you would or could never expect to be real. With the high cost of property prices on those private islands on Miami Beach being some of the highest throughout the world, that one room space would no doubt buy several large houses back in central London.

Angela was enjoying the hospitality that was being lavished upon us, the fine dining, choice of top restaurants and introductions to practically anyone we wanted to meet. We were usually escorted or met by one of Mr Uchitel's associates or friends, one of our favourites was his lawyer from New York. Only once did we let the drink influence us enough to ask the lawyer how he came to work for Mr Uchitel. Without any complicated story or excuses, he simply explained he once had serious clerical issues in New York, which were being investigated by authorities. Some people arranged that the problem went away – it involved someone being hurt (he actually said 'accidentally falling down a lift shaft') and him owing a debt, paid by moving to Miami and working for another 'firm' – end of story, as he would say!

## One thousand feet in the air sat on a flying deckchair

To cover the Miami feature, our original and sole intended purpose of being here, I wanted some aerial photographs of Miami, another telephone call to the Mayor's Office and it was arranged I would have a flight in one of the Police Air Patrols the next morning.

Angela and I arrived the following morning at Miami Airport, being given directions to the specially guarded police area where there were several helicopters and a fixed wing small plane.

This I thought would be fun (at last) and was looking forward to the short flight over Miami.

Meeting the officers, we were introduced to our pilot and at the same time Angela was invited to join us, everything was going well I thought. We

walked out, Angela and I heading towards the fixed wing aircraft but being called over by our pilot who was now standing next to what looked like a couple of deckchairs tied to a lawnmower, with a huge propeller sort of brolly thing sticking out of the top.

Now these small bubbles (police helicopters) in the air may look good on television, but believe me in life, standing next to them, they are small, flimsy and look as if they have the power of something you trim your lawn with on a Sunday morning.

Having achieved so much fame on numerous television series you think they would have by now made them human friendly – no such luck. "Get well strapped in" said our pilot. Strapped in? There was nothing else to do other than strap yourself in as tight as you could to one of the deckchairs.

Basically we have the three of us sharing two chairs, with a plastic bubble in front of us (damaged with a long split in the plastic which was secured by two five inch brackets, seemingly the only thing that was holding it together), this with a lawnmower engine at our backs with a propeller above our heads. Angela was in the centre, with the pilot and I seated either side (me slightly seeming to hang out a bit over the edge of the seat). Would I be able to close the door, no problem, I frantically looked but there was 'no' door! Yes, just as the movies, when there is only one or two on board, no door, just an open space! But there were three of us!

So, the machines rotary thingy started going around and round, faster and faster. At the same time I was desperately trying to push into the centre a little more, trying to claim a little bit more of the seating.

Up we went, straight up, me trying to look casual, my outside hand holding on to the handle that you use to pull yourself in (the only thing I could find to attach myself to) whilst my other hand held onto the under-part of the seat. As I said earlier no door, just me and the elements, still feeling as if I was hanging out of the side a little too much.

Now we were hundreds of feet high, the skyscraper hotels looking like tiny matchboxes far below and the pilot asked if I wanted to take my photographs now.

Here I must admit the truth, with my camera already hung around my neck, I suddenly realised I couldn't release my outside hand from the handle – which I think it was now welded to. No commands, no reflex or movement would make my hand leave hold of the handle – looking at Angela (who was comfortably seated and secure between myself and the pilot enjoying the

fight), I asked her quietly to lift the camera from around my neck and snap the landscapes below.

Of course the pilot still wanted to impress us more, so a few swoops and dives between skyscrapers and side tilts were on the programme, we were living out all the helicopter dramatic shots you have ever seen on television – putting it simple from my terrified point of view – never again during my life would I board (risk or hang on to) a helicopter that did not have a door attached to it!

## Beauty and the Beast

We still had two more days before Freddy Laker was due to fly in his inaugural (the start of Skytrain) flight from London, so still reminding myself I was supposed to be here working, and with Angela looking so good and suntanned, I decided to set up a photo session. I wanted a photograph that would be iconic, something that said where we were without even the need for a caption.

Easy we decided, a Miami motorcycle policeman, palm trees, the sea and of course, the beautiful girl.

For anyone to imagine a scene within the eye is easy, to a photographer the task is something more difficult. Palm trees for instance, numerous, certainly no shortage – except they are some twenty feet high – put that next to a policeman sat on motorcycle who probably sits some five foot high – then you have a problem, just a tree trunk and nothing else, unless you settle for a small photo of the policemen under a very, very tall tree.

Looking around, there were no small palms – except some four-foot-high newly planted 'baby' varieties positioned around the pool of the most upmarket and expensive hotel in Miami, the Fontainebleau Hotel.

Normally an impossible situation, having a look around its pool area I could find no obvious access for a huge beast of a Harley-Davidson motorcycle, let alone the chance of getting permission for the shoot with all the disruption it would cause the hotel. Especially this being the Fontainebleau, a hotel that would never dream of disrupting in the slightest its high-end top-draw clientele.

Of course, for me not a problem, one phone call to the Mayor's office, another to Hi Uchitel and within a couple of hours I received an

invitation to meet the management of the Fontainebleau – the shoot agreed immediately.

The following morning Angela and I met our motorcycle policeman at the hotel, who introduced himself as Chuck, a great guy who was more than eager to help with our photo session. We walked around the area where the photo would be taken, which was in the centre of pool area of the hotel. It was decided the only access point for the Harley-Davidson motorcycle would be through the car service basement of the hotel, travelling along the underground service areas and the heating and pool pump-rooms, and then by making some form of ramp, bring the motorcycle up a stairway from the basement which opened up via a double door hatch near to the pool area, ten yards from the small five foot palms we needed, this area even provided a sea view to the rear.

Impossible of course, but not to Chuck, with a smile he took up the challenge. Turning the key, he brought his giant beast of the road to life, a huge roar and we watched him drive down into the underground service entrance.

Angela had been given one of the hotel rooms to get ready for the photograph and when she arrived at the pool for the photograph, even by Miami's high standards of glamour, she looked fabulous, her hair cascaded over her shoulders, she was wearing an amazing skimpy bikini and with the perfect suntan she had gained from her recent Kenya Tourist Board modelling trip, she outshone even the best of the Fontainebleau's glamorous jet set clients.

We only had a few minutes to talk through the photograph which I had envisaged before we heard the roar of the Harley, the two hatch doors had been lifted open and the hotel staff had placed wood planking to make an impromptu ramp on top of the staircase leading up from the underground pool pump-room. Like some modern-day knight in shining armour on a white charger, Chuck flew up out of the basement doors. Momentarily seemingly flying in the air before the heavy motorcycle crashed to the ground and lurched to a stop – with a smiling Chuck receiving a hearty round of applause from the now gathering staff and amazed hotel guests.

Angela shone in this photograph; she needed no direction, as a professional she simply merged into the situation with Chuck and his motorcycle.

It took less than half an hour for me to be confident we had captured the scene – job done! Chuck engineered his machine back down into the abyss, hotel staff repositioned the sunbeds and after a few minutes there was no evidence we had ever been there. I was so pleased at the results, everything

looked perfect, even better than I had imagined. For Angela (now looking even more stunning, casually covering herself with one of my white shirts) and I, a short stroll back to our own hotel along the boulevard for a well-earned celebratory drink (or two) – it was lunchtime the next day before we appeared from our hotel room

The resulting photograph – fabulous, it was worth every minute of the three days setting it up. A photograph that needs no caption – it told its own story – this result is the ultimate and perfect photograph for any photographer (see photo page 66). Even today I still regard this as one of my top favourite and most beautiful photographs – a photograph when Beauty certainly did beat the Beast.

## Three for Vegas – and only two go

Freddy Laker was due to fly in the next day and Uchitel had left a message with the hotel reception asking me to meet him with the Mayor at his office, I obviously thought it would be to discuss our meeting with Sir Freddy Laker.

I kept thinking nothing could surprise me anymore with Hi Uchitel, well I was about to receive yet another of what the Americans would call a 'curve-ball'.

With the grand inaugural flight, with all its pomp, razzmatazz, ceremony, speeches and backslapping arranged for tomorrow at Miami Airport – Hi Uchitel and Mayor Meyerson would not be in attendance. Instead he announced they were flying over to Las Vegas and would I like to accompany them, two or three nights of some special fun was put forward as the only reason.

All our expenses would be covered, plus we would receive a special credit card, which would be in credit, for use on the Vegas tables.

We would be looked after in every-way by his 'associates' over there, 'everything' (emphasised twice) would be available to us, added Uchitel, with a smile so big that it would light up Blackpool.

"But I can't" I spluttered, "and what about Laker tomorrow, the *Sun* expects me to have at least managed to get a few photographs of him?"

Both Uchitel and Mayer Myerson looked at me with puzzlement, as if they had offered someone the Holy Grail and they had just refused it – possibly in reality this was what I had in fact just done!

Over the years I have thought of my reaction, my decision, a million times over.

Even though the invitation included Angela and myself for a fully inclusive trip to Vegas, both men were obviously still thinking that it was all slightly strange, considering what they were offering me and that I was turning them down.

When I arrived back at our hotel Angela's immediate thoughts were, I should have said yes! Angela still to this day saying we should have gone! But at that time alarm bells were ringing in my ears, this offer was so over the top, so generous that probably during the entire length of my life I would never be able to reciprocate this gesture.

I worried what was to be expected in return from me, I was so concerned at who or what they thought I was, what power or help I could ever offer if asked. Plus, the worry that I could have been swallowed up and easily lost in this elite world of the 'movers and shakers' of Las Vegas, those who control the underbelly of the famous gambling state. That I would have no control over any situation in Vegas and having so little to offer in exchange was the deciding factor – I had made my excuses of having to stay in Miami to see Freddy Laker the next day – both men looked on me I am sure as a huge disappointment. And that as they say, was my worry – just what did they think I could bring to the table?

## Sir Freddy and the missing Mayor

Next day it was the arrival of Sir Freddy Laker, Angela and I had travelled to Miami Airport with all the necessary press passes and invitations to allow us to have total access to all areas. Anyone who was anyone was there (except of course, Hi Uchitel and Mayor Meyerson), the high society of Miami had been wheeled out for this auspicious occasion. Millionaires, dignitaries, the very crème de la crème of Miami was here, Laker was the man of the hour, everyone's hero and the man you must be seen with. Inside the airport one of the huge arrival lounges had been made into the official reception and party room, with the Lakers jet being brought up to dock right in front of us all, filling the floor to ceiling twenty-foot high windows, all highlighted by huge search lights, it all had a surreal effect.

Waiters scurried around between the swelling crowds offering everything

from exotic cocktails to mouth-watering delicious canapés, gentle music flowed in the background by a talented pianist.

For Angela and myself, getting an exclusive photograph of Sir Freddy Laker, let alone an interview, was now looking less and less likely, the queue of press and dignitaries waiting for him was growing longer and longer.

Someone was tapping at my arm, I had just a second earlier turned down more drinks from a waiter, so was about to insist he leave me alone when I turned and peered into the face of a smiling man in uniform wearing a Laker Airways badge.

"Hi, Ken, Angela, Freddy would like to meet you."

And that's how it happens in Miami! We were walked to the side area near the windows filled with the giant Laker jet, literally parked inches from the glass, still all lit-up and still the star of the party.

Freddy Laker, with hand outstretched was there to meet us, "Hi Guys, nice to meet you, call me Freddy."

A firm handshake from Freddy for myself, followed with Freddy taking Angela's hand and giving it the royal kiss – all with camera flashlights lighting us up and attracting all eyes to our area. Freddy had his own photographer to witness and record the scene, which had brought the attention of other press photographers. We the hunters, were now the prey!

An amazing situation where our names had been passed down the line to Freddy Lakers people from The Mayor or Hi Uchitel? Obviously one of them, or both, a great result, all of which surpassed our highest expectations.

During the next hour we talked to Freddy, slowly moving around, working the room, as if we were his personal escorts.

Angela and I had several occasions to look discreetly between ourselves, especially when Freddy mentioned his pride at being about to receive the Golden Key to the City of Miami Beach. Freddy explaining that it is to be presented by one of the Mayors lieutenants, City Director Zeke George (someone who we had ourselves become very friendly with over the past weeks), explaining that unfortunately the Mayor who was scheduled to present the Key personally was ill and could not make it tonight?

Nearing the end of our meeting, Freddy asked when we were returning to the UK. Having not dared take Hi Uchitel up on his Vegas trip I had settled for the next flight home, which was now scheduled for the next day. Freddy laughed, "After tonight's party, which I am told is to go on until the early hours, surely you're not envisaging trying for an early morning flight?"

Without waiting for our answer, he waved over one of his assistants, "Arrange two tickets on our next two flights to London, make sure they are sent to Ken and Angela's hotel tomorrow." At that he turned to us saying it would give us a day or two to rest-up after tonight's party, we simply had to decide what day we wanted to fly home and turn up for the flight – all done.

## Time to go home

We took Freddy up on his offer, enjoying our final evening at one of my favourite restaurants, Place for Steak, feasting on the most delicious and truly largest giant silver platter of giant 'crab claws on ice' I have ever been privileged to be served. Accompanied with several bottles of the most superb wine, we admittedly left the restaurant a little shaky. As Hi was not around, rather than a limo we expected a taxi would be arranged for us (obviously all on the restaurants account). This time however, never forgetting that nothing is normal here, plus keeping in mind the non-stop generosity of our host (be that he was away), his chauffeured Rolls Royce was waiting to take us back to the hotel. This it seems being his last instructions before he headed for Vegas.

I never saw Hi Uchitel again, although back in London two weeks later I was advised there were several large packages from America that had arrived at Heathrow and they were awaiting my collection. Two boxes of clothes, including three very expensive handmade tailored suits – all a perfect fit.

Mayor Myerson, City Director Zeke George, Chuck the Motorcycle Policeman, plus so many others, what absolutely fantastic and generous people we met in Miami – and of course Mr H. J. Uchitel, a giant amongst men who we will never forget for the rest of our lives. All fantastic memories, but I must admit, I never watched the movie *The Godfather* in the same way ever again. After all, for a few short weeks, I lived the movie!

# 13

## BUNNY MANSION PARTY FOR
## ROCK IDOLS AND STARS

It was the most prestigious and glamorous club in London. A time when it easily counted the world's top millionaires and stars such as Sean Connery, Roger Moore and Jack Nicholson as its clients – with its logo recognisable throughout the civilised world – it was – The Playboy Club.

The top London club was famous for its iconic waitresses, the ultimate in glamour, the legendary Bunny Girls who dressed in costumes called the 'bunny suit' (inspired by the tuxedo-wearing Playboy rabbit mascot), consisting of a tight corset, bunny ears, a collar, cuffs and a fluffy cottontail. For the capitals jet setters, the trendy and the movers-and-shakers of the capital having a Playboy 'key' membership to this Park Lane Club and Casino was the highest achievement of status symbols. The proud owners of Ferraris and Aston Martins would eagerly cover their prestigious shiny cars with the black and white playboy 'Bunny' logo stickers. It became more of a life-style than just another club, it was the dream factory with its 'must have' restaurant tables and visits to the upstairs casinos being the ultimate way to impress friends, business acquaintances and the 'arm-candy' beautiful new girlfriend. Long queues stretching into Park Lane would quickly form on weekends, Playboy's restaurant tables were the hardest in town to book.

### Bunny Girls and a VIP Membership

In general conversation one day in one of the Fleet Street lunch time eateries I overheard in conversation that a new public relations girl had just started at the Playboy Club. No one else had taken any particular notice of this and the conversation just continued in general of who was doing what to who in the capital's world of journalism. But for me, commissioned to take Page 3 and 'Showbiz' photographs for the *Sun*, I would always keep in touch with anyone attached to the more glamorous aspects of London. So, a few hours

later with a quick telephone call, I made my introduction to the new Playboy PR, with an invitation to lunch, which I immediately accepted – and I was there!

The new young female PR was keen to make an instant splash in her new job, (and of course all this glamour and lifestyle was perfect for the *Sun*), so we agreed to combine ideas. I was to be given the exclusive access to Playboy stories and to photograph the Bunny Girls, this would obviously give the club maximum publicity, and for me, an amazing 'in' into the glamorous world of this seven-story high park Lane Bunny empire.

Playboy was the top address in London, nicknamed the 'Hutch' and included a choice of restaurants, bars, a nightclub, casinos and of course apartments and suites which were available to Playboy's very special members.

My next meeting was to be with the UK Playboys boss, Victor Lownes, who although having the reputation of being London's answer to 'Hugh Hefner', was not at all what I expected. No flashy dress-sense, not even the sort of playboy jetsetter lifestyle attitude – he appeared the image of very much a typical businessman, sombre three-piece suit, softly spoken and always (when first meeting him), very, very intensely serious. Of course, this was Victor's facade, where in reality his lifestyle was every promiscuous bachelors' fantasy – a reputation he was acutely aware off and utterly delighted with.

Throughout our meeting Victor and I seemed to agree on most things and at the same time we recognised we both had the same style of dry humour, something that would keep our friendship going for several years. Satisfying Victor's initial worries and concerns, I assured him of no hidden agenda and that I was not looking to stab him in the back. Finalising the meeting we shook hands and I was from then lunched on an incredible journey into the world of Playboy. Within two days I was given a VIP membership, an introduction to the management, plus of course total access throughout the club. Even though Angela and I were already privileged with our press and modelling connections to open doors, the Playboy lifestyle was something else! This wasn't just another club! In London amongst the jetsetters, the rich and trendy, this was the ultimate, the dream factory and the little key emblazed with the Bunny Logo was for the few privileged select members, the true sign of being at the top.

After a while, having successfully achieved several Playboy features in the *Sun*, Victor Lownes invited me (Angela as my guest) to a special little soirée

at Stocks, the spectacular forty-two room mansion (which also doubled as the Bunny training camp), in Tring, Herts. This was obviously our first induction, our first trial acceptance, we were at last going to see the 'Bunny Palace', be it on this occasion, what Victor himself had described as a small-ish party for friends (obviously his dry humour coming to the surface once again). But whenever accepting a first invitation, you never know exactly what to expect, after all dinner with friends in our lifestyle would probably mean a group of ten in one of London's better restaurants, or if at a friend's home, then probably a group of six to eight. So we were cautious and as 'one does', we purchased the customary (very expensive) bottle of quality wine to take as a dinner gift and ventured forth.

## Proving the world is flat after all

Driving from Hampstead, we arrived in Tring early evening and slowly made our way towards the location of the mansion. "An awful lot of traffic tonight," was one of my comments to Angela as we studied the map and eventually approached within a mile of our objective

As we turned into the final lane, the approach to the mansion, it was like entering another world, we were shocked, intrigued and amazed. Straight 'down the rabbit hole again' we went, just as Alice chasing the white rabbit, we couldn't stop, forward and forward we went.

Huge searchlights were lighting up the early evening sky, Helicopters were circling, there were hordes of paparazzi being held away by a legion of security guards and police. As we arrived at the mansion gates, quickly showing our invitation from Victor, immediately we were waved through, paparazzi camera flashguns lighting up the interior our car. We were directed along the drive to the 'car park', an adjoining field with dozens of cars already parked. To the front of the mansion we could see four giant marquees with several hundred people sauntering around, suddenly one of the helicopters landed near to us as we parked.

"Alright mate, sorry for the scare," was shouted to us by the amused embarking passenger – Ringo Starr.

Embarrassingly, taking-in the situation, we left our 'customary bottle of quality wine gift' hidden under my jacket on the back seat, we took a deep breath, grabbed the camera, and ventured forward to join Victors 'little

soirée'! We were given badges to wear by one of Victor's trusted assistants, there was a colour coding, which allowed guests entry into different areas, ours covered everywhere including the mansion itself.

We had always asked for our badges issued at any of the club's special parties to say 'Press'. Although we were always invited and accepted as Victor's personal guests, we wanted to ensure everyone knew what the camera was for – although Victor when introducing us would always laugh and say we had his trust and to ignore the Press Badge. Whilst there was a huge presence of the national press at the party, they had seemingly been restricted with access only to the outer Marquee areas. I quickly realised we were the only member of the press granted 'access to all areas' (see photo page 65).

Angela and I ventured first into the guarded, strictly VIP marquee, where security and examination of badges was ruthlessly supervised, this was the ultimate marquee. No press (except ourselves) allowed in this the Hollywood Tent, as it was being laughingly called by The Who drummer, Keith Moon.

Immediately we bumped into one of Angela's friends who she had recently worked with, actress Susan George. Here it was drinks and conversations about the film industry, everyone politely pretending not to notice the grandeur of this spectacular and star-studded gathering, the buzz was amazing. It was like Christmas, birthdays and New Year's Eve all rolled into one! Actor Christopher Reeves (Hollywood's hottest star at that moment, already into production of *Superman*) literally bumped into us. Here we seized the opportunity of an introduction, and at the same time introduced him to Susan, who he had never actually met. This set off a group bonding for the night, with us feeling pleased with ourselves that we had brought together two stars of the silver screen. Our marquee had its own rock band with several of the Bunny's on stage singing and dancing. Drinks were unlimited, later it was calculated that over 800 bottles of champagne had been consumed during the party.

Could it get better we thought? Yes! As Hollywood superstar Dudley Moore, a friend of Susan's, joined in our group.

Our select group then went into the mansion itself, joining in with Ringo Starr, Keith Moon and Kenny Lynch. Another hot star of that era was Oliver Tobias, who was involved in the production of the film, *The Stud*, where he starred opposite Hollywood legend, Joan Collins, he also joined our group.

The party went on and on, for a young couple like ourselves (both from the industrial areas of the North East), this party was about as different as life

can get. Chatting casually to people like Ringo Starr was unbelievable, and of course Keith Moon really was like someone from another planet, he lived up to his reputation as the original party animal ('Moon the Loon' as he was affectionately known). One minute he was in quiet conversation, the next disappearing where I later found him with several of the female guests and Bunny's in the mansions huge private underground tropical jacuzzi, reputed to be the largest jacuzzi in Britain. Even here in the jacuzzi, with the party in full swing my camera didn't raise any concerns from the guests. (although I must admit the next day, I did personally censor some the negatives of the jacuzzi photographs).

During the party one of the more memorable (and controversial) photographs I took was of Anthea Redfern and Kenny Lynch. At this time Anthea was still married to Bruce Forsythe and this was during the period of reported troubled times in their marriage. On this night Anthea had arrived alone and for a while joined our group.

As I had mentioned earlier, I always wore a press pass, basically I was a photographer working then with the *Sun* and as a professional it is always difficult not to follow the scent of the chase, difficult not to follow a story that is happening right in front of your eyes.

Kenny and Anthea were down one of the corridors, under a stairwell enjoying a romantic embrace, and instinctively I snapped a picture, one opportunity, one quick click, one shot. After I took the photograph I turned and walked quickly away, around the corner back towards the main hallway of the mansion, but I could hear Kenny shouting and following quickly behind me. By then I had turned into hall, so I then did a 180-degree turn, walking back the way I had come, back towards the direction that Kenny would be coming from. Putting the camera out of sight behind my back and looking nonchalant, I literally bumped into a speeding Kenny.

"Did you see a photographer" asked an agitated Kenny.

"Yes" I answered, "he went outside."

Kenny followed in pursuit!

Two days later the photograph covered the whole front page of the *Sun*, this showing the couple in a romantic embrace, the newspaper talking of the troubled marriage and asking where had Bruce been that evening? Although to be fair to all parties, at the *Sun*, we decided to caption the picture that they were photographed 'dancing' together at the Playboy party, but the damage was still done.

It would be fifteen years later, now regularly meeting Kenny as friends at charity events in Mallorca before I showed him the cutting and told him my story – to which he laughed and said he had tried to find out for years who and how the photograph had been taken. For Kenny it was no problem, Kenny always had a bit of a reputation as a 'ladies-man' in London and as far as he was concerned the photograph had made him look even more a super-stud.

Throughout the party we mixed with the stars and had got on particularly well with Victor Lownes, to the point where at the end of the night he invited us to stay overnight and enjoy the hospitality of the mansion. The mansion had its own rules and pecking order – we were shown to the first floor, the guest rooms (for those specially invited – think 5-star hotel). Although we had heard the mansion also had a separate wing for the very elite (Hugh Hefner, etc.), these were the four-poster-bed executive rooms, with the mansion's top floor reserved strictly for the Bunny Girls (The Bunny Dormitory, as it was known).

It had been an amazing evening, an amazing party – the band's and entertainers, the endless list of celebrities and the pure scale of the logistics with so many bars, marquees, guests and staff.

On mornings for breakfast it was on a strictly help yourself basis, you wondered down to the huge Victorian-style kitchen (where many years earlier you would have imagined six or seven household staff and cooks scurrying around – think *Downton Abbey*) and if no one was there you just cooked what you wanted. Definitely self-service – bedraggled and bleary-eyed guests and of course the gorgeous Bunny Girls (the dress code stretched from those still in formal attire from the night before, to those simply wrapped in a towel, or even less), all mixing in. Toast popping up, eggs frying, bacon under the grill. And of course no breakfast would be complete in the mansion without the constant use of giant Bunny Fridge, full of champagne ('hair of the dog' and all that). All an absolutely hilarious situation with lots of sly and laughingly embarrassed looks fleeting between the male and female fraternity, it was an insight to a whole new secret world.

## Park Lane Club

Of course, all though these parties, newspaper work was the main priority, and with continuing access to the Bunny Girls and Playboy stories, everyone was happy.

I was now even being commissioned by the *Playboy* magazine in America to do the initial 'test photo sessions' in my London studio of any special girls they were interested in flying over to America to feature in their magazine (Playboy Playmates) – all very prestigious in the London world of photography – giving me amazing status in the profession

In my career there was always been an obvious conflict of interests, a conflict of loyalties (a bit like the Rod Stewart days in America), so a compromise has always had to be reached. Enough reportage and photographs to ensure you get the very best exclusives for your newspaper, but not too much as to invade anyone's privacy, in order to also keep your hosts trust!

Working on stories and photoshoots during the day at the Park Lane club with the Bunny Girls meant we were continually in and out throughout the week. With the status of our work and of course the top membership key. Angela and I were in the fortunate position that when we visited the club during the evenings, we could simply walk past the queuing crowds and enter unchallenged. Eventually we came to use the club as our local, this was the amazing lifestyle that we were able to enjoy there now.

## Mickey Mouse and the Footmen

Such was our relationship with Victor we were often invited to more intermate and private dinner parties at Stocks, although we had now got into the routine habit of asking Victor's secretary for the official number of guests who would be there. On this occasion we were assured it was a quiet dinner party for twenty (no camera, just come as guests), so once again we set forth, although since our first soirée, I never again entertained the idea of taking 'the customary bottle of wine' gift.

On this occasion, arriving at the mansion, myself all smart, suited and booted, I felt slightly conspicuous with the other ten guests who were all over casually dressed wearing everything from Mickey-Mouse T-shirts to way-out totally oblique designer fashions. Angela fitted in well, she had just

returned from modelling assignment for Slazenger in Kuala Lumpur and had a great tan, looked amazing and was dressed in a short white designer dress. Whereas I, in my conventional suit and tie looked more like the company accountant, so from that moment my 'smart' outfit was permanently ditched for any future mansion gatherings. The gathering was an amazing experience, all these way-out outfits (in my suit I felt like the straight man on a *Star Wars* film set). Yet in contrast to other guests dressed in way-out casual fashions, we were being served a superb five course dinner, each course delivered on silver under-plates, in the huge formal dining room, by waiters dressed in immaculate footman style livery, another eye-opener to the Playboy lifestyle.

Throughout the dinner party the conversation was on fashions, glamour and designs – this was the collective group, creative people with interests in publishing, retail or the arts.

This was also the first meeting we had with Marilyn Cole, an amazingly beautiful woman who had been *Playboy's* first ever full-frontal nude centrefold, this naturally followed later by her being named the first British 'Playmate of the Year' (Marilyn was one year later, 1985, to become Victor's wife). This had been a particularly enjoyable evening, and yet again we were offered the hospitality of the mansion – although on this occasion we found our status had been elevated – Angela and I were shown to the elite wing, one of the Hugh Hefner's executive suites. This was as far as 'making it' as you could get, the invitation to join the very top was even for us exciting. Angela and I trying desperately not to throw a huge smile or show how really impressed we were – cool, that was the way to react – although I am never sure how much of the excitement and joy we managed to hide. The rooms were huge, suites with even a small glass fronted fridge full of champagne. Totally luxurious with a touch of exotic Hollywood, even gold taps and monogrammed wallpaper in the bathrooms. The room centrepiece being an absolutely incredible four-poster bed with a mirrored ceiling – all very adventurous I suppose. Several other guests stayed over, and the elite wing had its peppering of Bunny Girls who seemed to be continually walking around the corridors. Angela and I looked at each other and laughed – but as they say, when in Rome!

## The death of a Bunny

Months later, after another evening soirée it had been arranged that the following day back in London I was to have a late lunch with Victor at the Club. There had been several hints thrown around during dinner about other projects which were coming-up, I certainly thought my dealings with the Playboy Corporation were about to escalate on a major scale.

Arriving at his office at the Playboy Club I was stunned to be told that lunch had been cancelled, there was also a strange awkwardness and silence from his secretary, even to the point that she looked upset. "Ring Victor tomorrow," was all she could say.

At home, early evening, Angela and I watched the six o'clock television news – the main story of the day was that Playboy Supremo, Hugh Hefner, had today sacked his Vice President Playboy boss, Victor Lownes, the highest paid executive in the UK!

Over the following weeks it came to light that Victor had been accused of irregularities by the British Gaming authorities. Hugh Hefner had panicked and without giving Victor a chance to sort things out, immediately sacked him. It was always said that Hugh had used this as an opportunity to get rid of Victor and there had always been rumours that he had become jealous of Victor's success and popularity. Also, earlier, an embarrassing situation for Hugh that he never forgave was when the two Playboy giants had both competed for Marilyn Cole's affections, Victor having succeeded in winning her heart!

Here fate took a punishing hand towards Hugh Hefner. The British authorities had always been uneasy with foreign controlled casino's operating in London, now that Victor was no longer in charge here on British terra firma, and as the casino was now being controlled from America, the Playboy gaming licence was immediately revoked and the American Playboy Corporation lost their most valuable financial asset – and possibly the true genius of Playboy – Victor Lownes.

## The Playmate Bunny photograph

Victor, later having proven he had done no wrong, was exonerated – proven innocent of any misbehaving or of breaking any rules. As part of a settlement

from Playboy he retained Stocks mansion which we continued to visit. Victor had now opened his own smaller nightclub on the Kings Road in Chelsea, named after the mansion.

A while later, Marilyn Cole was doing a feature for a Sunday Paper and had asked especially if I could be the photographer. It was a simple brief, Marilyn was an enthusiastic horse rider and the photographs were to be of her in her riding outfit, with her favourite horse.

On arriving at Stocks, Marilyn was already suitably dressed in her riding outfit (always a professional) and looked stunning. We spent an hour or so in the paddocks taking the photographs and then she suddenly broke into a huge smile and laughed, saying "Let's do something special." The horse was handed to the groom, and we walked back to the mansion.

Marilyn simply said, "I'll meet you down in the jacuzzi". I was probably the only photographer ever to be trusted in there, even on the occasion of parties I had always took my camera. It's a great fun place, but far too steamy and confined for a proper photoshoot. Nevertheless, not knowing what we were going to do, I started to set up the tripod and camera (on this occasion a cumbersome Hasselblad camera with a long one-fifty lens).

It was to be about half an hour before Marilyn walked in, she was totally naked, carrying a tiny piece of cloth attached to string which she fastened around her waist – she looked amazing. Although it had been a few years since she had been the 'Playmate of the Year', at 35 she was still strikingly beautiful. Even for me it was a surreal moment, the mist rising from the jacuzzi and filling the whole room with a white cloudy haze, with this gorgeous woman, totally naked, walking slowly towards me. Although not needed, as some form of approval I simply looked at her and smiled. We sat and talked for a few minutes on what we wanted from the shoot and I started taking the photographs. I always felt that Marilyn had thought this through earlier and decided now was her opportunity to show the world that she was still here, and still a very glamorous woman.

On eventually arriving back at the newspaper editor's office, I produced a polaroid of Marilyn's jacuzzi pictures which I had taken as a test at the start of the shoot. The polaroid was enough to make everything else come to a stop. Although the newspaper had already conducted an interview with Marilyn by one of their reporters, the photographs I had taken were to have so much impact that the editor, Eve Pollard, picked the telephone up immediately telephoned Marilyn and said she wanted to change and expand the

interview. This she said was to justify Marilyn's amazing photos, that she now wanted to make it a much bigger feature, and that she herself would come to Stocks the next day. This was the first time Marilyn had done such revealing photographs since her *Playboy* stardom, she could have asked for a massive fee, but no! She had obviously decided in her own mind that this was the right time, that she had the opportunity, the correct location and most importantly for her, the right photographer – for Marilyn, this was far more important than anything else. Of course, the paper seized the opportunity to use the photographs big, they quickly turned our photo session into a two-week feature, with my photographs having a front-page lead with a centre spread on the first day, and then used throughout the feature over the following weekend.

My very last visit to Stocks involved another jacuzzi shoot, this time to photograph Victor Lownes himself for a health and lifestyle article. To accompany Victor in the jacuzzi I had booked two Page 3 girls, Linda Lusardi and Monica Thimme, this session was the last I was to do with Victor and marked the end of an amazing era.

A year later Victor gave up Stocks, it was an extremely expensive property and grounds to maintain, and subsequently he and Marilyn moved back to London to live.

Now all distant memories of a past life – the end of an amazing era – the days when 'The Playboy Club' ruled the world.

# 14

## A NEW KING OF CLUBS AND
## THE HOTTEST DANCE

I was still working with Victor Lownes and Playboy when I first met Peter Stringfellow, this at a rather grand charity event in London. He reminded so much of Victor Lownes, Peter had the same showmanship and the same air of confidence. Whilst he didn't have the American smoothness of Victor, he did project that extra pinch of pixie-dust and was always ready to flash his trademark amazing smile. He was already going under the banner of 'The King of Clubs' (a monogram given to him by the British press) and with his years of experience he was clever enough to know how to cultivate and develop friendships. After our meeting I was invited along to his club, given VIP memberships and from this point on, although we didn't know it at the time, our paths were to cross for the rest of our lives.

A few years later with the Playboy now diminished, Peter's club offered one of the few genuine respites for weary celebrities stranded in the middle of the city. The club mirrored the elegance of the Playboy, but in a much smaller scale and without the casino. Velvet-ropes and red-carpet pavement entrance with immaculate formally dressed doormen, all welcoming in the rich and famous. The interior decor obviously over the top, but it was supposed to be just that, you could literally feel you were in somewhere special as soon as you walked through the door – somewhere you would certainly talk of having visited the following day.

His clubs continued success led him a few years later to reopen the previously famous London cabaret club, Talk of the Town. A giant landmark on the edge of Leicester Square. Peter opened it under its original name, *The London Hippodrome*, the launch being a hugely glossy star-spangled affair, the old building had been amazingly transformed, totally renovated and restyled.

The opening night became the 'must have invitation' of the season and on the night the stars flocked to this newest venue.

For me, covering these showbiz events for the newspaper features

department and now being a full time guest of Peter's was perfect – Bruce Forsythe (who I had just weeks earlier worked with in Miami) and his wife, ex-Miss World, Wilnelia Merced, were the first to pose for my camera. It became an evening for the popular television stars to join in with London's top society, everyone was there – the jet set of London was on parade, unlimited photographs.

There was an amazing cabaret on stage, with drinks and canapés passed around continually throughout the entire evening. The behaviour of two particular star guests kept the whole place in hysterics, Freddie Starr and Bobby Ball. Freddie paraded around with a near naked girl perched on his shoulders for most of the evening – my photographs of the night filling the newspaper for several days.

Everyone who was anyone was there, strutting their stuff on the dance floor or simply sat people-watching from the balcony of this amazing former theatre. Stars of showbusiness, fashion, sports, the arts, models and politicians, all were there, eagerly rubbing shoulders. You must remember these were the days before camera phones and instant social media – so other than the discreet photographer such as myself, the beautiful people were free to indulge themselves.

## Hottest dance in the room

Besides working for the newspapers and covering several stories with him, Angela and I constantly visited both of Peter's clubs as his personal guests. There were several memorable visits, on one occasion when Angela (just back from a modelling assignment in Israel) and I were dining with Peter at Stringfellows, famous for both its superb restaurant and the amazing girls that offered table dances for guests (at a price). One of his most stunning lap dancers (who weeks earlier we had been out with on Peter's boat in Mallorca) approached our table. Thinking the dance was to be for me, I shyly tried to stop the approach – but the dance wasn't to be for me, the dancer having a great sense of humour had targeted Angela, who was by then a top model and appearing regularly on television. I have never before witnessed a whole restaurant come to a stop, to go into a total silence mode, as every clients face turned towards our table. All watching as the Stringfellows dancer did an amazingly sexy close-up routine to a very glamorous looking Angela. Clients

who even had their own dancer at their table stopped them and watched our table – a girl doing a sexy semi-stripping routine dance for another girl back in those days was, believe me, something very, very hot.

Of course, back then Peter Stringfellow was still in his 'Playboy' mode and living the dream in his Mallorca villa or on his boat, always having several beautiful female companions with him (think Hefner and Lownes) from his London club – he would live the party life between Mallorca and Ibiza. His boat was an open speedboat style but with a cabin for a sleepover, it definitely wasn't the biggest we would regularly visit in the Mallorca port of Puerto Portals. Add to that his not over competent navigation skills, the joke amongst the boating fraternity became that when he first started sailing, if he went from Mallorca to Ibiza, he would sail mid-morning, so that he could follow the car-ferry.

We worked with Stringfellow many times, on one occasion taking photographs over four days when he recklessly dipped his toe into the music industry, backing one of his earlier Stringfellow Club girlfriends, Lucy, who wanted to become a singing star. A big budget production video involving a helicopter and super sportscars, plus securing her a place at the mega club BCM for her first live performance – Stringfellow would always put his heart and soul into anything he did. Unfortunately, on this occasion, it was not to be one of his best investments, eventually he lost both his investment and his asset.

We also became good friends with Peter's older daughter Karen, who I had photographed several times in our studio. An example of the social side was when one evening, with Karen, Angela and I set off from Stringfellows after having dinner to walk over to The Hippodrome. Karen had rung ahead to let the reception know we were coming, which was just as well as the whole of the Hippodrome frontage was absolutely packed with hordes of eager clients all queuing to get in. On seeing us approaching, eight doormen hurried out making a corridor for us to get through and enter the club. Once inside, again finding it packed we were wondering where could we sit, but just like one of the old cowboy movies, the doormen moved forward and a top table at the balcony was instantly cleared of glasses and bottles – plus the somewhat bewildered clients who had been seated there.

As with the Playboy, it was always a working relationship and the snippets of celebrity news and the many photographs of Peter's guests and girls kept the newspapers happy.

## The end of a dream

Peter Stringfellow throughout had always held his professionalism to the front, of course like any showman he had his own special ego. He certainly was no saint, but he was a nice guy who was easy to like. He always reminded me of Virgin's Richard Branson, who I also worked closely with, totally committed to his business and always without doubt one hundred percent a showman, a man who could front any business and always made sure that this was exactly where he was positioned – at the front.

Over the years I probably met and photographed most of Peter Stringfellow's 'favourite' companions, and there has never been one that I didn't think was a 'nice' girl – over the years I probably took hundreds of photographs.

Meeting Bella in 2000 and falling in love was probably the most profound moment of Peter's later life, the timing was perfect. He was noticeably getting tired of the playboy lifestyle and now aged over sixty, a quieter life certainly appealed to him, the ladies' man, the philanderer, and lothario was to become the family man.

In Mallorca, on what was to be a very special day, he telephoned me (like Peter, we had also made Mallorca our second home), asking us to pop over to his villa, "Bring your camera," he laughed "I have a special photograph for you to take."

On arrival, a beaming Stringfellow and Bella held hands as they stood in front of us and announced their engagement – Bella (as always, looking beautiful) holding out her left hand proudly showing us the ring – giving us the exclusive. There were many other examples of photographing his special days, an invitation to his big sixty-sixth birthday where the theme in presents from friends was sarcastically more to do with his age (never sure he totally enjoyed this accolade). Long-time friend Robert Winsor presented him with a 'walking frame', complete with a huge fancy bow and balloons. Angela and I gave him an oversized specially printed one-metre size senior citizens 'bus pass', again with Happy Birthday balloons attached.

A while later, for the birthday of their daughter Rosebella, he held a small but lavish birthday party at the Mood Beach Club in Mallorca where he once again invited us – and please bring your camera for some special pictures.

We worked for many years with Peter, both as friends and as clients, so many photographs and so many stories.

# 15
## GETTING FIONA FULLERTON
## BETWEEN THE SHEETS

Actress Fiona Fullerton was one of the hottest actresses around, having just being seen in a bath full of bubbles with James Bond (Roger Moore) in the hit 007 movie *A View to a Kill*, she was certainly one of the most in-demand and glamorous women of the moment.

So casually talking to an actor/model I had met on another shoot, Brett Sinclair, he mentioned how he had just finished shooting a small part in a movie working opposite Fiona, I suddenly had another of those eureka moments.

Bret was eagerly looking for publicity, he was soon to go over to Malta with Donald Pleasance plus a group of glamorous models (the models, I was assured by Brett, I already knew) to work on another movie in which he was to play a tough-guy hitman.

So, from this, my mind was already in overdrive – a movie on location with Donald Pleasance and a bevy of beautiful girls, (which a month later all happened, an absolutely amazing week). But for now, today, it was the immediate possibility to hook Fiona Fullerton for a photoshoot that I concentrated upon.

As an ambitious actor Brett was obviously keen on any chance to further his career, so when I suggested the chance of a publicity shoot if we could somehow arrange to get Fiona with him, he immediately took up the challenge. The following day I was working with the *Sunday Mirror* and mentioned to the feature's editor about the chance of the Fiona Fullerton showbiz style photoshoot – Yes! definitely, without doubt was his reaction. So later telephoning Brett, I found he had already followed up my idea and called Fiona's publicity agent, having done most of the spade work by selling the idea, it was only for me to now add the little bit of pixie-dust, casually telling Fiona's agent how I liked Brett's idea of the shoot and we had the full backing of the features editor for a showbiz feature.

The agreement instantly reached, a two-hour photoshoot promoting Fiona

with the actor Brett Sinclair, job done with a day and time entered in my diary.

One-week later Fiona and Brett arrived together at my studio, Fiona having a makeup artist, plus a stylist who was forever ferrying huge plastic suit cover style bags of fashion items into the studio. Brett bringing a white suit and shirt on a hanger and carrying a brown suitcase.

The idea and theme of the shoot (from Fiona) was that she had been able acquire a top range of designer dresses and accessories, which she would obviously wear in the shoot. Brett posing with her in a white suit playing out his signature tough hitman acting part, posing with several different guns and sniper-rifles which he had borrowed from the filmmakers props department (remember the brown case).

Now normally this would be good, even an excellent result, but I had seen Fiona already in several magazines in this style of shoot and thought mine could just look a little repetitive, a set of photographs that whilst nice, was not exactly going to set the newspaper world alight! Nevertheless, for one and a half hours we took photographs that would have no doubt happily graced the pages of any top London fashion magazine or newspaper. Fiona looking absolutely beautiful, with Bret portraying his part well as the macho-man with his arm around the girl's waist, gun in hand – all great, but predictable and very stereotyped.

Eventually we all agreed we had exhausted every fashion item, concluding that the shoot was finished, everyone looking pleased and starting to pack bags and boxes.

"Just one more idea," I hesitantly called out as Fiona was walking back into the dressing room, "Can we try one more quick idea, everything has looked so superb and stylised, so can we just try one quick alternative, a quick casual photo."

I was trying to look as if the thought had just come to me at that moment, whereas in reality, it was my master plan, something far more revealing and certainly very different than the designer fashion photographs.

All eyes were upon me – "What are you thinking of?" asked an enquiring Fiona.

At this (holding my breath) I held up a folded white bedsheet, holding on to one corner, I casually let the remainder unfold as it tumbled towards the floor.

For a couple of seconds I waited for a reaction, no body moved or spoke, all

eyes on Fiona. I injected immediately that I thought that something casual, rather than all the upright fashion stylised pictures, would be a good addition to the set, we could have Fiona laying down with a bare-chested Bret laying slightly behind her. Adding that Fiona would be covered by the white sheet, this all on a white base and white background, a total white-out, without any other props or fashions, their skin tones injecting the only hint of any colour

I could see Brett immediately liking the idea, a smile he was trying to hide appeared on his lips. Fiona's reaction, a half smile, but I could feel she did want to play this out, just to see where it would go.

"I will do a polaroid first, let's just see if we all like it?" I quickly added.

"OK," answered Fiona, deliberately slowing down her words, "let's give it a try."

Gone were the dresses, hats, gloves, shoes, jewellery and accessories. Ten minutes later Fiona walked back out of the dressing room dressed only in white panties, arms crossed in front of her clutching a towel, covering her breasts. Whilst she was away, I had pushed onto the set a bed-sized plinth, this I had previously covered in a high-gloss finished white plastic, perfect for the whiteout effect I was after. I walked towards Fiona, passing her the sheet, which she used to cover herself, letting the towel slowly fall to the floor.

We talked of how we saw the picture, her position and that of Brett. Fiona was amazing, after one and a half hours she suddenly came alive yet again, full of enthusiasm as if she was just freshly starting the shoot. She positioned both herself and the sheet, initially it completely covered her, showing only her face with a slight hint of a bare neck and shoulder. Bret behind her, bringing himself forward as if to cuddle her – as if lying in bed, spooning, both facing the camera.

It took only a few minutes for Fiona's professionalism to click in. I had tried to look enthusiastic on the photographs we were now taking, but instinctively she also knew I wasn't happy, the polaroid showed the picture to be claustrophobic, awkward, over dressed and looked uncomfortably restricted. Adjusting the sheet more (or actually, to be less) at each click of the camera, Fiona pulled back and tucked in the sheet until it basically covered very little – she looked absolutely stunning.

For an actress who was continually quoted as saying she never wanted to be regarded as a sex object, that she was a serious actress and that she even wore a bikini in any supposedly nude movie shots, she became completely professional and totally uninhibited for my photographs.

Next day in the feature's editor's office, I made the presentation of prints, bringing them out of my folder one at a time. The fashion photographs were in essence very beautiful, but I watched the editor's face as I then started to show the glamorous bedsheet photographs. The reaction could not have been better – these photographs of Fiona were amazing; she was right there in their face. She had an amazing sexual presence and it screamed out at you as you looked at the photographs. The paper used one stretching it across a two-page spread, using it immediately the following Sunday.

The biggest accolade was still to follow, when the editor of papers Sunday supplement telephoned me to ask if I had the session covered in colour – Yes!

It seems that they had earlier commissioned a photographic session with Fiona using one of London's top photographers who had also taken a set of photographs. All of course were beautiful I was advised, Fiona in a range of designer dresses and accessories, but dare I say all to very 'predictable and very stereotyped' – certainly for me very déjà vu.

The Sunday supplement agreed terms with me to purchase my entire colour set of the Fiona bed-sheet photographs for use over their next two issues, the first being used as a double-page centrespread.

Out of the two-and-a-half-hour session with Fiona, never once did any publication ever choose the Fiona fashion photographs – the bedsheet photograph being used constantly over the following year or two.

# 16

## COME FLY WITH ME, THE ROD STEWART TOUR

*Just where do you start on explaining one of the biggest career opportunities of your life – a dream that came true, an assignment that you could never comprehend, one that even the very top newspaper staffers were begging for – The Rod Stewart American concert tour, a journey that was to start in the heart of Hollywood.*

It was another of those days when you find yourself happily enough toddling around in the studio creating a set of glamorous fashion photographs for a Sunday newspaper, when suddenly the telephone rings. You announce to the models and stylists it's time to take a break, everyone quickly taking the opportunity to leave the set and pop back into the dressing room, a readjustment of makeup or a quick cigarette outside.

For myself, I answer the telephone, a welcoming distraction for a few minutes. It was one of Rod Stewart's management people commenting on how Rod was very pleased with our encounter a few months earlier in Paris and how Rod would be happy to work with me again. Of course, I immediately lighten up and join in the banter of how I was more than a little happy myself working with Rod, pushing and excitedly trying to get through the maze of the conversation to find where this was all leading.

"So," came the slow and drawn out conclusion of the telephone call, "Rod and all of us thought you might like to link up again to do some more publicity photos."

Here I must admit, and to be very truthful I cannot really remember my exact reply, but of course trying to sound cool (as was the way in those days), I simply said it would of course be fantastic to link up again.

"When is he here?" my first question.

"He isn't," the reply – "that's the point Ken, Rod's starting his American tour in a couple of weeks and wondered if you would like to cover the rehearsals and join him on the first leg of the tour. That will mean you obviously

prearranging the financial backing of a major newspaper by offering the first exclusive to cover the initial tour launch and of course you (and your reporter) are invited to come out and join him for at least two, probably three weeks."

"Where's here?" I struggled to get out (still trying to act cool).

"Los Angeles, here in Hollywood mate, pack a bag and we will see you soon, ring me tomorrow to settle dates."

The phone went dead, I tried to saunter back to the camera and nonchalantly asked the models to come back on to the set so we could resume the shoot – my feet not touching the floor and my heart bouncing all around the studio.

The photo session finished, during which my mind had been racing over which newspaper would be best for me to approach. A Rod Stewart exclusive was no problem to get backing for, but loyalty was the focus and recently I had developed an extremely good relationship with the *Sunday Mirror* feature's editor Robert Wilson. We got on well personally and he had certainly looked after me with several commissions and assignments that had been passed my way.

Next day, this was probably one of the easiest business meetings I have ever had.

"Wait there, pour yourself a coffee, I will be five minutes" said an excited Robert Wilson after I detailed the feature I had been offered. True to his word, within minutes Robert joined me back in his office with total agreement from his editor and with the newspapers top showbusiness reporter in tow, a reporter who I knew well and was easy to work with.

Everything was agreed, they to get the 'first use' exclusive and absolutely everything would be financially covered by the paper and of course a guaranteed fee for myself on my return.

A few phone calls later, a delighted acceptance of the deal from Rod's people, seemingly especially pleased that I had gone to the *Sunday Mirror* – perfect was their answer. Job done, a few meetings with the show business reporter and editors and we were ready to be on our way!

But of course, nothing ever runs that smooth, as always, problems! A few days later I was hastily called back into a meeting with Robert. The showbusiness reporter had just been found to be a little overzealous with his recent expense claims and the editor had set the punishment for him by curtailing any foreign trips for several months, a replacement had been wheeled out to join me, a reporter whom I had never met.

Of course the showbusiness reporter was mortified to lose this top assignment, appeals were made, even a little begging was tried but the editor wouldn't waiver – my new compatriot was reporter Tony Frost who I quickly had to bring up to speed and hopefully bond with – time would tell!

This was my first 'big' trip, bags packed and my very basic assortment of cameras, my Nikon F2 (Photomic head) and the Nikon FE as my backup were readied. I did have better, a two and a quarter inch frame Hasselblad with a beautiful 150mm lens. Probably the world's top camera, unfortunately very cumbersome and certainly not a camera you could use on the run, and from having worked with Rod previously in Paris, he was certainly not the guy who would give you the time to set up a tripod and ready your camera. So, it was down to 35mm Nikon, photos to be taken 'on the hoof' as it were – a week later Tony and I were on our way.

Tony and I more or less hit it off, he was amiable but projected a sort of awkward seriousness in his approach, although he did seem sincere enough. We were both there for the fun of this amazing trip, but obviously both knowing that we had to bring back the bacon.

Hotels and flights had been booked and paid for by the Robert's secretary, who was now to be our contact throughout the trip, we had drawn £500 advance spending money each (massive money in those days), with assurances of more available as needed.

## If they could see me now – those little friends of mine!

There is something hugely exciting about assignments and flights like this, for it all to be paid for, all expenses covered, and you are actually getting a fee to do the job that in reality most people would do for nothing. This was something very apparent all though my career, photographers, backup teams and models all live this life – nothing else gives you an amazing buzz like this.

The flight was comfortable although we were disappointed not to get business class seats, the effect of the expenses problem at the *Sunday Mirror* still causing a crackdown on spending.

It had been agreed that on landing one of Rod's people would meet us at the airport, what I didn't expect was a uniformed chauffeur with a huge limo waiting for us. If ever in my life, there was the occasion to sing Shirley

MacLaine's famous song 'If They Could See Me Now' it was at this precise moment. Having my bags carried and escorted to the limo, with the chauffeur rushing forward to open the door (with one of LA's finest standing next to the limo, winking at the chauffeur as he helped open the door), I looked around. The airport was packed, and the limo caused a sensation being parked in a no-parking area. It was one of those occasions when you just hoped for, willing to die for, for someone to be there who you knew – but no! No one to witness a moment that I still remember so vividly to this day – O! If they could see me now that little gang of mine – from the back streets and alleyways of Middlesbrough!

So here we were, in blistering heat, in the city that we were assured lives up to its tag-name of 'The City of Dreams', sitting comfortably in the airconditioned stretched limo. Even with the chauffer assuring us the champagne in the rear seating area cocktail bar was for our refreshment, it remained untouched – such was the disbelief between Tony and myself of our immediate circumstances. We were to be driven to our hotel on Sunset Boulevard to drop of our bags, the chauffeur waiting and then taking us on to meet Rod who was in rehearsals at a huge auditorium venue in Los Angeles.

The venue was a colossus of a stadium, which the chauffer assured us, when open can take over 10,000, although on this occasion Rod was using it purely for his rehearsals.

As we walked through the labyrinth of corridors and rooms it suddenly opened out into a giant spectacular arena that seemed larger than the airport we had just left. We had entered at the stage end, seeing Rod almost immediately up onstage with the band and technicians.

"Alright there, bonny lad," he shouted jokingly across the expanse of the never-ending space that seemed to go on forever (obviously my northern-ness had come out more than I realised on our last meeting).

I quickened my pace to show my eagerness and commitment, matching Rod's enthusiastic welcome, we came together with a hug and with Rod patting me on the back.

"Welcome to LA, come and meet the band, although I think you met most of them in Paris."

Tony hadn't kept up with me and was trailing behind, showing less enthusiasm for the situation, his quietness and reserve coming to the forefront again. One thing I did learn from the Paris meeting is Rod expects your full input, your total enthusiasm. If Rod is giving you his time, he expects

one hundred percent of yours in return – and in the circumstances, I always thought it was not too much for Rod to ask – after all he is the 'star'.

I introduced Tony, they shook hands but there was no big smiles or enthusiasm from Tony, probably the wrong time for him not to show some reverence, as Rod certainly was under no obligation to make the first gesture. The events which were to follow and the later attitude from Rod to Tony I always felt were set in stone from this precise moment.

We chatted for a while, Rod basically giving us a quick idea of his schedule, with a free invitation to attend all the rehearsals over the next week, then inviting us to come on the first gig of his tour which was on to Greensboro, Carolina.

Even Tony broke into a smile now, this was amazing, for me even more so as Rod held me back quickly adding he expects me to be his shadow and that if we both play by the rules, I will get more or less everything exclusive. Assuring me that there would obviously be an army of press on the first concert night, but I would be the photographer at his side – little did I realise just how near 'at his side' this was to be, or what he meant about 'playing by rules'.

Any rumour or stories on Rod Stewart's amazing fitness you have ever heard, believe me, they are all true. Rod is a football fanatic and there is literally no place he won't start a 'kick-around' in any spare time he can find.

This was evident on mornings when Rod would suggest (which of course from himself is an invitation impossible to refuse) a kick-around in the stadium car park before beginning rehearsals – something I always felt was more an offer of friendship rather than anything else, to which I personally was more than willing to join in with.

During the second day watching rehearsals, with me taking lots of photographs, Rod came over and said they were having a day off tomorrow and that the band and a few mates where having a kick-around in the park, why don't I come along and join in, giving me the location and telling me just to jump in a taxi, adding it's only a few minutes away from my hotel

Rod, away from his family, has a wicked sense of humour (which was to get even more evident later on tour), so I was always weary and kept an open eye on anything happening. Certainly he is a man's-man in that respect, loving nothing more than the pub life with a few mates – playing the game (very much reminded me of the late Oliver Reed who when I knew him, would hide out away from wives and/or girlfriends, even sleeping the night in local pubs, totally playing it as a man's game).

Most evenings, after rehearsals, we would be invited to join the band at Rod's favourite bar, very English (or Scottish as he would say). Everyone, knowing his habits would know where he would be after rehearsals, (including his wife Alana) and while Rod liked nothing more than standing at the bar with his band and roadies talking of football, we all knew the telephone would ring as the time got late. He liked acting out the man caught playing away from his wife routine and so when later the bar telephone did ring, everyone would look surprised when it was laughingly announced by the pub manager that it was his wife asking if he was there, shouting so it could be heard over the telephone "Is a Mr Stewart here?"!

"Time to put the tin-hat on and go home," Rod would announce, as if being a naughty boy who had been caught up to no good! Leaving us all with a sullen expression, he would jump into his Porsche and drive home, waving goodbye to all, with a now huge smile on his face.

## Field of Dreams

The next morning, wearing shorts and tracksuit top, which I had just rushed out and bought, I jumped into a taxi, (I had arrived in America with just hand luggage, wearing leather jacket and jeans, these being the main uniform of any trendy photographer), so I hadn't counted football apparel amongst my trips wardrobe.

On arrival at the park, "Are you meeting residents here?" asked the driver (noticing my camera bag). The driver explaining that we were now in 'Hollywood' proper, which is all very private, even having their own police force!

"I am meeting Rod Stewart," I replied.

Hearing, "Yeah, sure" from the driver as the taxi drove away.

So, there I was, in what looked like a very ordinary green park area except for the huge mansion style size houses that surrounded it. No evidence of any eager footballers as yet, I moved slowly into the park area.

"Hello sir, can I help you," was the first voice I heard, turning to find a police officer stood blocking my path.

"Waiting for Rod Stewart," my reply.

"And you would be hoping to photograph him would you, sir?"

"No, playing football actually" I unconvincingly spluttered.

"Well then sir, perhaps you can accompany me to the station so we can verify all this, you see sir this is Hollywood, this is a private property area and the paparazzi are not the most welcome people on this private estate here."

The police officer placing his hand on my arm, the other on his holstered revolver.

At that I must admit I certainly felt like a trip to the toilet (being polite), my pulse rate was going through the roof and I was already seeing myself trying to explain to London why I was in a cell in a police station in Hollywood.

It was the faint laughter that first alerted me something was not right, just to the left there was some huge bushes and flower beds which was from where I could hear the laughter. I turned to the police officer who was also now smiling, a quick look back to the bushes again revealed five heads, Rod's and four of the band, all in hysterics – totally at my expense.

It took a while for the smirks and laughter to die down, admittedly me joining in, more with relief of what I thought had become a very difficult situation, rather than actual humour.

OK, one down to Rod – the band a few minutes later assuring me that type of joke was more an acceptance than a put down, welcome to the gang they laughed, all patting me on the back as if a long-lost colleague had returned to the fold.

And now the football, Rod had suggested a quick limbering up while we waited for the opposing team (a few of his mates). Rod changing his shirt, allowing me the time to photograph him, an exclusive set of photograph of an athletic looking Rod, stripped to the waste was a very good start to the day – although one of the band a few minutes later did mention Rod asked me not to photograph his mates when they arrived, just join in the game with us all was his comment.

And down the park I could see the group of Rod's 'mates' jogging towards us. Coming ever nearer and in now focus and slowly becoming recognisable. Five of the cast of the biggest hit series in the world, *Dallas*! It was totally unbelievable, like millions of other television viewers at home I had watched these people, this cast of the world's most popular television series were the super-stars of the screen, and there at the front I could recognise Larry Hagman, followed by Charlene Tilton. I looked back at my camera laying on the park bench – reminding myself that some photographs are not to be taken – after all I wouldn't have been invited if there had been any thought of my going against the 'rules'.

"Just for the football eh! Ken," being Rod's quick reminder as he run off kicking the ball towards our opposing team.

This was their park, their home and here I was having a kick-around with the biggest pop star in the world and with the cast of the most famous American series ever produced – O! If they could see me now that little gang of mine …

On my return to the hotel, every muscle in my body was aching, I was nowhere as fit as these people and I could now hardly walk, I rang room service for a steak-sandwich and stayed in my room for the entire evening trying to rest my totally wrecked body (spending most of the time soaking in the bath).

Arranged by Rod's own people, Tony and I were to go to Rod's house the following morning to photograph him and Alana with their children. You can always tell if some photographs you are taking are under duress and this was certainly one of those occasions.

Rod's management had previously agreed on all this and although Rod had been more than happy for me to snap away with my camera on other occasions, I could tell here in his home he felt we were now invading his personal territory.

We arrived at the gates, a sumptuous Spanish-style villa surrounded by eight-foot high walls in the middle of the most expensive celebrity real estate in Beverly Hills. We parked at the entrance and walked through the huge gates and up the sweeping driveway, passing Rod's black Rolls Royce Corniche, a red Ferrari and a Porsche, all parked neatly around the centre piece of his front garden and drive, a giant ornate twelve-foot-wide fountain. The Villa double doors opened, Rod's there smiling, bare footed wearing his trademark leopard skin patterned tight pants and a T-shirt.

He made no secret in telling us that we are privileged to be in his house, "It's my little bolt-hole and normally only my very closest friends are ever invited through these doors, as for press, you're definitely the first."

The hallway is a shambles, huge trunks and cases are part filled with literally dozens and dozens of personal items strewed all over the floor. Rod is about to leave home to go on a 50-venue concert tour for four months, so in his opinion, everything goes with him.

Rod's family join us, Alana and his two children, Sean and Kimberley. For a while the super rock star image falls away, Rod becomes the doting farther, clutching Kimberley and kissing her – momentarily freezing the pose for me to take a photograph.

Rod then cuddles Alana, the two naturally setting a perfect pose for more photographs. Tony was seizing the opportunity to try to add to the already brief interview time he had been given but as soon as the photography was over, Rod casually walked us into the lobby and out of his home, pictures were one thing but he obviously wasn't about to sit down and give a reporter any more interview time in his home – plenty time on tour Rod added.

With rehearsals now finished and Rod satisfied, everything needed for the concerts was being labelled, numbered, catalogued and being meticulously stored in the line-up of five huge trucks which were to take over forty tons of equipment and most of his forty concert staff of technicians and roadies all around America.

Rod's tour was about to start, and Tony was still concerned about the lack of content for his article. Although Rod had been amiable and certainly answered any questions, the fact there was little or no camaraderie between them was showing, no depth and no inner stories were being revealed.

Tony consequently hatched a 'devious plan' to gain him more time with Rod and rang London, desperately telling the paper that Rod had personally asked us to join him on his flight from Los Angeles to Greensboro. Whilst the crews of roadies and entourage were already driving through to Greensboro, Rod of course would naturally fly there, first class!

Our tickets were tourist class and the upgrade to actual first class was hugely expensive. I never actually knew the exact words or explanation that Tony gave but somehow, he managed to persuade London to upgrade our tickets – we were now joining Rod, in the absolute luxury of first class – well done Tony!

The flight had a connection and our first stage was subject to a delay, making our arrival for the connection possibly late. The thought of missing the second leg of the flight was unthinkable, as Rod's people made sure the airline knew.

Once on board we found ourselves seated alongside Rod but parted by the aisle. This was first class (real luxury first class, not business or premium, the seats are huge and only two abreast – luxury beyond belief).

As the stewardess, champagne in hand, was seating us, Tony was seated in the window seat, me next to him on the outside of the aisle, across from Rod. This obviously wasn't part of Tony's plan; he had to get seated next to Rod. But any attempts to persuade Rod's assistant, sat next to Rod, to swap seating was unceremoniously turned down. Tony leaned across me several times

attempting to engage with Rod but without success, so I suggested I swap with Tony, at least he would be nearer and try to get Rod in conversation. Rod obviously hearing this quickly announced he wanted to talk to me first about the concert and photographic ideas. Tony sat back, accepting for the moment our plan had been foiled.

Rod talked very briefly to me about the stage set up and possible photographs, then winked and said (distinctly loud) that he would now get a few minutes shut eye. Tony and I swapped seats anyway, so he was now just across from Rod and ready for the interview, perfect, except Rod slept throughout the entire first leg of the flight.

On landing it was evident we were late for the connecting flight, I was obviously worried, but Rod seemed relaxed. As the plane came to a halt the doors opened immediately with the cabin crew making a barrier near the door so Rod could make a quick exit. We quickly took the opportunity to follow close at heel, as we made our exit an electric cart was waiting for Rod with security staff in a second cart, Rod and his assistant jumped on, Tony and myself hitching a lift on the two backward facing seats.

We were raced through corridors and waiting areas, much to the amazement of the airports watching passengers and staff plus the waiting press and television cameras who had all gathered expecting a short interview – a few ran alongside in attempt for a few words, but our convoy sped along without any slowing down.

Finally, we arrived at the connecting plane, which had been held back just for us for twenty minutes (passengers having been told they were about to leave, just waiting for a flight departure slot).

The remainder of this second flight also proved fruitless for any interview, our seating now two seats behind Rod's. A total disaster for any interview, but a great flight and experience for me nevertheless.

The concert night was drawing closer, Tony had at last arranged a few interview times (so he was now in a more happy mood), whilst I had the freedom to roam around and take pictures as they set-up and did their quick final run through.

During the band soundcheck one of the roadies came running up to me, panting he spluttered with laughter that they were trying the 'curtain raiser' and that if I was very, very quick and got in front of the stage right now Rod thought I would get a special photo.

Of course, I run around from the dressing room area towards the stage,

just as I arrived, still on the run. The special space-age umbrella style curtain instantly opened revealing the band lined up with Rod who was stood at the front, wearing just a short white T-Shirt with his trousers drooped around his ankles. Everyone was in hysterics with laughter and without coming to a stop I aimed and clicked the camera – one click and the curtain closed – all within a matter of two seconds.

"Did you get it" Rod shouted out amongst all laughter from behind the closed curtain.

"Yes I did," I shouted back – "Shit," laughed Rod. But of course this was in the days before digital cameras and there was no way of knowing for certain, I couldn't go and get the film developed locally in case some enterprising darkroom assistant run off copies for himself and sold them to the American press, or even worse to an agency that would sell them in Europe – this was just one of the many problems from the days when all you had at the end of an assignment was a few rolls of undeveloped film.

During the day I had walked around the giant stadium, as far back as the cheapest seats. It was such a distance that from that view I felt it would be impossible to distinguish who was on stage – now I understand why they have those huge television screens.

## On stage with Rod and over twelve thousand fans

On the night we had been invited to go to the concert with Rod and his bodyguard in his limo, complete with all the glamour and prestige of having a police motorcycle outrider as our escort.

On the way there, stuck amongst all the other traffic going to the concert, one of the cars full of fans travelling alongside of us were so shocked to find themselves face to face with Rod Stewart that their driver lost concentration and not noticing that his line had come to a stop, crashed into the car in front of. No real damage and no one was hurt so it had us all laughing all the way to the stadium, Rod now purposely keeping his head down so as not to be recognised.

The limo drives us straight into the Coliseum Sports Stadium, reversing and manoeuvring right next to the stage. We all clamber out, Rod's in a good mood and we all go to his dressing room where he limbers up and does his stretches and exercises.

We peek into the stadium, its already packed, thousands of eager fans excitedly taking their seats, an amazing and truly electric atmosphere.

Rod's then manager and mentor, Billy Gaff (nicknamed Mr Twenty Percent), pops in to announce the stadium is a completely full, Rod has a sell-out concert for his first night!

The head security manger came in next to meet Rod for any final instruction and to talk though procedures and how much Rod wanted from them as regards to crowd control at the front.

"As long as they don't get on my stage no problem," was Rod's answer, everyone nodding their heads in agreement As Rod predicted there was a huge press area for the many expected photographers and as yet, nothing had been said about my positioning, obviously I was hoping for some special photographs of him in action. At that point, Rod looking at the security manager, put his hand on my shoulder and said, "This is Ken, he is my photographer, so I want him an 'all areas security pass', he will be on stage with me." No words can describe my feelings at a time like that and even Tony now seemed happy as he was advised he had a seat on the front row

Rod changes from his casual tracksuit into his stage T-shirt with the 'Cruel but Kind' logo across the front and slips into his trademark tight leopard skin pants, adding a striped blazer and sun visor to complete the outfit. To relax he has a couple of glasses of white wine, he listens to a few of his of his own tracks. He then goes to each member of the band, as would a football manager before their big game, embracing each of them – time to go guys, the band leave the dressing room and head for the stage.

Two minutes later Rod looked at me with a huge smile, "Now it's our time"

I actually don't think I answered, I just followed Rod out of the door and waited at the side of the huge stage – the band already playing Rod's introduction music of 'Give Me Wings', the crowd already sending out the most powerful and amazing vibes.

The noise was so loud no one could actually talk, everything was now being done by hand signals. Rod was ready, like a racehorse waiting for the final-off, his body already motioning in time with the music, his eyes focussed towards the band.

Although I would have thought impossible the music actually got louder, Rod moves to centre stage and in an instance the electronic curtain is opened and Rod is there with his band – the crowd go wild, never in my life have I

ever been close enough to witness such raw and delirious passion from so many people. Such reverence towards one person, one man on stage, one man that was now bursting into song with a band playing so loud with huge giant speakers seemingly everywhere. I was transfixed, at the side of the stage, I hadn't moved an inch since the music first started, total bewilderment, total admiration for a man I had been with all week, but to see him in this context was unbelievable. The many, many thousands of fans created a strong chorus for his songs, all there to idolise, worship and to crown their hero, Rod Stewart.

The elation, the adrenalin and the feeling of total excitement that comes over you is amazing – I was with Rod Stewart on stage in front of so many thousands.

Coming to my senses, I moved around the stage slowly taking photograph after photograph of the pulsating rock star, but it was impossible not to get caught up in the fever that was happening on stage. Rod's songs came from nowhere or so it seemed, the man was singing his heart out and the homage that was being returned from the audience could be physically felt on the stage, whether an aura or plasma, something was there, you could literally feel the music, the fans adulation, the atmosphere.

The fitness that Rod had shown in our daily kick-around was now evident and I now realised how important his exercise regime was, the stamina that he displayed was mind shattering. By the time he was halfway through the concert and belting out his fans favourites 'Hot Legs' and 'Tora, Tora, Tora' the crowd are truly memorised. The King of Rock could do no wrong, his disciples are in their King's Cathedral.

We now go into 'Tonight I'm Yours' followed by 'Young Turks', then on 'I'm Losing You' and the crowd were in the mood for lighters (these days replaced with mobile phones), there were thousands lit-up, waving their arms in unison in the dark – again one of the most amazing and memorable events I have ever witnessed.

'Maggie May' and 'Do Ya Think I'm Sexy', bringing the concert to its crescendo. Of course, there was the curtain call 'Stay With Me', but the concert was coming to an end – his fans still ready to give hours more adulation, but for their King of Rock, there is no more to give. For over two hours Rod had rocked, pulsated and crooned his heart out on stage.

The songs came to an end and Rod had always explained how once the last song was given, it ended there and then – 'Rod has left the building' coming to mind.

Rod still waving at fans, he ran down the side stage ramp running towards me, heading towards the limo, his bodyguard Billy, more or less covering his back, now virtually attached to him.

Rod rushed by, as he did, he grabbed me by my leather jacket, pulling me with him into the limo, the bodyguard now pushing both of us into it from behind. Before any of us could even sit upright, totally dishevelled, the door was slammed and the limo was speeding out of the stadium, complete with our police motorcycle escort.

## The most secret eatery in the world

"Good eh?" Rod laughed, "What a night, God I love to tour, and tomorrow it's hello to the rest of America."

I sat up in the limo quickly checking my cameras, the world speeding by, wondering where did all this come from, there was just Rod, his bodyguard and the driver plus myself! And I didn't even know where we were going.

We arrived back at the hotel probably even before the first departing fans had left the stadium, Rod explaining that the band will follow on to the restaurant they had booked, I was invited.

A quick shower and change in the hotel and we were back in the limo, on our way to one of the best restaurants in Greensboro.

Rod had booked a long table for fourteen, to include the band, Billy Gaff, several of the organisers and management plus myself. There was no sign of Tony and only when one of the band told me how Rod has never allowed any member of the press ever to join them at their 'after concert dinners', did I realise how special 'my' place was.

Everyone gave their food order, with bottles of wine being placed at intervals along the table. With non-stop chatter about the concert, who did what, what happened and when, there was just as much excitement around the table as there had been in the concert. I realised just how much time must be needed for everyone to come back to earth after the show, to settle down and unwind from what I had thought was the most amazing 'high' two-hour period I had ever witnessed. How they were going to live this lifestyle for the next month or two I could never understand, the highs on everyone's faces was so evident, no wonder they need a cool down period, a period that was to both shock and amuse me as the night went on (and on).

The meals had just been served and suddenly there was smiling on everyone's face as Rod stood-up at the table, the first hint of formality I had ever witnessed in him. Rod looked around at his guests, raised his glass –

"Gentlemen, the downstairs club."

Each raising their glasses to toast Rod's words, this followed by what I can only describe as a stirring amongst the guests. Each member seeming to gather their knives and folks and drink in one hand as they grasped their dinner plates in the other. I frantically looked around not knowing the procedure, not knowing what to do. I hesitated but followed suit, gathering all before me.

Each stood up, pushing their chairs behind them away from the dinner table, then witnessed (and followed suit) the most bizarre and unbelievable ceremony I had ever been part of!

Everyone at the table, their plates, drinks and cutlery in hand bent down and clambered under the table where they all sat cross-legged on the floor comfortably to eat their dinner.

This amazing sense of 'Alice in Wonderland' humour (as I called it) was obviously their own eccentric and oddball way of acting out this most amazing day. They had worked nonstop, probably had little sleep over the last day or two and had managed to excel in their profession to the extent where they had entertained so many people to such a degree that we were advised they were still applauding ten minutes after Rod and I had left the stadium.

One of the strangest restaurant moments that I was ever to witness during my whole career was that of the wine waiter crawling along the floor, bottle in hand, under the huge dining table which we were all dining beneath, with him asking, "More wine, sir?"

As the night went on, our group, still drinking under the table, were joined now by a few other enthusiastic restaurant guests, all too willing to join the fun. One was a particularly attractive brunette that obviously had interest in our star guest. It was obviously very dark under the table but in humour I had been flashing the camera off now and then at the band, fantastic pictures showing the bizarre humour of the event. After a few minutes, grappling in the dark Rod grabbed my arm, "Remember the rules Ken!"

This had become an unwritten thing between us, if ever Rod was unsure of a photograph that had been taken, I was to destroy it on his request. Obviously, Rod was unsure of what had been taken under the table, and understandably he was always worried how even the most innocent of

moments could be misconstrued. I assumed something to do with one of our new additional restaurant guests who had pushed in to join us. Rod had been amazing over the past few weeks and whilst I realised, I would now lose all the pictures from under the table of the band, I didn't hesitate to open the back of the camera and pull out the roll of film. Rod stretched the roll completely out of its tiny cylinder and wrapped it around his neck as a sort of trophy. Everyone looked towards me and smiled, each giving an approving nod – I had done the right thing by them – immediately the fun continued.

Being a professional I had immediately reloaded the camera and still managed later to photograph Rod coming from under the table, probably like all of us now a little under the influence, Rod being helped up by Billy Gaff. Rod had no objections to this picture at all, we were pals and I had done what was asked, to be fair this was the only occasion Rod asked for the 'rules' to be engaged and all through our weeks, these were the only photographs he asked to be deleted.

And so, the restaurant fun ended, and we all made our way back to the hotel.

## Cloaks, feathers and a wrecked room

It was our last night, home tomorrow, so I did have a strange feeling as I returned to the hotel with Rod and the band, there were no big goodnights or goodbyes from any of them. There were a few waves and comments like, it's been great to have you with us, have a good trip back to London, as they entered the lift – all leaving me feeling a little disappointed, I thought we had become better friends than that.

That's the time my first suspicions were getting to be aroused, it didn't seem to follow through, these were suddenly not the overfriendly guys who I had spent the past weeks with. No jokes, no big friendly hugs and no pats on the back?

Once in my room I realised Tony must have been waiting for my return and knocked on my door. Quickly I explained the evenings events and I made my apologies for not realising he had not been advised about the after show gathering. I did feel sorry for Tony, it was our last night and he had missed out on a completely outrageous and hilarious evening, but in normal circumstances no press would have been invited anyway – so I had not lost him anything, it was never there for him.

We were in no rush for the next day's midday flight heading back to the UK, agreeing to have breakfast around 9 am and pack and leave the hotel about ten, everything settled, Tony went back to his room. But as I was getting ready for bed, I still had this niggling feeling it hadn't ended. Consequently, I decided to pack my bag now, putting it my under the bed – something just wasn't right about tonight.

I think I must have just started to fall asleep when I could hear muffled laughter from outside in the corridor, immediately my senses were awake. Memories of the policeman in the park fiasco hurtled through my brain.

No time, before I could put myself into gear, to move or make sense of my surroundings, my room door literally burst open. There in front of me were at least six people, bedsheets hanging from around their necks, some had feathers in their hair, but all had one common purpose, the complete destruction of my room. The most vivid memory I have to this day is of Rod Stewart bouncing up and down on my bed, a sheet tied to him like a cloak, giving a superb kick to the table lamp, sending it flying through the air smashing against the huge window that led out to the balcony.

Luckily there was so much laughter and hysterics that the group could do little else, eventually everyone coming around me hugging and patting me on my back, Rod grabbing me and kissing me on the cheek – "Alright mate."

"This is what we do when we especially like you," said guitarist Jim Cregan – followed by more laughter and man hugs.

"Now watch what we do normally." Again more laughter with added cheers. Handshakes all around and embraces with lots of backslapping – this was there real goodbye; this was their appreciation of the week of trust and work between us all. They left my room (what was left of it) but didn't go far, towards a hotel room further along the corridor, where I realised Tony was sleeping.

Rod turned to me, winked, pushed what looked like a passkey in the door lock and in unison the group charged through Tony's door.

I could only guess the destruction and chaos that was going on in his room but knowing my own situation and now with a few other guestroom doors opening with heads peering out to see what was happening, I closed my door. Still hearing the commotion, I quickly got dressed and dragged my case from under the now broken bed. At least now Tony and Rod would be bonding and having a laugh I thought, better late than never.

It was about twenty minutes later when I heard banging on my door,

thinking it could be a return visit from Rod's gang I peered through the door spyhole. There I could see Tony struggling to cover himself with a towel, watched by a few other guests, doors still opening with heads all looking out.

"Who is it" I hesitantly asked, fully knowing it was Tony but wanting to hear the situation first.

"Ken, open up quick, they took me through reception and out to the front of the hotel and left me there. I am locked me out of my room, I can't get back in, let me in quick"

I opened my door where a wet and cold Tony rushed in. He explained how they had charged into his room while he was asleep and trashed absolutely everything – looking around my room he commented how they had obviously been to visit me also. I, commenting on the destruction, he answering that "compared to his room my room looked as if they had been in to redecorate it."

I went down to the reception to a smirking receptionist, explaining the guys had had a bit of fun and somehow Mr Frost had been locked out of his room – I was given a key-card and returned to a waiting Tony. He had wrapped himself in my towels and we opened his room, utter chaos, a scene of total devastation. Tony in one aspect was right, compared to his room mine looked untouched. Not only that, but they had filled his bath with sheets and some of his clothing and left the water running – consequently water everywhere. It was now about six in the morning, Tony looked at me, then around at his room and said, "What are we going to do?"

I looked back at him and without any particular expression said, "There is only one thing we can do, just walk out, get a taxi and go to the airport!"

At that I picked my bag up and walked out of the hotel, no checking out, no asking the reception for a taxi, Tony following. We waived down a passing taxi (not ordering one from the hotel as this would only alert them of our early departure). Our flights connecting in New York, giving me twenty-four hours to sight-see around the city that never sleeps, the evening helicopter flight around the Statue of Liberty being captivating.

I was pleased to be going home, an amazing trip and reality was calling, get home and back to the real world.

Between flights, Rod Stewart's manager, Billy Gaff, telephoned me. He had another singer who was also commencing a concert tour, the singers name not bringing any sparks to mind, I just said I couldn't change my schedule, thanking him for the offer but explained I had to get back to the

UK. Just before boarding my flight I telephoned Angela, confirming my return times and in conversation mentioned the other singer I had been offered exclusively but turned down. Angela totally amazed (to be polite) telling me (and still reminding me to this day) that I had just turned down an entertainer who was at that time one of the biggest stars on the planet, Barry Manilow – O! well!

## Home and a bill for a thousand dollars

Of course, the choices from the mountain of exclusive photographs I had taken of Rod Stewart were a huge success back at the *Sunday Mirror*. The photograph of Rod Stewart with his trousers around his ankles on stage was superb, as were the photographs of Rod stripped to the waist on our football day in Beverley Hills. I never mentioned to anyone about the *Dallas* stars, as my favourite saying goes – 'if it's not on film, it didn't happen!'

It was another two weeks later I was called into a meeting with the Robert Wilson, feature's editor of the *Sunday Mirror*, arriving at his office to find Tony, already there, sitting in the corner.

"I have received a bill for over $1000 from a hotel in Greensboro, for damage in rooms you two gentlemen occupied there for just the one night!" said Robert.

I looked at Tony who said nothing, so turning to Robert I simply replied, "Send it to Rod's management company in Kings Road, you will hear no more about it" which proved to be correct, not another word was ever said.

The *Sunday Mirror* promoted the feature through their television advertising and ran a two-week photo-special, a massive lead on the front page and a two-page centrespread feature on Rod Stewart's American Tour – photographs by Ken Ross

# 17

## FOWER SLICES OF BREAD & BUTTER AND A WEDDING

Several years earlier in Saint-Tropez, when I presented Angela with the engagement ring we never discussed when and where we were to get married. Angela never asked, so now I felt it was time, I had none of these anti-wedding thoughts. I was totally committed to Angela and felt it was something I wanted to bring forwarded myself.

So over a period of several weeks, without a word or hint to Angela, I had scurried around to find the church and priest who would officiate (not as obvious or as easy as it sounds), at the same time trying to tie in the wedding date with a honeymoon date, especially as I was looking for January the first, a Sunday – looking for everything to fit together before I popped the question.

I wanted this to be everything Angela deserved, something that was also romantic and with all the work and details secured, no complications.

It was done – after weeks of exhausting and extensive checking of diaries and commitments, I had tied in the wedding date, the church, the priest, all tying in with our departure to go on our honeymoon. The decision as regards of where to go for the honeymoon was easy, after several modelling trips to Kenya, Angela had fallen completely in love with Mombasa Beach – so this was elementary – the white sands of its beautiful beach called, and I was to answer. It was booked, be it with specially arranged and massively expensive flight supplements to fit in with the specific set date and time.

### And now to pop the final question

But before all this, I had to ask the question. Of course, yes, we were engaged, but a wedding, now that's something else!

In Hampstead, a beautiful sunny day and it was a short drive to one of our favourite pubs, The Horse & Groom, for an early evening drink. The pub,

for those who don't know it, is between Hendon and Hampstead and was ideally situated next door to an amazingly quaint small church (where our wedding was now booked to take place, and where I was going to ask the final question).

Two white wines, a stroll outside leaning on the gate overlooking the church – I once again asked Angela if she would marry me – on January the First!

I was never sure what sort of reception arrangements Angela would want, was it to be big or small and how many guests? Consequently, that was the only arrangements I had not set to task. Although I always assumed that this was something I thought we would have to do ourselves, but on hearing the news Angela's mother, Anne, was so thrilled she completely took over arranging the entire wedding reception.

She had been horrified at the thought that her 'famous daughter' would have her wedding reception at anywhere other than the best venue in the area. Immediately she booked the reception and rooms for all of our families and friends at the very fashionable and expensive Hendon Hall Hotel. It seemed as though she had taken total control and was loving every minute of it.

The plan was set, both our families and relations would all travel down to London for our wedding which was quickly becoming a very big event with a lot of complicated logistical work involved. The day before the wedding, the families finally arrived, all staying at the hotel which most of them would describe as 'posh'.

The pre-wedding evening meal could be best summed up by the hilarious, and I must admit, a warming experience for us all. This when one of our favourite relatives, Cousin Hughie, who when being formally served the evenings supreme 'chef's lobster special' – tapped the waiter's arm and asked "Ay, canny lad, can I have 'fower' slices of bread and butter."

There was immediate total silence, and then an explosion of laughter! What's the old saying? 'You can take a man out of the North, but you cannot take the North out of the man.'

Minutes later, on a silver tray, the four (fower) slices of buttered bread were served, this by the white uniformed (complete with the chef's classic tall hat) smiling head chef himself. Any thought of formality was now gone, jackets off, ties undone and even a few high-heels were kicked away – it was a real canny neet!

Both Angela and I, and all the families still laugh at this today, the bread and butter request now having become a sort of colloquial saying or greeting between us all – 'fower slices of bread and butter.'

The hotel was superb, bringing the wedding into unexpected realms of total Vanity Fair, Angela's parents had done their part fantastically.

Wedding day, the church service was best described as simply beautiful, an experience we will never forget – if there really is a God, he was there that day! When I turned to see Angela walking down the aisle, it was the most amazing and heart-warming experience I have ever felt, totally inspiring, there in her white wedding dress she looked absolutely stunning.

I was not the only one who obviously realised just how amazing Angela looked, as we walked out of the church, we were surprised by a barrage of press photographers – their camera flashlights illuminating the entire interior of the church. For our families, from the north, a totally amazing showbusiness experience they will remember for the rest of their lives.

Creating an ideal photographic opportunity for the press, I stood in front of the church, cradling Angela up in my arms, with her 'white boots' showing from under her long wedding-dress (it was snowing, the church looking like a winter wonderland – January the First, don't forget). The press guys pushed and shoved each other to make sure they got this photograph, an ideal couple picture, and one they would use – I thought?

The photographers followed us to the hotel reception and for a while I didn't notice that they had spirited Angela away into the lobby to pose her for another photograph, this time obviously on her own. The pose skilfully set with champagne glasses being held by our friends from Angela's Model Agency, 'Top Models' as a frame around her, which to be fair, I must admit was an excellent idea – this, I thought, now no doubt giving them a second wedding photograph to use. I should possibly add as some form of clarification that Angela had by now become a successful, well known and extremely popular London model. Whereas her photographer boyfriend (now her husband – me), as a showbusiness-freelance photographer who had recently been chosen for several glossy assignments in Miami and L.A. was never going to inspire and befriend any of the Fleet Street staff photographers! They loved Angela, but Ken – ummm?

Our reception heralded a mixed and diverse assembly of our northern families who were joined by the elite of London. Model agency bosses and staff, famous model friends of Angela's, journalists and senior newspaper

people, actors and actresses that we had both worked with and a sprinkling of London friends – being so contrary that the selected grouping worked, everyone readily socialising and mixing well.

I had arranged the wedding and honeymoon meticulously, and at the end of the reception Angela and I were to leave the celebrations and quietly go off to Heathrow Airport, flying directly to Kenya. So at the appointed hour, we started saying our goodbyes – tears and laughter and kisses with our parents and families, cuddles to Angela's best friend, fellow actress Vicky Michelle, model agency bosses Don-Rosay and Alex, who had all come to join in and witness our special day.

Then another surprise from Angela's mum. Unknown to us Anne had arranged a Rolls Royce to take us to Heathrow and as we got ourselves comfortable waving goodbye to our families, and as the Roller started to pull away Anne leaned through the open window and threw in a huge handful of £10 notes (flying around the interior of Rolls like confetti). Anne waving, crying and telling us to have a good time in Kenya.

We drove off, our mums and dads now stood in the middle of the hotel driveway surrounded by all our relatives and friends waving us goodbye – the day could not have been better, no families could have ever been better.

For our mums, dads, relatives and friends who all stayed at the hotel that night, there was an amazing extra next day breakfast surprise. They all enjoyed another showbusiness experience when an excited hotel manager rushed to each of their breakfast tables (watched eagerly by all other guests). He was proudly giving out all the newspapers, announcing how our wedding has being reported by every single newspaper, front-page pictures on national newspapers beaming out at them – photographs of Angela surrounded by champagne glasses was featured in every paper.

Speaking by telephone a few days later from Kenya to our mums and dads, they told us the story of their special breakfast and of their pride, adding that everyone had a huge smile on their face for the rest of the day – it made the whole family gathering a most beautiful occasion, one that they would treasure and take of back home and never forget!

## Indiana Jones and a fish called Ray

The honeymoon was something special and definitely very, very, memorable! The hotel, its beach location and our tiny private house-lodge were a total paradise, so why didn't we just stay there and enjoy it?

The hotel was of course selling tourist safari tours for Tsavo Game Reserve, these with one or two night stays in the luxury jungle lodges – travelling around in a zebra painted Volkswagen minibus, with the top that lifts up a few inches so you can squeeze your camera through the gap to take photographs, all very easy, comfortable, clean and very safe – so not for us!

Within two days, with a bit of wrangling, I had rented the hotel managers personal long wheelbase Land Rover which had a rather unique tank top feature, an observation hatch in the roof allowing the front passenger to stand up on their seat (with their upper body out above the hatch) to observe and direct the route, something in earlier and more troubled times would have possibly been the plinth for a machinegun? The hotel had booked us four overnight stays in several of the safari lodges. So, with 14,000 square miles at our disposal and with our trusty tourist map (and little else) we set forth from the hotel compound.

Keeping this as short as I can, we quickly learnt that on the way to the safari park when driving through the local Kenya mud hut villages the youngsters would stand at the side of the road with their left hands stretched out asking for money. The lesson being that as you drove past them, if you hadn't thrown some pennies out the window, then their right hands would now come into action, by throwing hitherto concealed stones and rocks at our passing Land Rover. Teaching you villages on route were now a thing to drive through without slowing down, or at least have a handful of pennies ready to throw.

Once inside the enormity of the game reserve (the size of a small country) it was amazing, we had only been there minutes before seeing in the distance a herd of giraffes, too easy! Me telling Angela, that they were just wooden placards for tourists to see in the distance, that is until they all wandered off.

What lay before us was a vast uninterrupted scrubland of red clay that stretched as far as the horizon, we put our foot down and after driving for just a few hours we finally entered the areas of more lush green vegetation, more what we tourists would determine as the jungle. Luckily, we were there at what is described as just after the rainy season, with the greenery at its finest

and plentiful for the animals. Although it did have the distinct disadvantage of most of the lesser used tracks now being overgrown and completely covered. There was of course what we jokingly called the tourist bus-lanes, the specially maintained hardcore raised tracks, these being in constant use by sightseers travelling in the zebra painted minibuses.

Angela and I would take turns driving, whilst the other stood up through the tank top as observer with binoculars. Of course, the red clay dust was everywhere and soon with the hatch open the interior of our Land Rover (including all our clothes and other possessions) were covered in the red dust.

For miles and miles, the park was so spectacularly gorgeous, totally wild yet at the same time serene, it's difficult to adequately describe it in writing because so much of it is the emotions it invokes. The beautiful sunsets and sunrises, the lush green landscape, the sweeping savannas, the pure gorgeousness of it all. Yes, there are parts that are dangerous, parts covered with dense vegetation and dominated by forest trees. Other areas overgrown with tangled vegetation, here you had to be sensible and if you were not sure of, you just avoided it and changed direction.

Being on our own, we had no rules other than respecting where we were, we motored slowly through the jungle, keeping to previous rough tracks, using the tourist tracks very little (not the real jungle we thought). There are so many things that are difficult to describe, a simple picnic lunch for instance, but make the location of the soirée sat up on the roof of a long wheelbase Land Rover, and put all this in the middle of a jungle and the whole world turn upside down!

After hours of driving we had spotted a herd of elephants, something we had never imagined possible, seven adults and three baby elephants, the later carefully being guided by the adults. So, keeping a good distance between them and us, we slowly kept up the pace and followed them – this was so unreal, watching the behaviour of these gentle giants and being there in real life – totally amazing.

One amusing incident as we followed our herd, was as the elephants left the dense jungle area to cross one of the built-up tourists tracks, several surprised passing safari tourist minibuses were forced to an abrupt halt. The drivers stopping quickly and lifting the roofs so their passengers could squeeze their cameras out to photograph the elephants as they rambled straight across their path. Elephants gone, probably thinking that was about it, the sudden roar of our engine as we geared up to also cross the track was no doubt now

adding to the tourist's surprise and bewilderment. Our Land Rover appearing quickly from out of the bushes, bouncing up the small hill and across the raised tourist track, all this with Angela standing out through the tank top, her long blonde hair flying in the wind as she stood with her binoculars around her neck, looking like some wartime general directing her tank division. All this was obviously something the minibus passengers couldn't comprehend, a total look of shock from them all

We slowly (still respectfully keeping our distance) followed the herd for another few hours before cutting away to find our evenings accommodation, a night's luxury safari lodge we had been booked into.

As we approached the front of the lodge, several of the safari minibuses had just arrived, the passengers disembarking, all I might add still immaculately dressed. Everything from typical tourist safari suits to Americans dressed in bright coloured trousers and shirts – not a spot of dust on any of them!

We pulled up alongside; except for the driver's window (which we continually cleaned) our vehicle was now totally covered in the red clay dust, Angela and I equally covered in red, looking more like someone from the movie *Indiana Jones*. All we didn't have was his trademark whip – the rest of the look we had managed without even trying. I think we were the subjects of more photographs being taken than that of the elephants.

Next morning, six 'clock, the call went out on our room intercom (as all rooms) that a herd of elephants had been seen locally and the safari minibuses were leaving in thirty minutes. We of course had been with 'our herd' most of the day before, so we turned over and had another few hours' extra sleep. The lodges are pure luxury, so a good swim in the pool and a big breakfast was what we were looking forward to, especially as we surmised that most of the hotel guests would have rushed out to find our elephants – so a comparatively empty lodge for us to enjoy we thought.

Around the pool we enjoyed our leisurely breakfast, every other guest having answered the elephant call, and joined the armada of minibuses chasing off into the sunrise.

We were surrounded by most of the white uniformed hotel staff (we their only guests to look after) when unexpectantly their facial expressions started to change, this varied from alarm in the young staff, to amusement in the elders – suddenly from the bamboo walls surrounding the pool came a crashing noise – there, only twenty feet in front of us were our elephants. The one we had the day earlier started calling 'the old man' (probably the leader) came

through first – and as if a circus act, the family followed one by one. Seven elephants and their offspring had joined us for breakfast – the pool a good and immediate source of refreshment had 'the old man' dipping his trunk into it and trumpeting it all over himself. The fresh plants displayed around the pool proving a tempting treat for the younger elephants, immediately wrapping their trunks around the leafy delicacy, picking them up and shaking them so as the pots and earth fell to the ground – leaving a no doubt succulent and tasty treat. The breakfast staff stood back, quickly joined by the kitchen staff and porters as word went around the lodge. No one did anything, the elephants allowed to carry on (destroying the beautifully manicured gardens) as each young tender plant was lifted from its bed and eaten. I hadn't taken my cameras to the breakfast, but I did have our cine-camera, me constantly urging Angela to stand 'a bit nearer' to the elephants so I could get some good film. Another totally amazing experience, the whole lodges clientele was out there somewhere looking for what had decided to join us here for breakfast – a truly amazing memory that lasts a lifetime.

After about twenty minutes, 'the old man' trumpeted and the herd nonchalantly wandered back out, breakfasts all eaten and watered down, the elephants were satisfied. The manager later explaining to us it happens once or twice a year, but as he said, gardens can be reclaimed, the magnificent elephant cannot – so we just watch and never do anything, when they have had enough they leave – it is their world after all!

With many, many more experiences, after four days of total amazement, including me getting out of the Land Rover and throwing a croissant (part of our packed mid-morning snack given by the lodge) at a huge elephant that blocked our track. I did err by the side of caution and return to the Land Rover when it lifted its trunk and bellowed the loudest noise I had heard whilst in the jungle, especially when it brought its ears forward (imminent sign of a full charge we were later advised). All this with Angela who was still in the driving seat waving to get my attention and quietly pointing to a pride of lions some hundred feet away sleeping happily under the shade of a tree.

## Back safely at the hotel

Back safe in Mombasa at our hotel we watched by the pool as an instructor was giving guests elementary scuba diving classes.

Wow! We thought (here we go again!), this looks fun!

Having just survived our *Indiana Jones* expedition into the wild out-backs of Kenya, we were now going to throw ourselves into deep water (well a swimming pool anyway) – what can possibly go wrong we thought?

The diving course was over five days, the final two days swimming on the Mombasa Barrier Reef, what a beautiful thought – another amazing experience we assumed.

Next day in the pool, no problems, getting used the heavy tanks, learning to fall backwards into the pool and sitting on the bottom swapping mouth-pieces with your 'buddy'. Although a few seconds never sounds a lot of time but at the bottom of the pool when you pass your mouth piece over to your buddy (sharing one tank between you), believe me a few seconds is a life-time as you watch them taking deep breathes whilst you strain to hold your breath.

After three gloriously easy training days we were to be taken out by boat to the Barrier Reef – we were ready, after all we had trained in our swimming pool for two hours a day, surely, we were ready?

First worry, despite us all paying for the course in advance, we seem to have lost six of our would-be divers, they had arrived earlier but then seemingly changed their minds.

'Wimps' we thought, and we carried on checking our equipment and walked towards our boat. Second worry – this wasn't some pretty little painted tourist pleasure boat, it was a full-size fishing trawler – a veritable sea going ship to our eyes – also what most people would consider a 'rust-bucket'.

OK, we thought, let's all carry on, we had done all our training and gone through a few (short, in Pidgin-English by our German instructor) lectures. During the past three days we had made friends with another English young couple, Harry and Fiona, the remaining couples all being German. Aboard our 'ship' the engines thundered into action, and we set off – a big boat for a little distance we all muttered! On and on we went, out further and further, until the beach and hotel became a tiny spec in the distance and the waves hitting the side of our ship were getting bigger and bigger

OK, yes, the Barrier Reef, but I suppose none of us ever asked (we obviously assumed) that it was on the inside – but no! We were to dive on the outside of the reef. Refund, I want a refund, an expression that could be seen on everyone's face, now we realise why the other six had changed their minds and disappeared so fast.

Equipment all checked again, tanks strapped to our backs, checking air pressure, positioning face masks, we were being instructed now how to fall backwards from the boat (ship) and to try to time the fall as the boat went down in the waves – thus making sure you swam away from the boat as it lifted up on the waves – before it came crashing down again!

Looks of pure fear from everyone, all no doubt hoping that some else would be the first to start the mutiny. But no, we all sat on the rails ready for the backward fall. GO! One by one we were touched on the shoulder and one by one like lemmings, we fell backwards, throwing ourselves into the sea.

The sea was not warm, we wore only swimsuits (and a T-shirt to protect us from harness strap-marks). The sea was also angry, dark and a million miles away from those sun kissed brochures pictures you see of divers happily chasing turtles as the sun filters down on to the sandy bottom a few feet below. Now in the sea, instinctively we swam away from the boat before it came back-down in the waves. Nearby there was a large yellow painted oil barrel floating, secured with a chain that went to the sea bottom – that was our guide and we were to follow it – the depth we were to go on our first sea experience was the full 100 feet, to be repeated the following day for our certificate.

As we swam down, following the rusty chain from the oil drum there was no sign of the seabed and as it did slowly come in vision, you realised looking up you could no longer see the sky – total darkness above you. The only sound audible was your own breathing, which due to our own fear was far louder and probably using more air than we should have been.

Of course, amongst all this there was a surreal beauty, fish that you had never seen before you could put your hand out and touch. Our group of nine now all assembled together on the seabed, one of the Germans had stayed up top, refusing to complete the backward fall into the sea.

Angela being the lightest of us all needed extra weights, so the instructor, after giving and receiving all our hand signals that we were all alright, started to attach an extra weight to her belt. Suddenly, what for years since has been a source of fun and amusement as we now tell the story, yet at the time there was total and utter panic. 100 feet down and all-around Angela the clear sea became full of sand, the ground was moving and Angela herself was being lifted upwards. Sand spurted towards all of us, there was a huge earth movement.

Angela's earthquake, as we all looked in startled terror and amazement,

was in fact a giant four-metre manta ray. Settled on the sea bottom the manta ray had laid hidden in the sand, that is until Angela had swam down and landed directly on top of it. The Ray's massive wings now flapping created a sandstorm amongst us, with it pushing out between us to escape, fighting for its own space away from our group. I remember a famous logo for a science fiction movie, 'No one can hear you scream in space' – well believe me, it's the same 100 feet down at the bottom of the sea!

This cut our first trip short, the instructor being worried on how during the panic some of us may have used too much air, so prudence suggested after a few minutes swim we return slowly back to the surface. All hand signals again individually given, thumbs up requested from each as we made our way up into daylight – the instructor, knowing of the panic and that our hearts were no doubt beating too fast, gesturing 'slowly'.

As you emerge to the surface, the first thing that hits you is the weight of the tanks on your back, it's nearly impossible to swim normally. You have to sort of float or even dive back down for a while as you wait to be physically clutched by the guys on the ship to help drag you up the ladder (remember you have to catch the ladder when the ship is crashing down in the waves).

Once dragged on deck, I could see one of our fellow divers being sick, he instantly joined by several others as we looked at the face of another of our fellow divers. His face was undistinguishable, it was like a giant walnut which was covered in blood. On the way up he had forgotten the rule of 'equalizing' in the face mask, a simple procedure of blowing through you nose regularly, a rule that like many if you do not follow is extremely dangerous, the mask then becomes like a giant leech on your face. Our ship now back at the hotel jetty, there was an ambulance waiting for the unfortunate diver and for the rest of us, a very quick dash to the bar.

Next day was the final, the exam day, where we had to go back down to 100 feet and perform all the tasks which we had been taught in the ten-foot deep pool. Whether we went, for our English four, was a throw of the coin, none of us wanted to but it was for one last day and we could gain our licences.

Next morning at the jetty, our four and only one other German couple – six out of the original sixteen were there.

Following yesterday's dive, we knew the procedure and followed the same ritual. On the seabed, one after another with the instructor we performed the tasks, sharing the mouthpiece, flipping and spinning upside down to

clear the face mask, all of us carefully following all the hand signals and the instructor's requests.

Everything successfully done the instructor gestured us to follow, and for ten absolutely amazing minutes the whole experience had been worth all the worry and concerns.

We swam along the edge of the seabed, which suddenly fell away, descending deeper and deeper (now even exceeding our 100 feet), seemingly off a cliff edge into an abyss. We swam along and then down, Angela and I holding hands, as if superman flying through the air. Brightly coloured fish, shoals of them, swimming amongst us. It was truly as if we were the first to ever be there, a world so different and amazing, it is impossible to describe in all its glory!

Unfortunately, all this came to an abrupt halt as one of our co-divers was making the hand signal, he had gone onto his reserve air supply. This was too soon, the instructors signalling us to go up and probably now himself panicking that we didn't rush or forget the basic procedures.

Back on shore we collected our licences, logbooks and certificates, then for our last few days of our honeymoon Angela and I relaxed on the beach – and no! we didn't ever go for a swim again.

During the many years since, talking to other divers, none have been able to understand or explain our training, the depth we had gone down to and the extreme danger every one of them says we had unknowingly been in. Even my father, a wartime naval frogman awarded the Distinguished Service Medal who was taught to parachute into the sea and even ride mini-torpedo-submarines during the war was amazed that we had been down as deep as 100 feet – something he could not understand how that could be part of a first-dive on a licenced course.

# 18

## DEMPSEY AND MAKEPEACE – AT WAR

Glynis Barber was one of those up-and-coming young pretty actresses that as a showbusiness photographer I would keep 'bumping' into. Either at parties, film launches, or press days held at one studio or another – either way, they (young pretty actresses) were always there.

I had photographed Glynis previously, nothing very special although to be fair, she did usually stand out against her fellow hopefuls. I always felt she had that little extra, certainly she had her own look, she seemed to try harder – or was it raw naked ambition?

She had already won parts in several television series, be it usually a small guest part in a one episode, one scene scenario. Eventually she had been plucked out of the pack of actresses-in-waiting and had been cast in the starring role as 'Jane'. This, a rather light-hearted (and cringingly corny!) television series of the same name was based on the *Daily Mirror*s wartime cartoon comic-strip. Glynis played what was termed as an unintentional strip-tease heroine helping to foil the baddies, all this whilst finding herself in compromising and embarrassing situations with her clothing, or loss of them. All a bit of fun, but not particularly successful, the series only lasted for the one original run.

So suddenly seeing her named in a television press handout that she was to be the co-star of a new (still yet to be launched) major television series, tipped to be something very big, I started to make enquiries at the studio. The series was already in production and was to be ITV's new flagship television crime series. With the two lead roles being played by a relatively unknown American actor, Michael Brandon, along-side our own glamorous Glynis Barber, so far no one had seemingly given it much attention.

But this was something of interest for me, I immediately contacted the *Sun* feature's editor and was given a free hand to approach the producers to try for anything I could get. Of course, in these circumstances I was at liberty to promise the earth and haggle for that all important exclusive first photo session with its stars.

After a few hours I received the return telephone call from the series press office, there was no chance of getting the stars back into our studio but the producers had agreed with the director that I could join the film crew on location to meet and photograph Glynis and the American actor Michael Brandon, this being the chance of that all-important exclusive photo session.

Easy – no! What I was about to find is that the script in the series was about to interpret life itself, a script that was to turn out so real that it would eventually become reality for the two actors themselves – read on!

## On set – definitely a crime

Rather than using a combination of specially built filmsets at the studios to film the series, the producers had rented a disused warehouse complex with several adjoining buildings in the old disused area of the East Greenwich Gas Works (complete with car park and its own surrounding streets and alleyways). This, they explained, would give them a great choice of immediate locations and the gritty reality they were looking for in the making of the series. Inside the main warehouse, several office interiors and key locations had been specially constructed – the series was already into its fourth episode and its schedule to be televised already approaching.

I arrived on the set early (joining the film crew means just that, keeping up with them on their timeline, being one of the gang), luckily just in time for breakfast which was being served by the caterers. The location caterers offered one definite choice on food, remembering that old quote, 'never mind the quality, feel the width.' Big breakfasts, regardless of quality, big was the norm.

Glynis was there but there was no recognition to my 'good morning' shout. Quickly my mind went to another old quote, 'A star is born' and believe me nothing affects recognition and memory like a jobbing-thespian who has suddenly become a star. Any history with me was obviously, as with every other previous associate from the old days, now no doubt non-existent.

I was by now an old hand at working on television and film sets and getting on the good side of the director by assuring him of my patience and my wariness of his all-important filming schedule. This can make a visiting photographer's life a lot easier – this I did immediately.

His assistant took me to the main warehouse where they were filming and

suggested I use one of the empty adjoining areas to set my lights and camera up. This so Michael and Glynis could be quickly brought to me when there was a break in the filming, probably in an hour.

The area I had been given, a large annexed room, was festooned with lots of packing cases and old-fashioned tea chests. Quickly I started to make a stage area for myself, the packing cases being the sitting/posing point for my stars. Two brolly lights set up each side with a hidden back light for the rear white wall, camera tripod set – everything ready.

An hour went quickly by, I sneaked from my lair to find the filming had been stopped for half an hour, but the stars had both gone their separate ways – and this was where the assistant director told me the depth of my plight!

Within the plot, set in present time London, Michael Brandon (playing the part of a rough-cut lieutenant, James Dempsey, on loan from the New York Police Department) was to partner Glynis Barber (playing the part of Detective Sergeant Harriet Makepeace, who in the script is the daughter of a Lord – hence the 'rough' male lead and the 'posh' female lead scenario), both thrown into the partnership by their MI6 and CIA bosses to form a special police task force, and both (supposedly in the script) instantly disliking each other.

Here added the assistant director, is the problem, because that's exactly what has happened in real life, they really don't get on at all! In fact, there is a bit of a war of silence going on between them and everyone in the crew is walking on eggshells!

To emphasise the extent of the hostility, several scenarios were mentioned – "Out on location usually even the biggest star will 'muck-in' and get the job done without any 'diva' nonsense. But here, because we are filming in a 'permanent on-location site' and Michael being American, somewhere in his contract it says he has a caravan to relax in between scenes (all very American, like in the old Cary Grant movies). Obviously, Glynis, quite rightly, regarding herself as the equal co-star wanted, no, insisted, on parity. A 'what's good enough for him is good enough for me' scenario. Well we couldn't materialize a second caravan out of thin air, so a private room for her in one of the outbuildings had to be quickly decorated and furnished from the props department – and this is how it has gone along since we started filming."

My dream exclusive on this new exciting series was looking more and more in doubt. At lunchtime, back to the catering bus, I approached the director and without showing any concerns, forcing a smile, I asked him how everything was.

"You haven't had them for your shoot yet I assume?" he answered without even looking up.

"No, I don't suppose they have had chance for a break as yet," I answered. Both of us knowing that this was not the truth.

"Leave it with me," was the short reply.

An hour later, lunch finished, filming commenced with both stars being called on to the set – Michael from his actor's caravan, Glynis from her specially created room.

By now it was three o'clock in the afternoon, I had been on set since eight and had achieved absolutely nothing, other than of course assembling my own little studio area – something I was now feeling less enthusiastic about. I again walked towards where they were filming, keeping my distance but watching the action. Another break and another quick exit by the stars as they left in different directions. The director gave me a quick stare, and then went back to looking at the take-outs on his monitor.

Several more hours would tick by when eventually I heard them talking of the day being a wrap, my heart sank, if the stars wouldn't cooperate during working time I had little chance at the end of the day when it was time to finish and go home.

Ready to give up, to start packing, I turned to see the director walking towards me, his arms outstretched each side of his body. In each of his hand he held the hand of one of the stars, Michael and Glynis. He was like a parent taking two errant children to a school they didn't want to go into, total amazing to see three adults in this position – I could have kissed the director.

He walked right up to me, looking around to his errant children saying. "This is Ken, he is the *Sun*'s showbusiness photographer, he has an arrangement with the studio and both your agents for a publicity photo session with you today. He has been here for nine hours, never complained or made any problems for us on set, he has stayed here patiently, please give him ten minutes of your time."

At that he let go of their hands and walked back to his crew, every member of the film unit watching what had happened, with huge smiles on their faces.

Of course, it took only seconds to realise whilst I may have just won this little battle, I was now looking at a major war directly in the face.

I spluttered, "Hi, thanks, everything is ready, so just a few minutes of your time and we will be finished."

Nothing, and I mean nothing – two senior to-be television stars stood exactly as they had been left by the director, not a single movement between them, faces totally blank – the war had started, victim number one, the photographer!

I moved to my makeshift set, asking if Michael he could sit on one of the tea chests facing the camera and Glynis sitting side-on leaning with her back against Michael with her feet up on the box in front of her – again looking at my camera.

Slowly they moved into position, faces still blank. I quickly asked Glynis how it was going, reminding her of a previous shoot – no reaction, face still blank, total silence.

When I look at the photographs now, the pose looks so perfect for the part they played in the series. Where it would seem I had masterly captured, engineered and directed this moody and even stern look, in reality they were in fact so pissed off with me they could have just as easily being telling me to f— off.

All through my shoot, though I hesitate to make it sound as if it lasted any more than the one, twelve frame roll of film. I could not get them to change their expression or any change in direction or movement.

I could certainly sense any excuse to leave, to finish the session instantly, would be jumped on by the pair of them, so rather than make a pause by reloading my Hasselblad camera on the tripod, giving them the chance to walk away, I immediately picked up my loaded 35mm Nikon and continued shooting. I then took the big chance of changing the shot, Michael and Glynis both had prop revolvers in holsters on them, and so I asked Glynis to take out her revolver for a different pose.

She looked at me, took the gun out and immediately started pulling smiley faces, pointing the gun playfully (I hoped) at Michael. He seeing what she was doing brought the first change in is his facial expression, a smile slowly covering his face – for a brief moment, about ten seconds, they played the perfect publicity photo game together.

This not through any thoughts for me, probably the opposite, neither was going to do anything at all for me except sit or stand there with a blank expression. This was just a fleeting moment that I captured as they joked between themselves, smiles and even a quick sort of cuddle of Glynis by Michael.

Throughout these seconds of light-heartedness, I kept shooting – Glynis

then probably realising that my camera was capturing everything suddenly stopped the funny face routine, put the gun in the holster and without saying anything walked away, Michael following her closely. I stood, camera in hand, expressing my thanks as they left. I often wondered if that was their first joking moment together, that I had been the very first to witness the start of the thaw between them. Me being the common enemy which possibly brought the first signs of them being silly and joking together, realising there was actually something between them after all – certainly it was only a few weeks later when it was reported in gossip columns that they were now together as a couple.

Having packed my equipment away, I walked out past the director.

"Everything Ok" he shouted. "Yes, thanks for your help!" I shouted back. I have learnt many times that when it is all over there is no use in complaining, I had my few minutes with the stars and that was all I had asked for, the rest was up to me.

Next day back at the newspaper, looking though the contact sheets the features editor was delighted, "Great, fantastic, really moody pics, perfect, well done Ken."

The paper used the photographs the very next day, a huge centre spread with a front-page lead. I was then able to then sell the remaining photographs on to several other newspapers, plus two huge colour spreads in magazines. Other than a few headshots handed out by the studios publicity department mine were the only early photographs I ever saw of the pair.

In the end Michael and Glynis's moody moments worked amazingly for my camera, especially with the joking smiley face moment I captured with Glynis being used by several newspapers.

Of course, the *Dempsey and Makepeace* series were a huge success, immediately going to the top of the television channels ratings and being syndicated throughout the world. Glynis looked totally fabulous throughout with Michael achieving that raw American cop iconic style which made him so popular to the UK viewers.

The roles they took for the series transcended into real life, their feud (as in the scripts) slowly ended as they fell in love – and in 1989, in real life, Michael and Glynis were married!

# 19

## A ROLLS ROYCE, A WHITE AFGHAN
## AND A SILVER BOWL

In one of our more insane years of living in North London, whilst Angela and I were dashing around the world in our respective careers, at home we found ourselves driving around in a Rolls Royce (Silver Shadow). An early seventies model, but yes, a real one, shiny silver with a sumptuous and totally decadent burgundy leather interior, complete with a gold-plated Flying Lady (Spirit of Ecstasy) proudly standing over the iconic front grill. What I would also quickly add, these were the days when the Rolls Royce was still king of the road, a vehicle that demanded respect and reverence from other road users and pedestrians alike!

It was one of those things in life you sometimes wish for, in our case an opportunity arose and here we were – driving around London in a huge and expensive car that we were never going to be able to maintain, let alone even afford the annual service fees. And if in the past a car has ever given you cause for concern or financial worries – try owning a Rolls Royce and hearing 'a funny noise' from under the bonnet. Believe me when I say that as you pulled onto a garage forecourt you could literally see the mechanic looking at your Roller and then quickly booking his holiday to Barbados!

Nevertheless, for one mad year it was our 'Roller' and it was amazing, a year full of love and hate experiences. The 'Roller' had originally been bought by Angela's mum and stepfather, but as they were now going to be living abroad for the next year they wondered if we would consider 'looking after it' until they returned – of course what else could we do, we (obviously reluctantly?) agreed to being burdened with this amazing luxury gleaming fantastic automobile – life just gets better!

We soon developed several of what we called our 'Roller Party Tricks', the most obvious was the fun game of chauffeuring – one of us would sit in the back whilst the other would don' a chauffer's peaked hat (which we had found in a second-hand shop) and be the driver. Of course the best reaction was from when I sat in the rear reading the *Financial Times* and Angela

donned the hat – seeing a chauffeured Roller was one thing, but being driven by a beautiful young girl, blonde hair flying around her shoulders wearing a white shirt and tie, miniskirt and boots, complete with the chauffeurs hat, believe me a Rolls Royce doesn't get any sexier than that (well it does actually, but that's another story for another time).

Our favourite party piece was the 'Silver Bowl and Dog'. But firstly, I should quickly explain here the second love of our life was our dog, Maxwell. He was a giant (mountain-style dog) white Afghan hound – but wait! Before you go into the normal Afghan reaction let me tell you, first as a pup he was very, very big and not the skinny show dog that fits most people's perceptions of Afghan Hounds. Actually his brother, owned then by Angela's mum did make it as a champion to Crufts, which made us all proud.

But back to the story of our amazing pup – we took Maxwell at the earliest opportunity from the breeder (both booking a week away from work) to bond with him, we worked with trainers and as he got older we could walk out with him without a lead (even in the streets of Hampstead), he would sit and lay on command outside shops and even carry the newspaper for us in his mouth. Most of all he was an amazing protective guard dog who would have died for us. Other owners of Afghan hounds were amazed when they witnessed his unique behaviour, normally this breed can be notoriously scatty!

Back to the Silver Bowl! One of our favourite pubs near to Hampstead was The Load of Hay, where the parking, garden and picnic table benches were all to the front, this was overlooked by the pub's huge bar and conservatory. Our Roller 'party piece' was to drive up and park the Roller right at the front, in front of the conservatory next to all the picnic benches (obviously a no-parking area). Then whilst all eyes were upon us, with the nodding frowns and the 'who do they think they are' comments being openly mouthed – we would get out of the Roller, open one of the rear doors to let Maxwell out (here you have to picture the developing story – Silver Rolls Royce and a giant white Afghan hound). We would walk around to the boot, open it and bring out a beautiful silver-plated antique ornate bowl (which stood about eight inches tall on four small clawed feet), which we would place on the ground next to Maxwell. Then, from the boot we would then bring out a bottle of Bollinger champagne, pouring the contents into the silver bowl from which Maxwell would then happily drink. The dropped jaws of our earlier 'don't park here' critics were amazing – but as soon as the humour of this scenario dawned

on everyone they would all begin to smile and laugh, usually breaking into cheers and applause.

Of course, the champagne bottle was full of water and we had cut the cork so it could be put in and taken out easily – a great party trick and one that everyone appreciated (the pub manager even eventually allowed us to have that space permanently for Maxwell and our Roller).

We enjoyed a great year with the Roller, but expense and the fact we never dared to leave it out of sight became too much for our already busy lives – although if you ever want to be served quickly in a shop (or in a fish shop being called to the front of the queue) or park and forget about it at traffic lights for three hours whilst dining in Hampstead – buy a Rolls Royce – well, it worked for us back in those days!

# 20

## MINERS' STRIKE, VIOLENCE AND HELL

Not every assignment leaves you with a portfolio of photographs you can be proud of – some leave you with no photographs at all – but an experience you will never forget!

This was in the reckless winter of discontent in the mid-eighties when Margaret Thatcher's Conservative Government took on the might of Arthur Scargill's national miners' strike. It was to be one of the bloodiest of battles between the government and the unions, one that for decades had far reaching consequences for all.

Earlier the NUM had previously held three ballots (during 1982 and 1983) with a view to its members holding a national miners' strike, in all three ballots the strike action had been rejected. Miners had been split between those who supported a strike and those who opposed it (during the three ballots an average of fifty seven percent opposed any strike).

But suddenly, now with the threat of government mine closures, in 1984 NUM President Scargill, without balloting members, called the strike. By many this was seen as an erosion of democracy within the union, but the role of ballots in decision-making had been made very unclear after its previous leader, Joe Gormley, had ignored two previous ballots over wage reforms, and his decisions had been upheld in the appeals court.

So, with the strike declared, it immediately brought the country into total chaos. The argument of the rights of the strike split father from son, tore families apart and alienated friends who had worked together all of their lives. Small close-knit communities were now at war and the savagery on the streets became more evident as the strike stretched on from days to months.

Amongst the stories of the bravery (or treachery, depending who's side you were on) was those of the miners who had decided to ignore the strike call and continue to work, there were constant reports of extreme violence towards them on the picket lines. Miners still working were denounced as 'scabs' and subjected to massive intimidation and threats, with their homes

being stoned, and wives and children singled out for daily humiliation., striking families literally turned their backs on them.

Back in Fleet Street the *Sun*'s editor thought we should reveal what really is happening deep inside in the miners' community, to find the truth! But to report on such an emotional and sensitive situation, it was felt the only way to do this was to experience the situation ourselves. To be there amongst the community, to be where it was happening!

The next day, reporter Joe Slater and myself were assigned to travel to the very birthplace of the strike, into the very bowels of discontent, to investigate and to join in the community of the small mining town were the NUM delegates meeting had first called the strike – Barnsley in Yorkshire.

Here I have to admit this was not my style of assignment, but being a Yorkshire man myself the editor obviously thought I was the right man for the job, and besides I thought, what harm is there in having a chat with a few of the guys in their local pub? Once again, I got it so wrong – sometimes I query to myself how I survived my Fleet Street days for so long!

I have the greatest respect for the North East, a great love and an understanding of its ethics and lifestyle. And let us be clear, a Yorkshire mining community is one of the strongest and most loyal you will ever find on our island, even to the point of having tunnel-vision in their loyalty, you will never find a better man to stand by your side in a time of adversity.

So, our assignment was simple, to join in with the working miners, to hear their story, their troubles and to find the truth on the reported violence and intimidation.

Settling in our Barnsley hotel, we made the previously agreed phone calls to the local miners contacts we had been given, quickly realising that none of the miners who were still working were willing to go on record or meet us. Doors were shut firmly and would remain so. These men were already taking perilous chances by crossing the picket line each day, so looking as if they were seeking glory by talking to the press they feared could accelerate the intimidation and violence to their families even more – and to be honest, I agreed with their logic and neither Joe nor myself tried to persuade them otherwise.

There was one other way to report on this carnage, the intimidation and violence – for us to become working miners, to experience crossing the picket line.

The routine for the working miners was as secret as it could possibly get,

from different pick-up locations which would change daily, in the dark and early hours of the morning they would meet and clamber into the back of an unmarked transit van. After visiting several of the meeting points to collect the miners, the van would then be escorted by armoured police vehicles and drive to the pit, there of course to be met by the waiting picket line.

Three o'clock in the morning, it was jet black outside, cold and raining as we quietly stepped from the hotel. Due to all the secrecy of these pick-ups we were advised not to go by taxi, taxi drivers have ears and could be staunch friends of the strikers, so for us that morning a long wet walk was inevitable!

Eventually we arrived at the designated point, a deserted street, no sign of life whatsoever. Thinking we had got the wrong location, we huddled from the rain in a shop doorway – minutes later a van quietly drove down the street, coming to a halt and flashed its head lights.

Like some old zombie movie, men suddenly appeared as if from nowhere. We had seen no sign of anyone when we had arrived, but it was explained later that the flying-pickets had teams that constantly drove around the area on the lookout for groups of working miners that could be waiting to be collected, so discretion and the ability to fade into the darkness was paramount.

Our own presence at first caused a momentary stillness amongst the miners, all looking nervous about boarding the van. The driver quickly assured the group who we were and how it had all been agreed, and more importantly our sympathy towards their cause. There were two miners already in rear, plus the five now boarding and now ourselves, making it nine in total, all squeezed on the crude bench seating inside the rear of the van.

The driver leaned backwards explaining to us that he would now drive to another meeting point where we would join other vans and a police escort.

Inside our van my camera immediately caused heads to turn away, once again the thought of identification in the national press would be suicidal for any of the working miners and their families – the camera was quickly put away, both Joe and myself unable to think of any persuasive argument for them to be photographed and give their story or names – we travelled in total silence.

After ten minutes the van came to a halt, looking through the front windscreen we were able to see several more vans in front of us plus two heavily armoured police riot-vans.

Our driver stooped to the foot-well retrieving two crash helmets, which

both he and his co-driver (riding shotgun) quickly put on, the co-driver now also brandishing a baseball bat across his knees. We were on our way!

As we approached the pit gates we were astounded at the number of pickets, yes, I had expected ten or twenty, but these numbered in the hundreds.

## This was not a strike with pickets – this was civil war

The police vans drove to the gates first, seemingly parking side by side but leaving enough space for our vans to pass between, as if creating a safe corridor. Of course, the pickets were far more organised than everyone expected, with past experience of police tactics and routines, they had their own agenda to counteract this manoeuvre.

We were instantly surrounded by what were called hit-squads, strike hardened militant flying-pickets which had been especially bused in from other areas as re-enforcements.

Stones and bricks were hitting our van, the pickets forming a huge wall in front of us so we couldn't move forward. The van was being hit more, whether by thrown bricks or by strikers with metal bars we couldn't tell, but the deafening noise was getting louder by the minute. We were like caged animals, sealed in, but with the van now rocking from side to side, all we could see through the windscreen was one huge mass of angry people, pushing the van sideways. The look on the striker's faces was enough to terrify all of us, this was not a dispute, this was basic physical violence at any price, it was if the smell of blood was everywhere and the hunt was on – and we were the quarry. There was obviously no respect of any kind for each other between the police and the pickets, the violence from both groups being extreme and it seemed the law, the reasoning and the idea of why they were all there was long gone – this was just bloody and total violence.

Inside our van panic was starting to set in, we were all wondering how long before the van was pushed over on its side and the rear doors forced open.

Suddenly an army of police appeared, with no more protective clothing than their bobby's helmet and raincoats, they charged the line of pickets. The fighting was furious and far more violent than I ever expected, it was purely man against man, literally punching and grabbing at each other.

The police were quickly reinforced by a group of their newly formed 'Riot Squad', these officers wearing the normal uniforms but with the addition

of motorcycle style crash-helmets with visors, carrying shields and batons. The police now obviously attempting to up-grade their strategy by seemingly copying manoeuvres used by the early Roman centurions.

The police would hold the line, then suddenly break away leaving a designated gap/opening in their line, through this from the rear the mounted police would charge at full gallop. These would then be followed by the Riot Squad on foot who would then use the moment of disarray amongst the strikers and try to capture the front ringleaders.

All this fortunately distracted the pickets long enough for our line of vans to slowly advance forward and get through the gates.

With stones and bricks still being thrown at us and the deafening chant from the picket line and with the calls of abuse still ringing in our ears, each of the working miners scrambled from the van and rushed into the pit offices. With the gates now closed, outside it was still in turmoil, a sea of police and pickets pushing and shoving – but for the miners now safely inside, their workday was just about to start!

This terrifying daily confrontation with the picket line made me wonder just how long the working miners could keep this up – day after day, week after week, month after month.

The problem was that each side obviously felt their cause to be just – in fact it was hard to separate the causes and their reasoning, but there was such determination on each side to win, would this ever end I thought.

We were also now advised to go inside; bricks were still being thrown at us and the police felt taking flashlight photographs of the strikers fighting at the gate may have exasperated the hostile situation outside even more.

"For everyone's safety, no photos and please go inside," said the commanding officer.

Now seated in the pit-managers office, warm, comfortable – and safe, I felt slightly uneasy, a sort of guilt in our now warmth and comfort, remembering that outside in the freezing rain everything was still happening. It was hard to believe both the rioters and the working miners encountered this terrifying scenario each and every day.

It was at first hard to understand the extreme violence we had encountered, something you could expect from the third world yes, a broken society, a revolution in some African outback – but certainly something I never expected here in England.

For the picket-line, obviously there were extreme militants, some especially

bussed in to agitate and inflate the violence more – but the majority were just the normal working man in the street, the man who months earlier would have no more violent thoughts than weeding his allotment. Obviously, these people had their reasons, the men had no work, they had not been paid for months, their pride broken as their families were forced to accept handouts and visit charity food banks.

People change dramatically in these circumstances, the devil coming out in all – and I had just looked the devil in the face.

Inside the manager's office we were given a brief description of what to expect in the mine, Joe and I received a safety lecture and were escorted into mangers shower/changing room where we changed into overalls and donned helmets with safety-lights. My camera brought a smile to the manager's lips, not a chance in a million he said – taking a camera into the pit would break every safety rule in the book. The only camera ever allowed was a specially designed style that looked more like a heavily encased rocket launcher, where you paint the scene with a minuscule amount of blocked light – my camera and flashgun was locked away for safety, we were on our way down.

## Into a black abyss

The first part of our journey was we were told would be relatively easy, going into an open huge lift, which was more like an animals cage which suddenly went into an endless drop into the dark at a such a high frightening speed which you would normally only expect at some thrill seeking fairground – and this was just the start.

Eventually coming to a halt, the cage door was opened, and we found ourselves in a huge cavern with a ceiling height of over twenty feet, not so bad I secretly thought to myself. Joe even jokingly asking where the bar was?

At this stage we felt OK, I felt a wave of self-assurance, telling myself this would be no problem after all – a walk in the park!

We walked on for a few minutes, the ceiling height dramatically reducing as we journeyed along. Joe and I looked at each other as we listened to an ever-increasing metallic roar ahead of us.

Suddenly our nice cavern walk ended, my self-assurance drained, there in front of us was a giant mechanical caterpillar-like machine that was continually revolving, sending a none stop conveyer belt of huge metal open

bucket-shaped blades steeply downward into a tunnel of total darkness. This is the conveyor belt, which brought the coal up towards the surface, but more importantly, with horrifying thoughts for Joe and I, it was the form of transport the miners used to go ever deeper into the bowels of the earth, towards the coalface of the pit.

We watched as the miners casually timed their approach to the moving buckets, each bucket with just enough space for one person, sitting into each and holding the sides.

Joe and I looked at each other, not even being able to force a smile, we just starred – probably hoping one of us would back out, make an excuse for a refusal. But this was too late, we had committed ourselves and if these miners could do this as just a small part of their working day, then we obviously could find no excuse.

The manager went first, me following, more a case of getting it over rather than watching for too long, courage seeping out of me by the second. Even after all these years, I still remember this as being a horrendous experience. Sitting in what was no more than a coalscuttle and hurtling steeply down into the black abyss. I fixed my stare on the managers head in front and gripped the metal side of the bucket with all my strength – a journey that would last for hours and hours, but, was in truth probably no more than five minutes.

Being a skier, I was used to getting ready to depart from a moving chair, but never as eager as this, plus in this case you had little choice. The bucket was about to turn under itself, as if to quench its hunger by digging and filling itself with coal.

"Put your legs straight out and the bucket will simply push you off as it starts to revolve under itself," was the cry of the manager.

I was out of the bucket at some speed as if being spat out by the angry caterpillar – I was happy now, but looking at this huge endless caterpillar, I remembered that this later would be reversed and was also my only transport back to the top, to civilisation.

The ceiling height was still at this point relatively high, about seven feet. Though as we walked on, the ceiling height, as the width, both reduced quickly, nature reclaiming the borrows and passageways man had made. Here we saw the results of the unworked mine, what the months of strikes on the surface above was causing – nature was now reclaiming its territory. Without the continual daily maintenance and upkeep of the pit, the force of

nature was taking back what was its own. Although fitted with automatic ceiling jacks to keep the huge forces of gravity and pressure in line, without humans to adjust daily and maintain these – nature was winning.

"Don't assume this is the worst yet, I am going to show you what was one of the new coal faces," shouted the manager.

We struggled on, reaching the point of what was obviously total devastation of the pit face. With us now bending down to slowly scramble into what was now no more than a passageway with a ceiling height of five feet, we came to what looked like the end of the face. The manager looked at us, and then beckoned us to follow. He bent down, crouching down on his hands and knees and then crawled on his stomach through what was no more than a three-foot high hole.

There was a light coming from inside, the tunnel we were crawling through was half full of water and as we made the long crawl it was not only wet and cold but both Joe and I were starting to panic. Obviously for those with experience it was probably acceptable, but for us two lone souls who had never encountered such, it was totally terrifying.

The crawl went on for about twelve feet, opening up into another cavern, somewhere you felt had once been much larger but now was only seven foot in height, like something out of the apocalypse, we had found Hell! It was as if we ourselves were now discovering an ancient dynasty, an undiscovered cavern, a world of a million years ago!

The manager added that this would be all gone within the week, nature closing it and cocooning the cavern we had now entered, as if sealing off the treasure chambers in an ancient pyramid.

There in the centre of this fossilised cavern we had just entered was something best described as what could have been an early first world war army tank that had been left in a time long forgotten.

But of course, it wasn't, it was the huge machine that cuts the coal face, that several operators had only months earlier used to keep the colliery supplied from the new coal seam, meant to be forever slowly moving forward opening the face.

The machine was now idle, still, but more than that, it was being reclaimed by the forces of nature. Already it was half embedded and had actually become part of surrounding rock that was actually merging into it, not so much crushing the machine but becoming as one, a total metamorphosis, as if it and its surroundings were now evolving as one.

The lower half of the machine had already been claimed by the rising rock, becoming part of the floor surface we scrambled over. The cavern ceiling now down to the height of what was once its operators seating and controls. This is something you would expect to happen over a millennium – but this had happened over just months – such was the extreme pressures that exists this far below the surface – a sight I shall never personally forget – it was deathly still, even ghost like, something so alien and as if out of another world, something you would expect to see in a science fiction horror movie.

This mine is lost said the manger, the miners are up there fighting for something which probably can never be reopened anyway, a total dereliction by man.

The journey back up was as scary as our arrival but we forged ahead knowing we were eventually to see the light of day on the surface. It was only when we went to the shower rooms and saw our own reflection, I looked as I remembered the old pictures of my uncles of the past who were all miners. We were completely blacked out, our overalls wet and torn from crawling in the tunnels, gloves torn leaving our hands scratched and bleeding.

At the end of the working shift we left with the miners, once again huddled in the battered van, drivers helmeted and again everyone ready for the pounding from the picket line.

The picket line had been there all day, us now giving them their chance yet again to vent their anger and frustration – and anger it was! Now being greeted by the darkness of the night, the vans moved slowly towards the exit gates. Instantly we were attacked, our van shaking from side to side as the waiting men threw themselves at the van, screams, shouting abuse, bricks hurdling at us as we tried to escape the mass of the picket line – police again on hand and ready to engage to strikers – the stage set for this tragic daily repetition of war and anarchy.

A police van followed us out into the streets, stopping after a few hundred yards to block the road behind us, this stopping any attempts for any picket's cars to follow the vans.

The miners inside our van (and in the line of those vans travelling in front of us) had done all we had, plus they had worked a hard day in the mine. In our guilt we realised the working miners hadn't had the luxury of a warm managers office to relax in afterwards, they were not going back anonymously to a comfortable hotel to rest and have drinks, followed by dinner – they were in fact going home to the worries and concerns of just living.

They couldn't leave their houses, no more happy trips to the local pub – the strikers were the majority and held the town. Whether their cause was right or wrong, these working miners were without any doubt heroes (as were their wives and children). They lived a life of having to look over their shoulders, of constant abuse and isolation – former friends and families forever turning their backs on them.

The strike was to last twelve months before the miners capitulated, the striking miners voting for an official return to work in March 1985.

The Government had branded the striking miners as 'the enemy within.'

When the strike finally ended, it was estimated that the total cost had been £3 billion. Two striking miners had lost their lives, over 7000 arrested and 2000 injured, some seriously.

Whole communities, which were built on the black stuff, pit villages, which were renowned for their close-knit spirit, had been at war, now lay broken. The healing process was to take a long time – in some cases it never did return to its previous state, with many deciding to leave the previously harmonious villages.

Many of the threatened mine closures, the cause of the strike, took place in 1992.

Scabs or strikers – there were no winners amongst the miners – all heroes, all victims!

# 21

## SOVIET SUBMARINE, JAMES BOND AND VODKA

'Nothing is stranger than the truth' is an old saying – never more relevant than when I was working in Pinewood on the James Bond movie *The Spy Who Loved Me*.

This stared Roger Moore alongside the beautiful Barbara Bach – and in a smaller role, at the time a firm favourite amongst the UK males, Caroline Munroe.

Whilst a lot of the filming was done in Egypt, Sardinia and the Bahamas – back here in Pinewood Studios the biggest sound stage ever built had been created to depict the interior of the villain's giant super tanker, containing captured British, American and Soviet nuclear submarines. It was on this set in the UK, prior to the movies show piece explosion sequences (the spectacular destruction of the tanker) that I had one of the strangest personal encounters of my career. I remember on that day security was on a high level as the studio had the Prime Minister and several high-ranking officials being shown around – so everyone was on their best (and most disciplined) behaviour.

I was photographing the huge submarines (remember these were totally full-sized and detailed) on the set when someone approached me from behind speaking with a Russian accent, asking if I had photographed the Soviet submarine. Obviously, I had, I was photographing the whole set, which was taking hours slowly moving around from one side to the other.

My new Russian-speaking companion (complete in naval uniform) then produced his business card, introducing himself as Captain Boris Morzhitsky, the Assistant Naval Attaché to the Embassy of the USSR London.

He commented openly on the similarities of the mocked-up Soviet submarine on the set in regard to the actual real submarines in the Soviet Navy. Stressing his concern and interest on several details visible on the film mock-ups which were only featured on their more recent, and so far, he assumed, secret versions of their actual nuclear submarines.

Here, I must admit, I did look furtively around in case this was some kind of wind-up by the film crew or the cast of stuntmen who were there rehearsing for the explosion scenes (jokes were always a favourite pass-time during the long boring hours between filming). No obvious signs of jokers, my Russian friend still being serious and attentive.

"Can you send me a photograph of the submarines?" was his request.

Obviously, I agreed, we shook hands and at that he disappeared as quickly as he had first appeared.

No time for anything else, the claxons sounding to clear the set for the first explosion rehearsal.

Several days later, after checking that the address on my Russians business card was genuine and the correct one for the USSR Embassy (in case all this still was a joke), I posted the photographs.

A week later found me outside the house Angela and I had just bought in North London. I was digging postholes for our new wider driveway gates (this to get our newly acquired Rolls Royce into the garage).

Obviously digging new holes, moving countless bags of cement and mixing concrete was all proving to be a particularly cumbersome and messy job. So, dressed accordingly in my oldest gardening clothes, now also cement covered, my attire complete with Wellington boots, an old cap and rubber gloves, I was not my usual well-dressed self and certainly not in a state to receive guests – to say the least!

So suddenly when I was put into the shadow by a huge black limousine, which pulled up right alongside me, I immediately thought how at this particular moment in time there wasn't anyone who I would like to meet or be seen by! Nevertheless, popping out, with a chauffeur opening the door was my Boris Morzhitsky, the immaculately dressed (still in full uniform), smiling friendly Russian who I had met earlier on the Bond movie set.

"How are you Ken?" the Russian dialect going way over my head, but in any language, it is always possible to read a greeting.

"Hi! I am well," I stuttered embarrassingly as I struggled to remove my now cement cased rubber gloves to shake hands.

"The photographs were perfect, I come to thank you very much," said Boris passing me a bottle of their special Soviet Embassy Vodka as a gift.

At that he made a quick look (a sort of recce') around? He gave me a salute and with the chauffer still holding the door, disappeared back into the limo. Chauffer following and the limo speeding away – all over within minutes

I did make enquiries to the Pinewood press office on invited people that were allowed on the set that day, certainly without doubt due to security no one had been invited from the USSR Embassy?

So another mystery, how had the Russian gained access to the movies set (did his naval uniform make him more or less invisible – it was a naval movie, even Roger Moore was wearing a naval uniform) and what particular details was he interested in on the mock-up submarines? The studio did, purely as routine, mention the story to a British Home Office official, who later telephoned me, but there was nothing else to add.

But why did my Russian personally come to my home to thank me? Was he in fact there to check 'me' out as genuine?

A mystery for the archives, one that we will never know!

# 22

## A SECRET RENDEZVOUS IN THE CLOUDS

For a few years it became a sort of tradition that for Angela's birthday I would arrange a flying lesson. It wasn't that she was serious in gaining a pilot's licence, it was just an experience that she enjoyed, helicopter or fixed wing.

So, on this particular year I had booked a lesson in one of Angela's favourite aircraft, a high wing Cessna, this at Biggin Hill.

We arrived, the usual pre-flight check for Angela and then half an hour later she was streaming down the runway and up and off into the sky-blue yonder.

Only this time I had thought of something different, so as soon as she was up in the air, I rushed from the tower to meet my own pilot – I had booked a second Cessna. We took off; with my own pilot secretly radioing Angela's pilot to find out their location.

Keeping at a slightly lower level, unknown to Angela, we made our way to a meeting point the pilots had previously agreed upon. Eventually we could see Angela's Cessna in the distance and made our way to it from behind, keeping at the lower level so as not to be visual in Angela's sightline.

Over the radio, Angela thinking I was speaking from the tower, I asked her how things were going – as she was describing her location my pilot brought our Cessna from under Angela's and sidestepped to her side, now flying level with her some ten meters away.

The look of surprise on Angela's face as she saw me flying next to her, me waving like mad, was amazing. I took a few photographs of her and after a brief radio chat we peeled off leaving her to enjoy her birthday lesson, with me returning to Biggin Hill.

# 23

## A GLAMOROUS ACTRESS AND
## A BROKEN DOOR

It had always been said that Cubby Broccoli had personally chosen Caroline Munroe to be in his Bond movie after seeing her in the Lamb's Navy Rum television campaign. During this time, she had become a firm favourite of the British males, but as an actress had never seemed to hit the real big time that she possibility deserved, a sort of glamorous actress forever in waiting! She made several lower budget horror and science fiction movies, but it was the Bond movie which gave her the biggest chance.

At Pinewood Studios, although I had talked to Caroline on several occasions, there was little chance of me taking any glamorous photographs of her there, she had done most of her filming on location so anything around the studio would have to be just ordinary snaps, nothing glamorous. Certainly, I didn't want to be the photographer who worked with one of the sexiest looking actresses of the time and took back a snap of her sat in a chair in Pinewoods reception area.

So Caroline and I agreed that I would go to her apartment where we would work on something a little more glamorous, she could try on a few different outfits she jokingly quipped.

A week later when I arrived at her place, I found it to be in total chaos. She had just moved in, everything a bit of a mess with the white wooden door from between the passage and the lounge having literally been taken off its hinges and leaned against the wall. Nevertheless, Caroline still looked amazing, casually dressed in a T-shirt and jeans and as usual. She oozed sex appeal.

I started to unpack my lights and set up the camera while Caroline went into the bedroom to bring out the outfits which she had already chosen, the idea was then we would work on a few ideas.

Here every photographer must use these vital minutes whilst setting-up his lights and camera to think of something different – I looked around – a fur blanket on the sofa caught my eye, and so did the door having been left leaning against the wall.

By the time Caroline appeared I had moved the door, placing it across two dining chairs which now provided me with a flat six-foot long stage. Putting all this against a white wall, with my lighting now all set up, all this made a perfect impromptu studio platform – and yes, the fur blanket was the only other accessory I needed to complete the photograph.

Caroline smiled, instantly knowing where I was going with this idea. Now looking down at the selection of outfits she had brought with her from the bedroom – "I assume I won't be needing these then!" laughingly Caroline dropped her selected garments on a nearby chair.

She picked up the fur, took it back into the bedroom and returned a few minutes later, wearing nothing else but clutching the fur around her.

Totally professional, in what is probably one of the nearest to nude photographs she has ever done. She positioned herself lying full length along my improvised studio platform (a wooden door balanced across two dining chairs) and gathering the fur around her – within seconds she was the glamorous actress and the face that launched a thousand, probably a million, glasses of Lamb's Navy Rum. She looked absolutely amazing – as the photograph shows

Appearing within two days across the pages of the daily newspapers – 'Bond Girl Lays Bare'. A totally professional and beautiful lady – an example of how you don't need to be in an exotic location to get a glamorous photograph.

# 24

## WE ARE SAILING – WELL NEARLY!

Want to sail the seas, the blue idyllic waters of the Greeks islands – easy – just charter your own five berths twenty-nine-foot yacht and enjoy the splendour of the idyllic seas as you spend day after day island hopping, steering your own magnificent white sailed yacht into paradise.

That's just what Angela and I did – problem? Only one – we had never sailed in our life before!

To charter the yacht in the location we wanted, offering a mix between bare-boating and a flotilla-sailing we had to have a good seafaring knowledge and experience, groups who applied had to have at least one member of the (up-to five) crew who had sailed.

No problems for Angela and myself we thought, we had several months before our charter, just how difficult can it be?

So, to complete the booking forms questionnaire on our experience, I purchased a sailing monthly style magazine and from here we extracted the names of several twenty-something long yachts which I said we had sailed. Our experience complete, booking sent off, confirmation received – we now had just one task in mind – how to sail a yacht? We had eight weeks and lived in North London (not exactly a sea going location).

First things first, a 'Simple Guide to Yachting' (self-learn) book was purchased – this along with a child's wooden toy yacht, complete with sail and jib, the type you would sail on a pond.

Here, after breaking off the bottom keel (so it could stand upright on our carpet), we would move the sails (moving a cardboard arrow placed to the side showing wind direction) so we could imagine how we would tack and turn.

Of course, even we knew this was never enough, so we drove up to Broxbourne Reservoir where we had booked a course of four lessons in a sixteen-foot open Wayfarer dinghy at their sailing club. This plus another book, this on navigation – just how difficult could all this be?

Our chosen destination was Greece with its soft breezes and idyllic, calm seas. We would sail along the Lefkas Canal and then spend our days peacefully cruising around the assorted islands of the Ionian Sea.

On the night we arrived in Greece, being transported to the harbour where a line-up of our twenty-nine-foot (five berth) yachts were tied up, the fist shock was their size! It was already late evening and even with the harbour being floodlit, the masts of the yachts were so tall they disappeared up into the darkness of the sky.

We unpacked and slept in our assigned yacht (our home for the next seven days), an earlier meet and greet drink being held in the local tavern with the organisers and the designated captain of each yacht. As said previously, ours was a mix between bare-boating (entirely on your own) and a flotilla (strictly follow the leader). We would be given freedom to make our own way to the agreed island meeting places, meeting every other night and there anchoring as a flotilla. So, the next morning, prior to embarking, we had the captain's meeting where we went through charts and agreed meeting points. Our first task of the day, down the Lefkas Canal and out to sea, and then on to the first evenings island meeting, dinner being booked for us all at the local tavern.

So back on our yacht Angela and I surveyed our 'ship'. Certainly, we thought big enough for us to call it a ship, all the other crews were of four and five people, no doubt they all thinking how we must be vastly more experienced than they, with us taking on this huge vessel with only the two of us to sail it! Worry and trepidation was hitting us like a giant wave (more still to come).

Ropes (dock lines, bow lines, stern lines and warps) were going into the sea and onto the harbour side from every direction, looking at them I wasn't sure if we untie them and throw them on to the harbour side, untie and pull them on to our yacht or even just cut the things (well that's what they do in the pirate movies).

So, I did the only thing an experienced sea going captain could do, I waited until our next-door neighbour, the yacht right next to us started to 'make ready' for the sea. So, as he untied a rope, so did we, as he pulled in or threw away a rope – we did the same.

Unfortunately, it didn't take our neighbour long to suss out we were complete novices, with no experience whatsoever – Mick and his wife Peg, with their family friend Ern (crew of three) were to bond with us that minute and

become friends for many, many years to come. Setting off and sailing along-side Mick's yacht, he shouted us instructions as we quickly ventured down the Lefkas Canal and out to sea, again keeping next to them and mirroring their every move.

It is actually amazing how in this situation every second gives you more and more knowledge and experience – by the end of the day we were accomplishing every manoeuvre, the anchoring and engine procedures – admittedly with Mick's help and guidance – we had buddied up for the first two days sailing.

Of course, every holiday brochure talks of idyllic seas, light winds and clear blue skies – well it's a bit like the old saying when asked when you want to go – 'the same week as your brochure photographer' being the reply.

Whilst this week was another of the most exhilarating of our life experiences, it was also the most unnerving and nearly disastrous.

First there are moments when you achieve perfection, very little can ever take away the memory of 'goose-winging' on the open sea, completely on your own (by the very fact you are actual in that manoeuvre) sailing perfectly – everything exactly textbook when sailing downwind! Having your mainsail set to the leeward and your jib set to the windward with the sea gentle lapping at your hull is one of the most fulfilling moments of sailing, the yacht takes on the look of a giant swan (or goose) with its wings outstretched each side, totally magnificent. You are doing this without the aid of motors or electronics, in total silence just you, your own judgement and the sea and wind – a magical moment that lasts in the memory banks forever.

In our innocence, never really getting enough confidence to stretch out each day into pleasure sailing, on most daily trips we made a special effort to navigate directly to our selected end-of-day port, no happy sailing in circles for us, a straight line on our charts, from A to B. Consequently, with our exuberant efforts to get our legs on dry land we were usually first to arrive at any of the designated destinations for the full flotilla meet. What we didn't appreciate was that it was the flotilla leader that usually assumes this grand first 'pole' position, one which when we all arrived, we would see and gather around, anchoring or tying up next to. Therefore, in the case of Angela and I usually now being the first to arrive in a harbour, we were always naively overwhelmed by the friendliness and welcoming approaches of the port-side taverna owners, all eagerly beckoning and waving at us as we sailed in. All this and when we did decide which beckoning taverna owner to tie up next

to, we were given an amazingly warm welcome, a free meal and lots of drinks? Yes, of course at the end of our cruise the organisers told us that these nice friendly taverna owners were under the assumption that as our boat sailed in first, then we must obviously be the flotilla leaders and that all other arriving yachts would congregate around the first yacht (as did happen), and this is where the whole group would berth and dine (as did happen).

On the opposite side, dark stormy skies can dramatically appear within minutes without warning, high winds channelling down from mountainous islands catching you out whilst enjoying a lazy sail into port. Several days (remember the 'idyllic light winds') were spent challenging the force seven and eight gale-force winds and seas themselves – racing to the safety of the nearest port, only to find yachts escaping from it as the winds were making harbouring too dangerous. On to the next port or island, radio warnings coming over our speaker. No book we ever read, or morning captain's meeting explained these phenomena's – these experiences you must suffer and learn yourself. This where you shiver in the cold winds with icy seas breaking over your hull, having no warning of the weather change, even too fast for you to change from your swimming costume into a waterproof jacket, even struggling to just reach your nearby lifejacket – in this situation you are truly alone. More than once, trying to bring down the mainsail I physically tied myself the mast so I could work with both hands, reefing the sail, leaving Angela alone to navigate the yacht and make sure that the wind did not shift causing the sail to move and drop me into the drink!

One of our group's yachts had been de-masted, another which had made it into a port, tied up, with the whole crew abandoning ship, all flying home the next day. Although we had our problems by crewing such a large yacht with just the two of us, other yachts crewed by four or five had their own problems with such a tight environment and restricted space – and as they say, there can be only one captain on a ship!

But all that was another day long gone and today is another day's sail, the sea calm and the sun shining. We sailed on our own to a small abandoned island where we had planned a quiet romantic evening, tying up at the old dilapidated village jetty.

The village was totally deserted, for years uninhibited, the wilderness and nature having reclaimed most of the old stone-built cottages – a romantic evening we thought, but on arrival walking up the old streets to the church on the high ground made it feel very remote and eerie. Rather than a romantic

setting it had more a feeling of a scene from a horror movie. Doors of the deserted cottages swung and rattled in the breeze; sinister whistling noises came from the windowless buildings with ghost like images flashing inside the cottages (probably reflections from the sun we decided – hopefully). With the church looming towards us and presenting more a scene from a Dracula movie than our hopeful romantic setting, we made a quick decision and ten minutes later we were motoring out of the bay setting sail for the next island.

This actually brought us into one of the most enjoyable evenings of our trip, sailing into the harbour we saw several of our fellow yachts, with two more on the horizon following us in. This unscheduled meeting of our flotilla, a free night without the leader, made it a rather special fun occasion for us all, with one tavern owner no doubt feeling rather wealthy after our raucous and somewhat wine filled evening.

The week has such amazing memories, and as is in life you put aside the disastrous side and think only of the fun and camaraderie. Filling some one's dinghy with rocks after we all paddle ashore to meet for a meal and drinks. Falling from your dinghy fully dressed as you leave another yacht after a wild and silly evening drinks party – a sea shanty certainly worth remembering.

# 25

## KENNY EVERETT'S RED-HOT DANCE GROUP

One television series which included red-hot innuendos and extreme sexuality, not to mention the filthiest jokes ever told on television, would certainly in these present times of 'political correctness' be the cause of any television company to be closed down in seconds – but back in the early eighties it still went ahead, even with the 'moral guard' of Mary Whitehouse condemning every single show – welcome to *The Kenny Everett Video Show*.

Kenny had risen to the very top from a bunch of extremely talented DJ's who had challenged the establishment on the newly established iconic 'Pirate Radio'. He quickly made his reputation as one of Britain's top performers with his weird and zany humour.

Suddenly launched on television, first titled *The Kenny Everett Video Show*, he pushed his zany humour to the extreme, even introducing his own cast of very sexy dancers –with the controversial dance group Hot Gossip exploding onto our television screens. At the time all this was considered to be extremely risqué, plus he had also combined this with a host of saucy, sexist and political sketches – but unbelievably the ratings went up and up. The fact that the show was denounced weekly seemed only to attract more and more viewers – it was the show everyone would talk about the next day at their workplace, the nation was intrigued, shocked and yet seemed to love every minute.

Which is where my connection with Kenny and his dance team started! I had hit on the opportunity when first reading the press release on Kenny's coming series. Telephone introductions made to his management team, within two days I was there to meet them at the studio on one of its first Kenny Everett show productions. At this stage my interest was more in photographing the dance group. Although it was Kenny's ragbag of jokes and send-ups of his star guests that made the show, for the male viewers it was the sexy dancers, Hot Gossip, who had them spellbound in front of their television screens.

Although my first photographic sessions were for the newspapers, Kenny's management commissioned me to take more and more photographs throughout the series production – with the result that for a while I became one of their team.

Each week on the show, Kenny would introduce Hot Gossip as his 'Naughty Bit', where the group would perform an over the top steamy sex bump-and-grind raunchy routine, choreographed by the future *Strictly* judge, Arlene Philips. These routines were far removed from what we were all too familiar with the strait-laced and immaculately costumed Tiller Girls of the London Palladium, who at that time were as sexy as it got?

Knowing the reaction, the dancers would create, Kenny was quick to direct his own particular style of sarcasm towards his objectors and protesters. So immediately after the dancers' performance, he would face squarely up to the camera, dressed in an old lady's wig and coat, wearing horn-rimmed glasses and carrying a handbag (spoofing anti-smut campaigner Mary Whitehouse herself), he would denounce the dancers for their over-expanse of bare flesh and open sexuality. Sarcastically, as an angry complainer, shouting about the show's rudeness, all this before Mary Whitehouse could do it herself the next day.

All this constant stream of publicity increased the demand for more Hot Gossip photographs, and of course I was happy to oblige!

Model and actress Cleo Rocos became a huge friend of Kenny, appearing regularly in the show. Over the years previously I had booked Cleo several times, so we were already friends and she was a regular in my studio. Now on the *Kenny Everett Video Show*, she was the girl of the moment, adding a lot of glamour to his fun sketches, totally professional.

One hugely funny real-life episode was when Kenny's fame had spread so much that film director Michael Winner invited Kenny to address a rally of young conservatives, this was just ten days before the General Election. In an earlier programme Kenny had used a giant pair of rubber foam hands (now used everywhere), so Winner asked him to bring them along for some light relief, hopefully Kenny adding a little fun to the proceedings.

Kenny walked on stage in front of over 2000 loyal Conservative followers, watched by the television cameras and in the presence of the Iron Lady herself, Margaret Thatcher. Receiving a humongous round of applause and nonstop cheering, Kenny walked forward waving his giant foam hands in the air – as it went quiet, everyone expected a rehearsed and approved political

speech, but Kenny suddenly shouted – "Let's bomb Russia" – the crowd went absolutely wild, the cheers, applause and laughter lasting a full ten minutes. Margaret Thatcher walked on stage afterwards with a frozen smile as if in a daze.

His television show produced a huge number of sketches that saw stars such as Cliff Richard, David Bowie, Elton John and Freddy Mercury all allowing themselves to be exposed to Kenny's ferocious jokes and absolute unbelievable ridicule – and they loved every minute of it. Kenny would introduce his top line guests by looking straight at the television camera saying, "Are you tired of seeing fabulous good-looking talented superstars, so am I – so here is Elton John!"

Kenny would always end his show with "Well kids, that's the end, I hope you liked the show. If you didn't, it's too late – I have already got the money!"

# 26

## LIVE AID – AND I DIDN'T EVEN SEE THE CONCERT!

*I had worked the odd time with Noel Edmonds, and it was a passing comment from him that first caught my attention – "Biggest charity concert ever to be held."*

*And that was the opening line for my involvement in what was truly, certainly, without doubt to be – the biggest worldwide pop concert ever attempted!*

Although never really given any acclaim, it was always said that it was Boy George who was the very first to suggest the Live Aid Concert idea, this to Bob Geldof (after Bob's success with the 'Do They Know It's Christmas' charity single).

Bob Geldof took this up and with Midge Ure and a few others, including Noel Edmonds, in 1985 the whole thing came together. During all the set-up time (over three months) I had been invited to several of the meetings (originally covering the snippets of gossip for the *Sun*). As time went on, being amongst them at so many of the meetings I was more and more becoming accepted by the organising group and eventually somehow (I never quite knew how it actually happened) finally becoming one of the photographers involved in the concert – my task (a photographer dream job) was working onboard the helicopters photographing, accompanying and travelling with the stars as they were collected and delivered to the Wembley Stadium.

With the difficult logistics of getting the performers in and out of Wembley it was decided using helicopters could be the only answer. So, there I was, at Wembley hopping on and off the helicopters like someone would a bus, finding the destination of the next outgoing flight and who was to be its pop legend passenger. Then simply climbing aboard and going for the ride. Getting so many exclusive amazing photographs, it was mind-blowing! Flying to an agreed point (a park, a field or some one's huge garden) to collect one of the stars and then flying back to Wembley – a totally amazing experience. Joking with Elton John, George Michael and the likes of David

Bowie (the list goes on and on) was all part of the excitement – everyone was really on a high!

Of course, like with every great opportunity, there always is a downside – mine was that out of the global audience of Live Aid, which was 1.9 billion, across a staggering 150 nations – I was probably one of the few people in the world who didn't see the concert!

Months earlier Angela and I had booked a week away together, making sure it didn't conflict with her agency bookings or any work I had planned, a rare and not to be missed totally free week in our diary! We had our flights booked and were on our way to our beach-side property in Spain for a much-needed break. Unfortunately, as happens in life, all this turned out later to be the exact same day as Live Aid.

But as agreed from the start, late afternoon when most of the transportation of superstars was concluded Noel Edmonds on one of his last helicopter flights dropped me off in a field halfway between Wembley and Luton Airport where Angela was waiting in the car. At the same time I handed over all rolls of the film I had taken over the day (which held all the amazing photographs of so many stars), this to Noel, who would have it processed and distribute to the national newspapers on behalf of the Live Aid organisers.

A truly exciting star-studded day on which if Angela and I had not booked our trip, we would have no doubt finished with us joining in with the stars and enjoying the concert all night – however in those days, believe it or not, this was just another day at the office – and for Angela and I, our week away together was more important.

# 27

## AND SO, THE STORIES GO ON AND ON

All during these years the 'Ross Studio' next to Fleet Street became one of the most known by celebrities, a constant stream of television stars, models and pop stars all making the daily pilgrimage. Although my foreign assignments were now becoming nonstop, I even remembering once when someone shouted about another available press-junket to America, I actually turned it down, emphasising as an excuse not to go that I had only just returned from Miami two days earlier.

Some photographic sessions were hugely successful, others a total failure. For a showbusiness-photographer every session has to be looked at as an investment – some you like, some you do not. Some make your name (and a great fee), some you never find a buyer for and the photographs stay in the darkness of the filing cabinet.

One particular case comes to mind, after a press screening of an absolutely terrible movie, which actually had a host of stars including Fay Dunaway, John Gielgud, and Alan Bates and was directed by Michael Winner (it was a remake of the earlier old black and white film *The Wicked Lady*). There I met and talked to Marina Sirtis, an actress in the movie who seemingly was the only one who had the courage to attend the press showing in real life. She had a minor role in a scene in which Fay Dunaway used a whip on a local peasant girl (played by Marina), which saw some of her clothing being ripped off. Slight titillation for the audience, probably added to try and bring the movie into the modern times, but in fact so mild it only added to the boredom. Marina herself was a nice girl who you felt was even embarrassed at her part in the movie, so feeling obliged but without any real enthusiasm, I arranged to take some photographs of her the following day.

Consequently, next day we tried a few ideas, a sort of glamorous semi-topless set of pictures but it wasn't a particularly memorable session, nevertheless one of the photographs was used the following week in a critic's movie page, at least it gave Marina a nice plug, but as for the movie, a scathing review.

Marina's picture brought in no worthwhile financial reward, but I did feel good about helping her, she was one of these hard-working young actresses who you meet on movie screening events and she certainly deserved the help and encouragement.

But, as I said earlier – you sometimes have to look at some sessions as an investment, and this business is full of surprises! Nearly a year later with a huge fanfare and press launching, the new *Star Trek: The Next Generation* was to hit our television screen. Amongst the cast, headed by Patrick Stewart was a young unknown actress, Marina Sirtis, who had been given a starring role in the new series. She was to play the part of Deanna Troi, the starship's counsellor. Marina, who for six months had been trying to pursue her career in America, later told me how on the day she received a call offering her the *Star Trek* role, she was actually packing to return to Britain, she was about to give up as her visa had expired – now suddenly she was Hollywood hot property!

Back in the UK newspapers and magazines clambered to request photo sessions with her, obviously impossible due to her now being in America – but I was here with a library of recent photographs of the star – job done!

With success comes the obvious rewards. Our lifestyle for two Northerners was truly out of this world. And yet with all the razzamatazz and showbiz possibilities, when it came to weekends, Angela and I would like nothing more than a weekend on the River Thames. Picking up the telephone and asking the boatyard (Bensons) if they had a boat for the weekend (these were simpler times, back when they still had the famous Benson Fiesta, a sort of floating caravan for two, lounge/kitchen plus a bedroom with a shower-room and toilet – perfect weekenders). We would throw a few bits and pieces in a bag, grab the dog and jump in the car – what a weekend. Once on board we would always cruise down to Goring Lock, tying up at the Swan Restaurant, in Streatley. If you booked a table for dinner here, you could berth right outside the restaurant for free and in the morning you had the use of use the hotels shower rooms and toilet facilities (remember what I said about simpler times). An absolutely amazing top restaurant, although probably less formal back then where we remember clients would generally join together and finish with a singsong around the piano. It always took a double take for people we had befriended for the night when as it all ended and everyone was going to their very expensive rooms, we would walk out to the patio and step on to our boat – what a way to spend an evening.

Yes, we loved the club life, the Playboy, Stringfellows and of course the terribly upmarket and exclusive Tramp and Annabelle's, but away from it all, it was our private time together we loved most.

## The ones you never forget

I still have countless untold stories of centrespreads, front pages and huge glamorous features which all appeared in the national press and magazines, stories of humour, drama and yes, sometimes even tears.

Some photographic assignments are quickly forgotten, others I will remember until the day I die. Newspaper trips that included skiing were Angela's and my favourite winter assignments, projects where we would always arrange to work together over Christmas or New Year. Working in France, Austria or Italy for a day or two was usually all that was needed, giving us free time for the rest of the week to enjoy our skiing – superb! Other favourite assignments were covering movies, there to record the whole story or just being there to take a set of glamorous promotional pictures of the stars. Whether a high-end budget Bond movie or a lower budget movie with (ex- Bond baddie, Blofeld) Donald Pleasence, who on this occasion was accompanied for the Malta shoot by a bevy of beautiful models – a nonstop photographic holiday for me!

I particularly enjoyed a three-week assignment working with Richard Branson, photographing him on his famous canal barge (office) and in our London studio. I also worked at his home photographing Richard and his family, where lunch consisted of the thickest cut bread and cheese sandwiches I have ever been served, but to bring it into prospective, all washed down with a rather superbly chilled vintage champagne.

Two of my personal favourite photographs are the Miami picture of Angela with the motorcycle policeman, the second is a studio picture of a set of beautiful girls (well at least after two attempts, the second attempt needing stylists, makeup and a hairdresser), the McClain twins.

All adding to the most amazing memories that you make, collect and create throughout your career – although like in all aspects, it is always the first you remember most, not necessarily the most glamorous, in my case the Hyde Park photographs of the police and rioters which I sold throughout Fleet Street and to *News at Ten* – the photographs that started it all!

# 28

## ANGELA ROSS, GIRLFRIEND, MODEL AND ACTRESS

Throughout my journey within these pages I have mentioned and described some of my life with Angela and about her career, to the extent that it would be unfair to finalise my autobiography without at least summing up her own amazing career – one that ran so close to my own.

When arriving in London our careers in many ways were entwined, such was our closeness that it became more by instinct to help one another in each of our projects of the day.

### Here Angela, in brief, tells her own story:

I had been brought up in coal mining village, where my father (as every other father) was a coal miner in Washington, Tyne and Wear. My mother struggled her way throughout my childhood working as a nurse at various major hospitals in Newcastle including the prestigious R.V.I. When not working or looking after the family she would use any free time to study, eventually, due to her hard work and dedication she achieved the position of Nursing Sister and then progressed on to Ward Matron.

Don't forget that these were the days when it was frowned upon for women to have to go out work. My father was always embarrassed that his wife worked, but I was so proud of my mother, not only was she beautiful but she was strong and independent as well. She brought up two children (myself and my younger brother Tom) and at the same time passed all her complex medical exams – gaining the titles of Anne Johnston, S.R.N and R.M.N.

So, for me, one day I was a shy little girl from a little village just outside Newcastle and the next I was one of the elite models in Manchester, eventually going on to be a successful top model in London. I had reached such dizzy heights in such a short space of time – the 'rollercoaster' of my life had begun!

Having moved from Manchester and staying with friends in London, for a while I was alone in the 'Big City' – using my free time to look for somewhere for Ken and myself to live. I didn't even know where to start. First, I went to my Model agent, Don Rosay for advice – big mistake. I didn't realise that he was such a snob and a drama queen that he would never dream of recommending anything less than the very expensive Knightsbridge, or at least Kensington area! Eventually, being more realistic, I found a nice apartment in Golders Green. Don and his partner Alex, were horrified ("Darling, it's in the middle of nowhere," they exclaimed). Actually, I found out later that it was quite a trendy area, being just within the Hampstead borders which housed a sort of 'Primrose Hill' style actors and models jet-set enclave of its day. One of my nearest 'next door' neighbours was none other than top model Jilly Johnson who was also with my agency. She was then a well-established Page 3 model and good friends with Nina Carter, another well-known model and Page 3 favourite. The three of us became firm friends and worked on many top assignments throughout the world. Jilly and Nina, being singers, later formed Blonde on Blonde and made a success as a glamorous singing duo.

In London my feet didn't touch the ground, my career was more a rocket launch rather than my expected slow climb. The *Sun* was another prospective client that had been regularly approaching my agency. Their staff photographer Beverly Goodway wanted me for the papers legendary Page 3, I was never quite sure and I had often sidestepped the issue of whether I wanted to do it or not. Eventually he and I did meet up, more by accident than anything else, at a press call which I was appearing at while under contract with the giant Swedish lingerie Company, Abecita. A few months later after my contract with them had expired he finally persuaded me to give it a try. I had already appeared in several of the *Sun*'s television advertisements so in the newspaper's eyes it was a simple progression that I should now feature on their Page 3. It was a nice experience and it was only due to several new exclusivity contracts with some larger worldwide companies that saw me having to terminate my short but fun and highly successful run with the paper. In my short time I had quickly become one of their favourites.

As my career moved forward former small studio assignments from Manchester soon progressed into top London agency bookings with their subsequent glamorous and amazing locations. Low budget photoshoots now being exchanged for seemingly endless weekly trips throughout the Mediterranean and beyond. I was now being flown out to exotic locations

such as the famous Safari lodge, Treetops (Kenya Tourist Board), and on several occasions the golden beaches of Mombasa (British Airways). On one occasion only five days after returning from Mombasa Beach I found myself journeying back to exactly the same beachside hotel on assignment for a famous tanning cream. There were also the magical locations such as Kuala Lumpur (photographed there as part of a two-year special contract for Slazenger). Others included the snow-covered resort of the rich and famous, Saint-Moritz, (a photoshoot for White Horse Whisky). Then there were the private jets, one such occasion was when I was flown all around Israel to be photographed in the most beautiful historic and stunning locations, a huge advertising campaign for the Israeli Tourist Board.

I was enjoying a huge success and we were living the life, my face was suddenly seen on huge billboards, at the same time I was on thirty-foot long posters on the side of London buses. I was also featured in many adverts throughout the London tube stations; in one of the posters, a very tasteful lingerie advertisement (by one of the top labels), someone, somehow, complained to the advertising authority that on the poster they could see the outline or shadow of a nipple through the bra. This made the news, the posters were on the escalator walls and to look closely you only had a few seconds as you whizzed past, but nevertheless the complaint was upheld, and the advertisement posters had to be replaced with a new set which had to be all retouched. This cost the lingerie label thousands of pounds in reprinting and changing them everywhere. Nevertheless, the extra publicity for them, which made the front page of every newspaper and becoming television news was all worthwhile. I was interviewed by newspapers and on television, everyone asking for my personal opinion – for a while I became a household name. All over a complaint, that these days would be laughed off in seconds, with the original posters then becoming collectors' items.

Suddenly I became the face, or body, of every major lingerie label. After several exhausting castings which involved most of London's top models, I was chosen to be the face of Gossard, being their first major plunge bra promotion, with my photograph being in literally every magazine throughout the world.

Television castings were the next offerings from my agency, I was chosen for a staggering twenty-two television commercials throughout my career.

There were several small parts in movies following, but by then I had basically had enough, the glamour was wearing thin and I had other interests, no longer wanting to be told where to stand, I now wanted to direct and produce

my own projects, to be at the other side of the camera. Consequently, together Ken and I ventured into publishing a glossy celebrity packed showbusiness magazine.

*Here, the following pages showcase just a few photographs of Angela's assignments from her modelling and television career. Written in her own words, we include three or four tales (out of the hundreds) of her amazing trips and television appearances.*

Just a small sample of the many international advertising campaigns in which Angela featured

# BRING ME SUNSHINE

One day I walked into the offices of my agency, Top Models, which. as usual, was filled with booking agents, models and photographers. On arriving my agent, Don Rosay, leapt to his feet and raced over to greet me. Don was even more animated than usual, whispering "Darling, you've been asked to attend a special audition. Come through to my office and I'll tell you all about it." With that, he ushered me away as all eyes followed us and all ears were straining to hear what was being said.

"Sorry about the secrecy" said Don, "but the director was most specific that no one involved with the show should talk about it until it is about to go on air by which time the BBC will have put out a press release themselves." Don didn't know why it had to be so secretive but assumed it was for security or copyright. "Anyway, you've been especially asked to attend. It's a casting for *The Morecambe and Wise Christmas Special*. A television director you have worked with before was obviously impressed and has asked that you be cast for the part. They haven't asked to see anyone else... only you."

To be asked to audition for the *Morecambe and Wise Show* was special, but their *Christmas Show* was even more so. It was iconic. Everyone in the whole country would be watching it on Christmas Day – it was traditional – it was television's top audience rated show. Every year this was the talking point throughout the Christmas holidays, with its jokes and sketches being repeated and copied by everyone at their workplace or in the pubs. It was impossible to get away from the endlessly repeated gags, 'get out of that', 'short fat hairy legs' – the jokes, laughter and talk of the sketches and of the star guests would go on and on. So, to be especially asked to attend a casting from these 'comedy giants' was enough of an accolade to really impress my agent, not to mention the open mouths of the other assorted models who were all sat around the agency office waiting to hear if they had any new auditions or bookings.

The casting, or just a friendly meeting, as Ernie Wise laughingly called it,

went well but it was to be a whole week later before my agent rang to confirm that the producers had telephoned to say yes, I had the part.

'Bring sexy black undies' was my only wardrobe call, that and I was told to be ready one hour before the scheduled rehearsal time. Those were my only instructions. Morecambe and Wise were known for their professionalism, their timing and their ad-lib humour. But what I was about to learn was that there was actually no such thing as their ad-lib humour! Every quick joke, every expression, all were timed to perfection. However we were warned that if Eric thought that you were trying to hide a smile or stifle a burst of laughter then he would be quick to spot it and would hound you mercilessly until you were reduced to helpless giggles. I have seen him do this many times and the results are hilarious as the actors struggle to contain their mirth.

The talented Polish/English actress Rula Lenska was on the same show as me although she was in a different sketch and she admitted that she was terrified that she would smile or burst into laughter whenever she was working with Eric and Ernie. They were so incredibly funny and their humour was so contagious, it was really difficult not to laugh.

The skill and expertise from Eric and Ernie was amazing, nothing was left to chance. And yet at the same time they were generous performers, spreading out the many humorous lines between their guests, allowing everyone to take some of the stage credit from the audience. It was like being in a famous family, being a member of a star-studded club, I watched as their star guests arrived, one after another, they again were shown the tight schedule, and again rehearsed their way through the strict timing of the sketch.

## Blink and you miss me!

It was soon time for my rehearsal, this to be alongside Eric and Ernie. Here I must admit to some nervousness. I have worked on television with many legendary television comedians such as Les Dawson, even working with the Goodies, but here, now with these two guys, it seemed even more special. It was a simple routine, but again to Eric and Ernie nothing was considered too simple not to be rehearsed and rehearsed, with the ad-lib and laughter pauses all calculated and timed.

Most of my appearance was with Ernie, part behind a backlit screen. This showing my silhouette, hence me appearing in just bra and panties. With

Eric (followed by Ern) we walked on set then walked behind the screen, so if you weren't quick or if you had popped away from the television to get the sherry, you missed seeing my face. It was a fun sketch, Eric and I were prancing around with our silhouette's letting the audience assume or think what they wanted as regards to who or what we were doing – all very Morecambe and Wise humour, terrifically funny and something very different. It was fun yet above all it was an honour to work with such absolute professionals.

After recording the actual show, the generosity of these two guys came to the front once again, announcing a 'wrap party' on the actual set, under the glare of the lights and amongst the television cameras, with tables and chairs all hastily set up for dining – everyone, stars mingling with the crew, all enjoying a superb meal and drinks set up by their caterers.

Weeks earlier Ken had arranged with the programme producers to pop in and take some publicity photographs of the guys and was also asked by Eric to join us for the wrap. Such a surreal moment, dinner on the set of what within a month or so would be the biggest show on television, no doubt again attracting record-breaking viewing figures of millions – and here I was, with the guys, the stars and crew having dinner! Throughout the pre-drinks and during dinner Eric and Ernie would be constantly moving around the tables ensuring everyone was being looked after, more jokes, more thanks. And there I was, a glass of wine in one hand, having the other shaken by Eric Morecambe whilst he expressed his gratitude for me appearing on his show – what a day!

An amazing showbusiness experience, two of the nicest guys I would never forget.

# A HUNDRED MILES AN HOUR
# WITH BARRY SHEENE

With film star looks and a smile that could melt the heart of the coldest of ice-maidens, Barry Sheene was one of those lucky people who was born to be a star.

Even by the age of twenty he was already the British 125cc Motorcycle Champion, going on to pick up more and more championship titles and fame over the coming years. By the age of twenty-two he was signed by the motorcycle giant Suzuki and in his first year with them he won the Formula 750cc European Championship.

Sheen brought a glamour and sparkle to motorcycle racing that it had never previously enjoyed, suddenly everyone was now watching motorcycle racing. Sheene was the King of the track, a world star with every sponsor beating at his door, an ad man's dream! Sheene was incorrigible, flamboyant, brilliant and sometimes even rude, but the crowds loved him

He was one of the biggest stars of the early eighties and was made in famous after he flashed a cheeky V sign to a fellow competitor. He was racing against the reigning world champion Kenny Roberts and when he overtook Roberts at 180 miles per hour he put his hand behind his back and put two fingers up at him. Sheene lost the race, but that cheeky gesture had made him world famous in the racing world.

Whilst recovering from yet another motorcycle injury and walking with the aid of crutches, on a promotional photoshoot Sheene met and instantly fell in love with glamour model Stephanie McLean, (a former *Penthouse* Pet of the Month and *Penthouse* Pet of the Year). Almost immediately the couple started a glamorous and much-publicised affair, with the result that Stephanie left her husband and moved in with Barry, whom she later married.

Throughout this, Barry and Stephanie enjoyed a star-studded Hollywood lifestyle, socialising particularly with their famous friends. James Hunt, Ringo Starr and George Harrison as well as many other 'A' listers.

It was during these hectic glitzy days that my agent rang me to say that

I had been booked by London's top advertising agency to partner Barry on a special motorcycle photoshoot for Suzuki. I had worked for Suzuki many times before so I had no worries. They would have the motorbikes set up and I would be dressed in cycle gear, swimsuit or just jeans and T-shirt. Then all I had to do was would sit and pose on all the different bikes and be photographed on each one… simples!… no worries?

Now here I have to say that motorcycling is not something I am familiar with, obviously I had seen them whizzing around London, and I had watched Barry, on television as he soared around the racetracks, I had sat and been photographed on many motorbikes, but as for riding on one – never!

Of course, there was no need to worry my agent had assured me that this will be a nice easy photoshoot with me looking glamorous the bike in centre of the photo and probably, Barry Sheene would be there to endorse his approval of Suzuki Bikes. All very glamorous, sitting on a stationary but very beautiful Suzuki bike. All very civilised and all quietly seductive.

Well, there was nothing at all quiet about this shoot! I suppose I knew something wasn't quite right when the Suzuki motorcycle was brought to life with a humongous roar at the side of the track and we were not in a photo studio at all, we were at a pitstop in Brands Hatch.

Where was my glamorous studio location and the quietly seductive ambiance? Here I was at Brands Hatch, being dressed in a skin-tight Suzuki leather motorcycle one-piece zip-up suit, with the mechanics discussing the size of crash helmet I would need, if indeed one was needed at all when I was on the bike? Minutes later, with his entourage, Barry Sheene entered, his smile momentarily putting me at ease.

"Hi I'm Barry," said this shy but charismatic sports hero who really needed no introduction, after all, I had seen him on the telly!

OK, so yes, he does have that cockney smile and charm that instantly of gives you a sort of calm assurance, but when he suggests I might want to take a Valium tablet, then his smile and all the assurances in the world start to fade fast!

I am sure I was given a full briefing but throughout the mumbling from the art director all I could do was to stare at the still loud growling huge motorcycle.

Next thing, Barry Sheene jumps on the motorcycle, then holding out his arm towards me, obviously to help me on to the pillion seat, except there wasn't a pillion seat? This was a racing motorcycle and no space for

a passenger, so the only space was when Barry pushed himself forward towards the petrol tank, leaving a miniscule space at the back of the seat for me!

I cannot remember how I climbed onto the bike, whether helped by Barry and his team or whether I just bravely and nonchalantly jumped on myself, certainly there is nothing in my memory banks that relates to this. Nevertheless, suddenly I found myself sharing the small seat and clutching hold of Barry as if my whole life depended on it (as indeed it did)– and we were not even moving yet!

"Very brave of you not to want the Valium" shouted Barry as he turned around to check how I was.

"Obviously we should be wearing crash helmets but as this is strictly for the camera, I won't go too fast, I'll keep it well under a hundred!" shouted a smiling Sheene as he revved up the engine.

Suddenly the motorcycle roar got louder, and it lurched forward, the pit-stop, art director, photographer and crew becoming blurred as we weaved out on to the track, the wind hitting my face.

The idea was that we would go around the track, coming back to pass by the pit-stop where the photographer would be positioned, snapping at us, with me leaning out to face the camera.

So, firstly for those who are not an aficionado in motorcycle racing techniques, let me briefly explain that for me to lean out so far as to be seen from behind Barry, meant I would have to lean outwards, in the opposite direction to him and the bike, all very wrong of course on a motorcycle. At the same time I was to look relaxed, striking a glamorous pose, not forgetting a beautiful smile and, as the photographer happily suggested, giving him a wave as we flashed by – all, I was assured would be at a speed of well under 100 miles an hour. This, again as a reminder for the non-aficionados, was to be on a 'one seater' racing motorcycle, me hanging onto the rider (now with just my one hand), who would at that precise time lean the bike over to achieve a more dramatic racing effect – all very simple eh?

Not sure how many times we went around and around the circuit, passing the pitstop for the photographer to snap away, but I do remember the bike eventually slowing down as we came into the pitstop, ending our shoot. Everyone had huge smiles on their faces, Sheene asking how it looked, "Amazing" the photographer shouted as he and the crew gave themselves enthusiastic and celebratory pats on the back!

Barry helped me off the bike, my legs having seemingly welded themselves to the side panels.

"Fun eh?" said a smiling Sheene – suddenly his smile was not so infectious and assuring! So, giving him a huge slap across the face for taking me on that suicide mission was what was on my mind... but unfortunately my arms were also welded into position, so a simple smile back to him was all I could muster.

Half an hour later, coffee in hand (laced with brandy) and all laughing and enjoying the banter, Barry and I became good friends. Even I (as I lied through my clenched teeth) said how much I had enjoyed the experience and how nice it would be it would be to do it all over again.

Our friendship had bonded, and within days I had been invited to Stephanie and Barry's home for dinner, the other guests being Formula One racing legend James Hunt and his girlfriend, then obviously myself and Ken. It was a particularly enjoyable evening. Our first conversation, initiated by the boys, was naturally on speed records and who was champion of this and of that, but girl-power eventually came to the fore and we brought it around to models, glamour and photography – the girls proving they were the real champions.

Next morning, over coffee I mulled over the events of the previous evening, the social gathering, the dinner and the stories and enjoyment with two of the most famous and fastest men on the planet. Two world champions who thousands of fans queue up for all day only to see them zoom past them for a split second – and there we had been, joking, chatting and being served a superb dinner cooked by Barry's girlfriend Stephanie, an intimate get-together of fun and laughter with Barry and James Hunt – but that was now our lifestyle, Ken and I were enjoying one of the most glamorous and privileged of lives!

# SPLASH IT ALL OVER WITH HENRY COOPER

Henry Cooper (OBE KSG), British, Commonwealth and European Heavyweight Champion boxer, was without doubt one of the most popular sportspersons Britain had ever known. Famous as the boxer who downed Muhammad Ali (then Cassius Clay) in their first meeting in 1963 (the end of the round three bell just having saved Ali as he stumbled back to his corner). Henry unfortunately lost the match in the next round, when it was halted by the referee because of severe cuts and bleeding on Henry's face.

Cooper was much loved by the British people. He was the first person to have ever received 'Sports Personality of the Year' on two occasions. He was also awarded an OBE from Her Majesty Queen Elizabeth and later a Knighthood. Henry was every man's hero, every woman's perfect gentleman and every child's favourite uncle – a true gent in the world of boxing.

Fabergé were quick to jump on Henry's popularity, he was a top sportsman, a national treasure and so he was to be one of their main figureheads in the campaign for their 'Splash it all over' advertising campaign and television commercials for their top selling aftershave for men – Brut.

Of course Henry needed a lovely lady to add the glamour, after all it's no good having the top aftershave if it hasn't attracted any of the girls?

Consequently a massive casting was arranged by Fabergé, the call went out to all the top model agencies in London and like many young hopefuls I was sent along by my agent. Entering the advertising agencies huge offices was like going into Kings Cross Railway station – whilst the building was huge with a very spacious reception it was still shoulder to shoulder with what seemed to be every female model (between twenty-five and thirty) that the capital could offer.

Never the less, clutching my portfolio I gathered all my courage and pushed my way through the throbbing mass of people and speaking with some assumed authority (it usually works), I looked the receptionist straight in the eye and said, "I am Angela from Top Models, as a matter of urgency

I have been especially asked by your agency to attend this casting, but I'm afraid that I am on a very busy schedule and only have half an hour to spare!"

Probably with the help of all the confusion, somehow, ahead of dozens of other models, I was sent straight up to the casting directors office. Here the director, without even an introduction, took my portfolio to look through, which obviously showcased me with photographs from my many assignments from all over the world, plus stills of my previous advertisements and television work. He seemed interested straight away. Suddenly coffee was served, and he seemed to relax, and finally introduced himself. Obviously if you didn't match his criterion immediately you would be despatched that instant, no attempt at friendliness, no intro, no coffee! But for me, so far, so good – we had a friendly chat about what she was looking for – a wholesome girl, someone who could project the girl-next-door image (but obviously someone who could complement Henry but without taking the attention and showmanship away from him). The chosen girl had to look right alongside the nation's recently acclaimed hero, Sir Henry Cooper. So, the director definitely did not want a sex siren or any over the top hard lookers. This I felt fitted in perfectly for me, I had rushed there dressed in just jeans and a white shirt (casual, but with a suntan and my flowing long blonde hair this combination is always a winner). This understated look was perfect for the director, especially when I thought of all the over-made-up and sexily dressed models still waiting to meet him downstairs.

A week later my agent telephoned me and happily announced I had been selected by the advertising agency to be part of the Brut advertising campaign, working side by side with Henry Cooper.

The day of the shoot was combined to fit both stills and the video, so I was warned to expect to be there for the full day. This of course wasn't going to be a problem, the booking had a huge fee attached to it, plus there are harder things in life than working with the famous Henry Cooper.

Henry was of course Henry, an overpolite guy but with a wicked sense of humour, so the day was all about him and I having a good laugh, only stopping our fun and games when ever work called, both then behaving sensibly for the cameraman and photographer. The location of the shoot was a Ten Pin Bowling Alley, this being the backdrop for both the stills and the video. Besides track suits the wardrobe department had also supplied Henry and I with matching Brut T-shirt's to wear, this for an extra Brut promotional shoot. There was a hairdresser on hand to make sure my hair was perfect each

time the director called us on set, with two makeup artists checking Henry and myself before the cameras rolled!

A busy day, but a fun one, Henry making sure it was never dull, joking all day about splashing it all on – and on and on! It was one of the many advertisement assignments I really enjoyed, all ending nicely with Henry and I joining the director and crew for a drink in the local pub afterwards, a perfect working day.

# THE ROYAL CAVALRY, THE PALACE
# AND A PARACHUTE JUMP

Kenya was a place I instantly fell in love with. I had been lucky enough to be chosen by several top brands to feature in their advertising campaigns where I enjoyed the luxury if a photoshoot in the tropical setting of Mombasa.

The beaches, the clear blue sea and the lifestyle in those more innocent days was second to none, for any of these assignments I would have gladly done them for free (although on all of them, my modelling fee, which I was totally grateful for, was always embarrassingly high). The shoots on these trips, remembering the expense for the clients, was always going to be very, very demanding – the hours would be long, starting at first light (when it was at its coolest) and only finishing after using the beautiful orange glow of the sunset.

So, any respite or deviation from the work schedule was always a bonus, and on this trip even the art director, photographer and the entire crew were overawed at the presence of our rather special fellow beach hotel guests – a segment of Royal Regiment of the Household Cavalry (twenty of their officers). They were in Mombasa on a goodwill visit (or on a freebee junket as we all laughingly called it), and the guys were probably just excited to find a full London crew on a glamorous beach photoshoot for the Kenya Tourist Board, as had been booked into the same hotel – the prestigious Mombasa Beach Hotel. They were obviously pleased to meet us. So big handshakes and hugs all around when we met!

They said that they were having a Bar-B-Q that evening in the hotel and asked if we would like to join them. This set the agenda for a soirée every evening for the week, even our art director would now be more eager to wrap up each of the daily photo session so we could get back to meet up with our new friends, for what was now becoming a huge carnival dinner event. This was something that didn't go unnoticed by the hotel management who quickly added a touch of pixie-dust to the event, a free giant punch bowl laced with Kenya rum and even adding local entertainment – in all, the whole hotel now enjoying our nightly get-togethers.

On the last day there were all the usual 'we must keep in touch' offers, lots of hugs and promises – but the Major did ask to talk to me as they were leaving, this on behalf of all the officers, to offer me 'tea and scones' back in London with the regiment. Now tea and scones may not seem such a big deal, but this is the Royal Household Cavalry Regiment, and the officers have their tea at Buckingham Palace! It was a longstanding tradition that when an officer leaves the regiment, he is allowed to have a celebration and can also to invite one non-regimental guest. They had used this opportunity of one of their troop leaving to invite me. What an honour, but what I didn't know was that there was an ulterior motive. The guys had all seen photos of me which had appeared recently in a national daily newspaper and they reasoned that if they could persuade me to train with them and do a parachute jump then this would be great publicity for their new 'Freefall Parachute Team'.

Two weeks later, back in London, having accepted their invitation, saw me driving my old black Mini down the Mall, where for an instant I looked up to the rear-view mirror and there, filling the mirror view, by pure coincidence, was a troop of my Household Cavalry, in full regalia, trotting behind me! This was the most amazing view and one I will forever remember and take with me to my grave!

Trying to drive my Mini straight ahead I was transfixed by the cavalry behind me, then suddenly I realised I had reached the gates, what do you do then? I mean, yes OK, if you're a special diplomat with an escort and the police are expecting you, but my little Mini cast no big shadow, certainly it was never going to impress four police officers and the section of Royal Guards there on gate duty? But as they say, in life stranger things happen! Pulling up at the gates of Buckingham Palace trying to say something that was better than an incoherent mumble, a smiling (almost laughing actually) policeman stepped forward and asked if I was a guest at the officer's mess – my relieved smile and nod was enough. Looking down his clipboard list he read out; Angela Ross – guest from Kenya! With a wave forward, I drove through to the courtyard, being directed to park in the corner at the northside.

By the time I had parked my friendly Major was already in view, giving me a cheery wave, "Welcome to Bucks-house," followed by a firm handshake and a reassuring smile, I was there!

I was then treated to a quick and what he laughingly called the 'seven and sixpence' tour of Bucks House, strictly the tourist route, even my Major

wouldn't pass the line of incursion at the Royal Residence (although I was advised Her Majesty was not in residence this week).

On my entrance to the officer's room there was a light tapping of spoons on the tables, a sort of applause or approval of a person's entrance. All very boys-own and exactly what you would expect in a movie as I sauntered through towards a table where the officers had stood up.

And there it was, literally, tea and scones, a tradition that makes you proud to be English, something that probably hasn't changed for 200 years. Many of the officers were in full uniform (about to go on duty), whilst those not about to go on show were casually dressed in light fatigue wear. The talk was all about Kenya, the trip and the experiences they had there, but later it turned to their up and coming two-day event at Ashford Airfield, their sky-dive and parachute training session. This was an official jaunt, full military kit, even the tents, Land Rovers and catering vehicles had been comman-deered. Although official (the regiment encourages any parachute themed event for its men), it was called 'Freefall Team' and therefore was something the men could volunteer for (or not), more a club event and very much in its infancy stages, where most on this particular event were taking their first training session and their first jump!

The next few minutes were an amusing blur of laughter and jokes, but on leaving, I had somehow signed up (well, agreed to anyway) to join them for the two-day parachuting training session, Ken was even invited to come along to take photos and join in if he wanted.

A week later, Ken and I were packing our overnight bags, as we were not sure of the overnight accommodation rules we had booked a room in the local pub on the edge of the airfield, more or less walking distance from where the guys had described as their located billet. On arriving it really was an army experience, like something out of a war movie, Land Rovers, heavy army trucks and a complete catering section plus six or seven huge kaki tents and one especially big one which was used as the office or command centre – amazingly impressive leaving us somewhat disappointed we had booked in the pub. It was still early so breakfast was being served, all mess-tins and tin mugs – absolutely fantastic, Ken had decided not to join in the training ses-sion and parachute jump on this event, he thought that one of us risking their lives on that day was enough! After breakfast I was called to join the training session, basically how to fall, because as the instructor told me, in parachut-ing it seems it's only the last few feet that cause the problem (team joke)!

219

So, it was on with the parachutes, getting the straps in the correct position, we were jumping off tables to go through the landing procedures, remember it's only the last few feet (Ha! Ha!)?

With the strenuous lectures on safety and parachute procedures this took up the full day, with our jumps being scheduled for the next day. The evening was great fun, sat around the huge campfire with the catering division making sure everyone had enough to eat. Drinks were limited, obviously no one could jump with a hangover, but a few cases of beer were handed around.

The next morning the winds were stronger than had been forecast which meant the jump was delayed, ('Thank God' I was secretly saying to myself and so, I heard, were most of the other new recruits). More practice at the method of the fall, going through all the theory of when and how to pull that all-important ripcord (and the emergency chute if needed). When the subject had first been brought up at the casual Buckingham Palace discussion (it all seemed very glamorous back then) I assumed it was one of those fixed line jumps where you could close your eyes and just step out of a big aeroplane – no! This was the Royal Regiment and things had to be done strictly by the book

Their motto is all about Honour, so no fixed lines for this group – ugh!

Thinking it was all to be cancelled, and all of us making the right noises. O! what a shame, etc, etc, we all secretly thinking of the whereabouts of the nearest pub – but no such luck. Our smiling Major came running towards us, we have a window now, so grab your chutes, we can arrange an eight jump. Of course, all the recruits who were scheduled to jump next were suddenly being so magnanimous, so polite and so gallant, all pointing at me, in the best tradition of the army, all eagerly offering me 'their' place!

And so, I was on the plane, a 'high-wing' Cessna, with one door removed. The pilot showing us how, when over a thousand feet up we climb out, firstly putting our feet onto to the planes fixed landing wheel, holding on to the overhead wing struts, edging slowly out, and when ready – let go. Feet first he impressed, following a second later by letting go with your hands of the struts, so the wind takes you horizontally. "We don't want to hit the tailfin do we?" he smilingly added – believing that it was a joke and would bring a smile to our eight dumbfounded and terrified faces. The engine roared, we crouched in the plane like sardines (or squashed lemmings as one of our fellow jumpers described us)!

Ten, that was the magic number we were told had to count out before pulling our ripcords. Remembering the count, saying 1001, 1002, etc.,) This all after

edging out of the door of our Cessna at what we were now told was nearer 2000 feet, holding on to the wing struts whilst putting your feet on to its landing wheel, all this whilst enduring a force ten gale hitting you in the face is not as easy as may sound. It is difficult to understand the initial fear that courses through your body, the height (don't look down), and actually forcing your body to physically manoeuvre out of the safety of the Cessna, hanging on to the plane in a position that you would think would even be impossible at ground level!

A hand on my shoulder told me it was my time, my jump moment. Somehow, you never remember exactly how you managed to summon up the courage and physical strength to push yourself out of the plane, hanging on to the wing struts. Letting your feet be swept off the wheel by the horrendous wind pressure, instantly letting go with your hands. All this done so quickly it is done more by instinct rather than precious thought – hence the training the day previously (thank God)!

One thousand and one, one thousand and two, one thou… it goes on, again more by instinct than any astute mathematical counting, soon in the spinning, the feeling of hurtling to the ground and all the apprehension, you reach one thousand and ten, and without any further thought, you pull your ripcord – Wow!

I looked up, above me the most beautiful sight you could ever behold, a huge white silken canopy that stretches out covering the whole sky. Your world stops spinning, your fall stops, even taking you higher for an instant. It is as if the whole world is on hold, nothing else matters. I looked down; the world was below my feet – absolutely beautiful. Silent and feeling almost still, I gently floated downward, twirling around to take in the beauty of the landscape and the coastline. Whoops! Got carried away with the magnificence of it all. Shaking myself and bringing myself to my senses, suddenly realising I had to find my target zone, my field of waiting army officers. I could see the coast, the whole county was below me, my target only a spec, a miniscule dot on a map, but to me the most important of targets. We had been taught how to look for landmarks, fields and buildings, and yes, I could finally see my destination. Pulling the parachute guide ropes, I started the manoeuvre to bring the parachute in line for my target zone. Remembering the training, I brought up my feet, bending my legs in position for the final approach, the landing.

The field was now in full view, I could see the encampment, the tents, the vehicles, the soldiers scurrying around and even the chute still spread on the ground of the jumper who had gone before me.

This is one of the most exhilarating moments of my life, once the chute is open you feel totally safe, the visionary moment, the silence and that you are there just on your own, the world below you is yours, all totally amazing.

In the final moments, the ground comes up to meet you very quickly, there is little time, but I had put myself in the landing position much earlier, I was ready to hit the ground.

You don't hear anything, just a rush of wind and bang – you're on the ground. I rolled over but I was prepared and ready for this. No problems, I quickly stood up to see the guys all running towards me, I had landed dead on target, in the exact scheduled part of the field. Two of the officers in a Land Rover were the first to reach me, the guys jumping out and helping me off with my harness, all looking slightly amazed that I had landed so well without any problems. I was already up on my feet taking off my helmet, my long blonde hair now tumbling around my shoulders, (always remembering I am a model and people, regardless of the event, still expect a little glamour). Three of the guys were folding up my chute, another carrying my helmet, everyone had run over to help me. Triumphantly I walked across the field towards the tents, this to a round of applause from the guys. My first jump had been perfect, especially when you realise that two of the guys who jumped right after me had gone floating off into the wilderness and were now being searched for by two of the regiment's Land Rovers.

I had done it! I was so elated, little ol' me, a miner's daughter from a small village in County Durham had jumped 2800 feet from a moving aeroplane and landed right on the spot – a perfect jump. I had actually been so scared, I had tried hard not to let anyone know how scared I was but I have a feeling that they might have guessed. I had been unable to speak until after I had landed but now it all came tumbling out, Thrilling, Magical, Unbelievable. I could not find the right words to describe it. No wonder that once you've done it – you are hooked!

Ken had photographed the whole event, saying how it was so silent that even at our height he could hear the pilot shouting and telling us when to jump, He even heard one of the soldiers laughingly shouting 'Geronimo' as he threw himself out of the plane.

A totally amazing experience, in the later award ceremony I proudly accepted the Regiments Parachute Certificate, all this adding yet another experience that I will never forget for the rest of my life.

*Angela*

# IN ACKNOWLEDGEMENT

Any thanks, acknowledgement for help and guidance must go first to my parents, and indeed Angela's, for without the direction of our families and the sound base they provided, neither of us would have started our journey with so much confidence.

For myself it is my father, Frederick William Ross (Naval Frogman, DSM), and my mother Joan, (who's own badge and medal of honour was simply that of being a Yorkshire mum, one who worked tirelessly every hour of her life to look after her family) – these two people for me were my backbone and strength, and my appreciation for the home they gave me knows no bounds.

From Angela, "Thanks go to my mother, Anne Johnston (formerly Horrigan) who supported me throughout my career and who even had the foresight to send me to elocution classes, even before I went to school.

Angela's brother Thomas Horrigan was another source of our enjoyment of family life, so tragically taken in mid-life, with heavy heart we forever miss him. With his wry Geordie humour, he kept us grounded during our rise to fame. His favourite saying, and that of and his wife Jackie was, "We canny dee posh." Although when he was with us, he revelled in it! We mixed with famous faces and visited 'posh' clubs and restaurants – and they joined in the fun.

All through our life together, for Angela and myself, our loving parents were our conscience, our standard by which we gauged everything – they were the place called home, our sanctuary.

In our careers, I have mentioned how from The *Sun*; Tom Petrie (picture editor and later, News Editor), Arthur Steel (picture editor) who both helped me so much in those early days, they, along with all the *Sun* features and fashion team plus the then Assistant Editor/Editor, Nick Lloyd (now Sir Nicolas Lloyd, Media Consultant) helped shape my career. Special thanks also to several of the *Daily Mirror* picture desk and fashion team. Also, the *Sunday Mirror* picture desk and its feature's editor, Robert Wilson. Plus my

thanks to all the television stars, pop idols and sports heroes who gave so much of their time and patience to us both – thanks to you all.

For Angela, we must mention Don Rosay (CEO) of Top Models Agency London, who persistently encouraged her to make the giant leap to London and then looked after her career so much. Plus of course, all the team at Granada Studios in Manchester and all the amazing stars and celebrities she has worked with since the start of her career. everyone being a dream to have met and worked with (that includes the Officers and Troopers of the Royal Household Cavalry).

*Ken Ross*

**'Living the Life – With Just a Camera'**

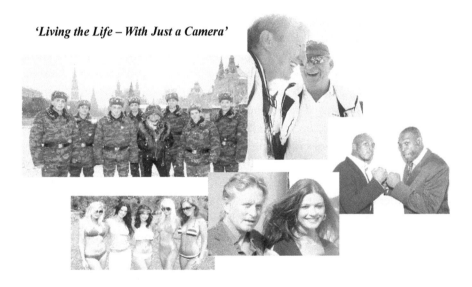

*But for us, to move forward, our very own 'Celebrity Magazine' was about to be launched – but that's another story – this of dining with Hollywood superstars, world renowned pop idols, sports heroes, the ultra-rich and Royalty. All this plus nonstop invitations, whether jetting-off to be the guest at Miami Beach for a week, or invitations for two absolutely amazing (and scary) trips for us to visit the inner sanctum of the Kremlin, in Moscow! All will be revealed in our amazing sequel, this in our following book; 'Living the Life – With Just a Camera'.*

Lightning Source UK Ltd.
Milton Keynes UK
UKHW030404140121
376915UK00006BA/110